# HOGARTH

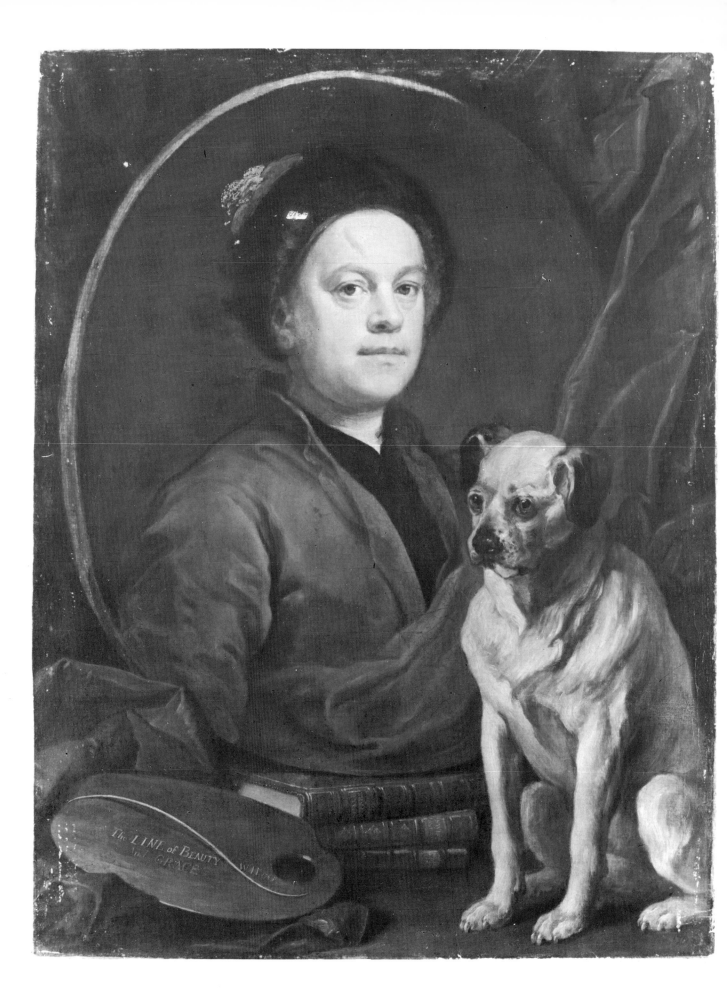

# MICHAEL ROSENTHAL

# HOGARTH

JUPITER BOOKS *Publishers*

*London*

*(frontispiece)*
*Self-portrait with Pug*
LONDON, Tate Gallery. 1745. Oil on canvas 90 × 70 cm.

Hogarth presented his own portrait on an oval canvas surrounded with green drapery. It rests on the works of Shakespeare, Swift and Milton. In the foreground are his palette and one of his many pugs, a dog called Trump. Hogarth's choice of authors, rather than reflecting the exact literary bias of his art, may well have implied a tradition of which he saw himself as part. The palette was the tool of his trade, and 'The Line of Beauty' ('And Grace', which although painted over is still visible) a three-dimensional symbol of his aesthetic. The dog is an emblem of himself, small, fierce and English.

*ACKNOWLEDGEMENTS*
I should like to thank Robert Oresko for being an exemplary publisher. I am extremely grateful to Amanda Simpson for reading through and commenting upon the original typescript. Lastly I thank my wife and various friends for never allowing me to take anything seriously.

*David Garrick and his Wife, Bookplate for George Lambert, Boys Peeping at Nature* and the view of the King's Staircase, Kensington Palace, are reproduced by Gracious Permission of Her Majesty the Queen.

The publishers would also like to thank the following for providing photographs and giving permission for them to be reproduced: Admiral President, Royal Naval College, Greenwich; Albright-Knox Art Gallery, Buffalo; Beaverbrook Foundations, Beaverbrook Art Gallery, Fredericton, New Brunswick; British Library, London; British Museum, London; Fitzwilliam Gallery, Cambridge; Fratelli Alinari, Florence; Guildhall Library, City of London; Lady Teresa Agnew, Melbury House, Dorchester; Lord Brownlow, Belton House, Grantham; Musée du Louvre, Paris; National Gallery, London; National Portrait Gallery, London; National Trust, Ickworth House, Suffolk; Paul Mellon Center for British Art, New Haven, Connecticut; Philadelphia Museum, Philadelphia; Royal Academy of Arts, London; St Bartholomew's Hospital, London; Service de documentation photographique de la Réunion des Musées Nationaux, Paris; Sidney F. Sabin, London; Tate Gallery, London; Thomas Coram Foundation for Children, London; Treasurer and Masters of the Honourable Society of Lincoln's Inn, London; Trustees of Sir John Soane's Museum, London; Victoria and Albert Museum, London; Walker Art Gallery, Liverpool.

This book is intended to provide an introduction to Hogarth, stressing what we can discover about his art by looking closely at his pictures. The captions to the plates are intended to be complementary to the text. Most illustrations are mentioned in the text, the few that are not serve a supplementary function.

First Published in Great Britain by

**JUPITER BOOKS (LONDON) LIMITED**, 167 Hermitage Road, London N4 1LZ.

ISBN 0 906379 43 1

This book was produced in Yugoslavia

# William Hogarth

WILLIAM HOGARTH IS the most prominent figure before Ruskin in the history of English art. He played many rôles, satirist, propagandist, great artist and politician, usually in such a manner that it would have been impossible not to notice his performance. He exasperated, charmed and delighted his contemporaries, and from the late 1720s until the 1750s he dominated the small but increasingly active world of English art. The chief reason for this was that he was indisputably the greatest English artist then living.

Walpole began his life of Hogarth thus: 'Having despatched the herd of our painters in oil, I reserve to a class by himself that great and original genius, Hogarth'; but, he continued, he was considering him '. . . rather as a writer of comedy with a pencil, than as a painter'. This wilful paradox illustrated something of the difficulty to be met in studying Hogarth. On the one hand his works amuse the literary historian who finds in them narrative techniques and themes paralleled in contemporary writing. On the other we can amass from them information about fashions, behaviour and the *look* of eighteenth-century London and use them as a depository of historical information on the conditions, for example, in a madhouse (Plate 27). Further, they often achieve greatness as art. The *Portrait of Captain Coram* (Plate 39) may be the consequence of the growing interest in painting of a rising 'middle class', but it is also an outstanding portrait. A final and important point which tends to be forgotten is that much laughter and pleasure may be had merely from the idle perusal of Hogarth's works.

Walpole's quotation reminds us, too, of another of Hogarth's characteristics, his tendency to provoke extreme reactions. When Benjamin West remembered him as a 'strutting, consequential little man' he captured the external show of Hogarth's personality. Although a highly-developed self-awareness was not unusual in the eighteenth century Hogarth's was exceptional even by contemporary standards. He knew his own worth and was not afraid to state it. The latinized title of his engraved self-portrait *Gulielmus Hogarth* (Plate 85) demonstrated something of this self-esteem. This print shows a portrait of the artist, his palette, graver and dog Trump with some books which the original painting (*frontispiece*) shows to be the works of Shakespeare, Milton and Swift. Hogarth, in every-

day dress, gazes steadily out, a trace of amusement both in his eyes and his mouth, and the scar on his forehead accentuated. This matter-of-factness allows us either to take or to leave him, but only at his own valuation. He permitted us this unequivocal choice because of his over-riding honesty, and, as this quality is often found disquieting by those who do not possess it to such an advanced degree, Hogarth's contemporaries reacted against it. Hogarth did not pretend that it was the inspiration of some 'new muse' which led him to abandon conversation pieces in the early 1730s, but stated bluntly that he found such paintings

. . . a kind of drudgery, as it could not be made like the former [i.e. portraiture] a kind of manufacture . . . That manner of painting was not sufficiently paid to provide what my family required. I therefore . . . turned my thoughts to a still newer way of proceeding, viz. painting and engraving modern moral subjects, a field unbroken up in any day or any age.

He knew the power of novelty to sell and was determined upon reaching, through engravings, as large an audience as possible. Such unabashed business mentality is not normally considered a 'typical' artistic characteristic. Similar straightforwardness led Hogarth to risk and attract ridicule by proposing himself the equal to Van Dyck, and he suffered deeply through the general refusal of patrons, artists and the public to take *Sigismunda* (Plate 77) at his own exalted valuation. Throughout his life he was in the public eye, and throughout his life he stung contemporaries to extreme reactions. In *Peregrine Pickle* Tobias Smollett lambasted the artist as a bigoted and ridiculous dandy who would not act his age, yet he joined many contemporary writers in using automatically such qualifying phrases as 'the pencil of a Hogarth' to indicate his intended range of literary characterization. Samuel Johnson's epitaph is unashamedly admiring and closes

> Be Vice and Dulness far away
> Great Hogarth's honour'd dust is here.

A few years previously Charles Churchill, one of Hogarth's victims (Plate 84), had been less adulatory:

> Be wicked as thou wilt; do all that's base;
> Proclaim thyself the monster of thy race.
> Let Vice and Folly thy black soul divide;
> Be proud with meanness, and be mean with pride.

The contrast is forceful. Indeed, such contradiction

of opinion emphasizes the massive complexity of Hogarth. He was an artist of overwhelming variety and an individual of many parts. This essay could not hope to deal adequately with the man, his life and his work, but, nevertheless, one can sketch the biography and attempt to point to certain themes and problems in Hogarth's art.

William Hogarth was born on 10 November 1697. His father Richard Hogarth, a schoolteacher from the north of England, had settled in London by 1689. The family lived in Bartholomew Close, near Smithfield, a part of London which had escaped the Great Fire of 1666, and where, consequently, the buildings had a random character achieved through years of accretion rather than the more ordered look of the new streets. Richard Hogarth had come to London hoping to make his way as a teacher of Latin and Greek. This project did not pay, however, and he was reduced to doing hack work for publishers. Then in January 1703 he opened a coffee house where only the classical languages would be spoken. This failed. In 1707 or 1708 he was confined to the Fleet Prison for debt, but by the end of 1708 had bought himself out, so that he and his family, his son William and his two daughters Mary and Ann, were living within the 'Rules' of the Fleet, a defined area about the gaol in which prisoners were allowed a circumscribed liberty. Freedom eventually came with an Act of Amnesty in 1712. This childhood of poverty and confinement, paired with a non-conformist religious background, was instrumental in the development of Hogarth's attitudes. His surroundings, the London of *Gin Lane* (Plate 72) or *The Four Stages of Cruelty* (Plates 73–76), were barbarous, and the filth and chaos of the streets in *Night* (Plate 37) illustrate the urban squalor of Gay's *Trivia*. Hogarth was used to a life which would have made the modern sensibility blench, but his family background would have led him to recognize the possibility of, and to desire, a 'superior' way of life. Hogarth's humble beginnings probably lie at the root of the ambition he manifested constantly. Furthermore, his low-church background would have accustomed him to drawing a moral conclusion from events, while honing his susceptivity to their deeper significance, so that in art he would have had a natural turn towards symbolism or allegory.

In February 1714 Hogarth was apprenticed to Ellis Gamble, a silver engraver, but endured only six of the statutory seven years. He later admitted that he was too fond of his pleasures and too impatient a personality to attain 'that beautiful stroke' which betokened the good engraver. Nevertheless, having set up on his own as an engraver, his 1720 shop card (Plate 1) shows that he already was a craftsman of some note. In 1721 he produced *The South Sea Scheme* (Plate 2), a print satirizing the consequences of fiscal foolhardiness, within a tradition of such pictorial attacks. It was probably executed for a printseller desirous of an instant profit and is notable for its ponderous allegory with the wheel of fortune used as a merry-go-round by the directors of the South Sea Company and for a sardonic depiction of the flogging of Honour, encouraged by a dandified ape. Foxes skulk around the Monument erected to the destruction of the City, complemented ironically by the distant dome of St. Paul's Cathedral, representing Wren's rebuilt London after the Great Fire of 1666. Foxes are an emblem of the collapse of society, and thus civilization:

> The fox obscene to gaping tombs retires,
> And savage howlings fill the sacred quires.

Pope had written these lines in *Windsor Forest*, published in 1713, referring to what he saw as the catastrophic aftermath of the tyranny of William III. It must be pointed out that the pictorial 'reading' of Hogarth's print is not straightforward. His perspective is awry and the placing of figures or groups does not lend itself to pictorial clarity. Hence to make his point the artist relied conspicuously on language, in the form of a caption, of labelling of figures and of legends within the picture itself. He intended us to move from object or action to its moral consequence and ultimate result. Because Hogarth and his audience found their world ordered and comprehensible, moral inversion demanded satirical treatment. Although allegory is particularly evident in this very early print it appears, often reduced to the pictorial 'pun', throughout Hogarth's work.

*The South Sea Scheme* lacks artistic accomplishment. Hogarth was apparently aware of his deficiencies. In 1720 John Vanderbank and Louis Cheron opened an artists' academy at St. Martin's Lane. Here they offered a formal artistic training, and Hogarth parted with two guineas to be among the first subscribers. His desire to study art stemmed, too, from a wish to exceed the status of a mere tradesman, an engraver, and at St. Martin's Lane he not only learned techniques of drawing and painting but also mixed with practising artists. This academy closed down in 1722, and Sir James Thornhill instigated a free one at his own house, Hogarth participating in the venture which, although short-lived, did have some effect on him. Thornhill, an accomplished baroque decorative painter, was considered a great artist by many contemporaries, who were impressed with the artistic accomplishment of his Painted Hall at Greenwich (fig. 1) and the grisaille decoration in the cupola of St. Paul's Cathedral Hogarth admired Thornhill and on visits to Sir James's house, which was stocked with pictures, would have been able, both through study and conversation, to have increased his knowledge and appreciation of art. It is in this context of his acquaintance with Thornhill that Hogarth took the first of many stands on one side of a current artistic controversy. Although the London art-world of the 1720s was small, it contained distinct groups of artists, such as the one which assembled at St.

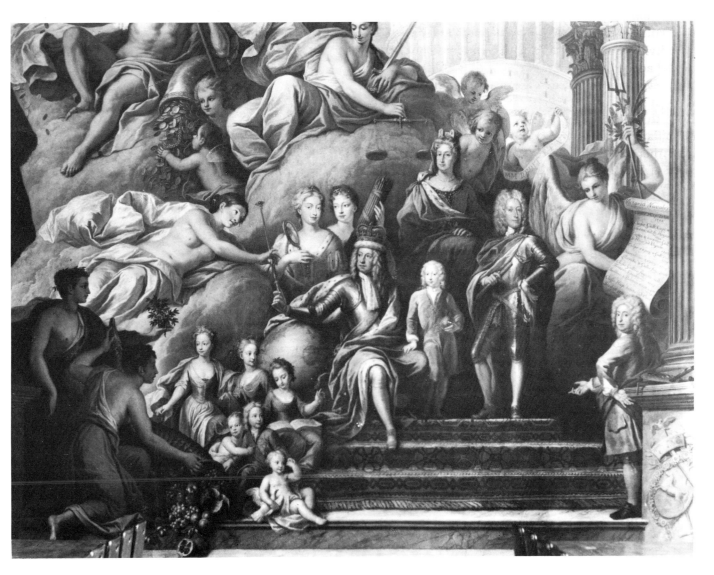

*fig. i* James THORNHILL
*The Family of George I*
Greenwich, Royal Naval College.

Thornhill's celebration of the House of
Hanover, which dominates the Painted Hall at
the Royal Naval College, displays both his
mastery of the trappings of baroque illusion
and the pictorial skill which led to his
deservedly high reputation among his contem-
poraries.

Martin's Lane and included Hogarth and Mercier.
This clique excluded the Yorkshireman William Kent,
whose Maecenas was Richard Boyle, third Earl of
Burlington.

Burlington was enormously rich, drawing income
from both family land and government sinecures. In
1714 he made a twelve-month tour to Italy, purchasing
on a grand scale paintings and anything else that
caught his fancy. Then, in 1715 and 1716, two
important architectural folios, the first volume of Colen
Campbell's *Vitruvius Britannicus* and then Giacomo
Leoni's edition of Palladio's *Quattro Libri*, were pub-
lished. The former, produced by an ambitious Scot,
was an expensive picture-book of recent British
building. Campbell advocated the work of Palladio

and Inigo Jones as the best architectural models, and
the book's very existence implied that it was time to
take not only native architecture seriously, but also the
buildings designed by Campbell himself. He was not
obviously dogmatic in his preferences, and the only
important contemporary architect he failed to mention
was his fellow Scot James Gibbs, at that time erecting
the superb little Church of St. Mary-le-Strand. But
despite, for instance, Campbell's fulsome gratitude
expressed in *Vitruvius Britannicus* to Vanbrugh for
helping prepare the plates of Blenheim, his ideology
became abundantly clear when he described Italian
baroque architecture as 'licentious and affected', and
that of the 'great Palladio' as the '*Ne plus Ultra*' of the
art. To produce such expensive folios both Campbell
and Leoni must have felt confident of their market, the
coming generation of *virtuosi* amongst whom we may
place the third Earl of Burlington.

Burlington had returned in May 1715 from his first
Italian trip, and by January 1716 had engaged Gibbs to
direct the remodelling of Burlington House, in London,
with paintings begun by Sebastiano Ricci (fig. 2). In
1717 Campbell replaced Gibbs. Burlington had been
converted to the new taste, and indeed, on his second

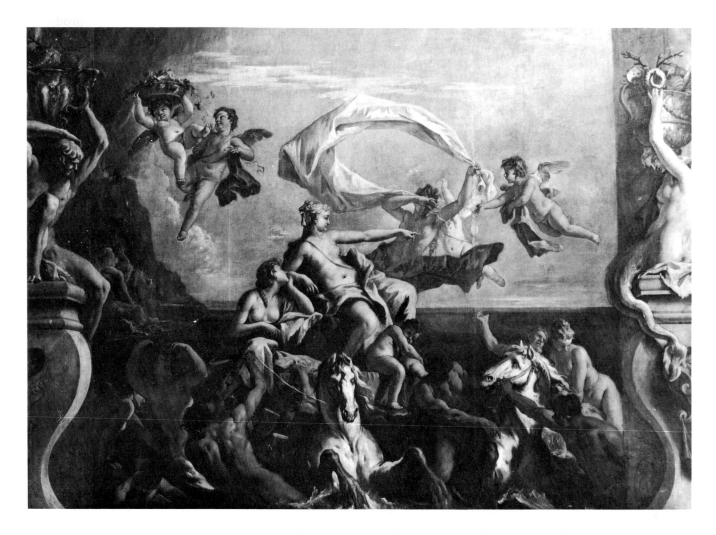

*fig. 2* Sebastiano RICCI
*The Triumph of Galatea*
London, Burlington House, Royal Academyof
Arts.

Ricci was one in a procession of foreign artists
to take rich pickings from English decorative
commissions, in this case one from Lord
Burlington.

Italian visit in 1719 he went with a definite, if limited, brief to study Palladio and Antiquity. Kent, whom he met by pre-arrangement in Italy, confirmed this, and on returning to England Burlington acquired, mainly from John Talman, a collection of drawings by Palladio, Inigo Jones and John Webb. He also installed Kent in Burlington House. The latter had just spent several, apparently none-too-arduous, years in Italy, financed by a group of Yorkshiremen who, with Burlington and one or two others, considered Kent to be the rising painter of the age. Hogarth, however, summarized the majority opinion in writing 'never was there a more wretched dauber'. Kent's installation was part of a deliberate policy by Burlington in the exercise of patronage towards creating a 'British School' in the arts, something which Shaftesbury in the 1710s and later Jonathon Richardson were both concerned to see established. Besides Kent, Burlington's group included a sculptor in the soon-to-be-abandoned Italian, Guelfi,

while in his early English days Handel benefited from the earl's generosity. Both Pope and Gay were also associated with his circle. While the only arts to be much affected by this new 'school' were architecture and landscape gardening, it did provide for contemporaries what was seen as a focal point for certain trends in taste. Hogarth, besides resenting what he viewed as the misdirection of wealth, also disliked such Burlingtonian tastes as Palladian architecture (Plate 50) or the Italian opera (Plate 3), which he saw as artificial and pretentious. Moreover, Burlington had considerable sway at Court and was able to arrange for Kent rather than Thornhill, who as Serjeant-Painter had the prerogative, a commission, between 1721 and 1727, for the staircase paintings in Kensington Palace (fig. 3). This was a gross affront to the man considered to be England's greatest artist ever, and Kent's third-rate work only rubbed salt into the wounds.

Hogarth already had aligned himself with Thornhill, for instance accompanying him in 1724 when the latter had drawn the convicted thief Jack Shepherd, and this cavalier treatment of the older artist was one immediate cause of a bitter animosity towards the Burlington circle. In Hogarth's response we see the germ of attitudes which were to be important in his later life and work. Burlington's patronage of both foreign artists and foreign ideals brought out in

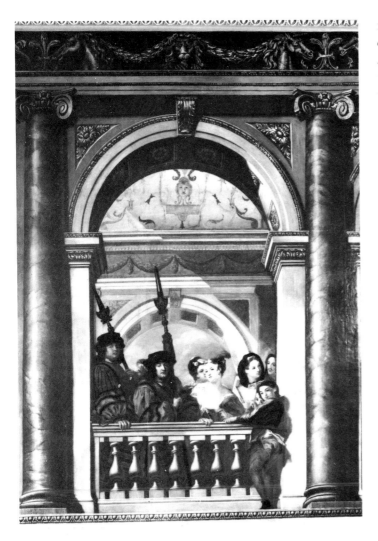

*fig. 3* Willam KENT
Decoration of the King's Staircase
London, Kensington Palace (Reproduced by
Gracious Permission of Her Majesty the
Queen).

Kent's *trompe l'oeil* staircase paintings at
Kensington Palace, a commission Hogarth felt
should have been awarded to Thornhill, are a
typical example of the decorative art favoured
by Lord Burlington's circle.

Hogarth a patriotism verging on jingoism and a
continuing craving for the supersession of a general
'taste' for old works by dead foreigners with one for
those of living Englishmen. This combined with a
loathing of misused patronage and a desire to direct
both public and private money towards encouraging
native art.

In 1725 Hogarth took one opportunity of attacking
Kent and thus, by association, Burlington, with the
scandal created by Kent's altarpiece for the Church of
St. Clement Danes, London, in a figure of which the
public had allegedly discovered a likeness to the Stuart
pretender's wife. The outraged parishioners had peti-
tioned the Bishop of London, who subsequently
ordered that the painting be relegated to the vestry.
Hogarth, gleefully aware that any 'likeness' resulted

from an accident of artistic incompetence, produced his
own comment on the affair in his *Burlesque* on the
altarpiece (Plate 9). In its merciless parody of bad art,
the print shows just how much more Hogarth had come
to know about painting. Limbs are ill-proportioned
and disjointed, and although the composition gives an
initial impression of unity, on closer inspection it
fragments. It is an extremely funny design, with the
humour in its emphasis on the ridiculous, the stringing
of the harp to the right, for instance. It defines his
opposition to the Burlington circle more directly than
his earlier attack in *Masquerades and Operas* (Plate 3).
This increased sophistication is the result of enormous
expenditure of energy on Hogarth's part and, in the late
1720s, a demonic application to his art.

In 1725, besides burlesquing Kent, Hogarth was also
working on plates illustrating Butler's *Hudibras*. These
display a clear increase in artistic refinement, particu-
larly in the way the compositions look to 'high art' to a
greater extent than anything Hogarth had previously
done. Scenes with a few figures are arranged to form a
frieze within the picture space, with crowded compo-
sitions like *Hudibras and the Skimmington* (Plate 4)
showing clear generic links with baroque bacchanals.
Hogarth was alway willing to study the Old Masters
and to learn from them. He had also, since 1725, been
painting signs (Plate I). As signs ought to be, these are
crude, schematized and clear. By turning from engrav-
ing to painting the artist was continuing a self-
conscious process of artistic expansion, begun in his
baulking at being just an engraver on silver.

He rapidly became skilled with the brush. Legend
has it that it was this which mitigated his 1729
elopement with Thornhill's daughter Jane, which
occasioned an altercation between Thornhill and
Hogarth. The former was said to have been won round
after seeing some of the latter's paintings. 'If he can do
things like that', Thornhill is supposed to have
remarked, 'he can earn enough to keep my daughter',
and provided no dowry. In 1728 in fact Hogarth had
produced the first of six versions of '*The Beggar's Opera*'
(see Plate 7), thereby exploiting the enormous popular-
ity of the piece. All the pictures show the scene where
Lucy Lockit and Polly Peachum, each supposing
herself wed to Macheath the highwayman, beg their
fathers, respectively the gaoler and the informer, to
save his life. Gay's plot parodied the Italian fashion,
closely paralleling the heroics and passions of the
criminal classes with those who make the laws. Such a
satire must have appealed to Hogarth, as his repetitions
of the theme and, in particular, his later development
of its lessons in *A Harlot's Progress* attest. The canvas in
the Tate Gallery (Plate 7) is based largely on the first
version of the scene and shows just how well Hogarth
had by the late 1720s learned to manipulate paint. The
pigment was applied fluently and his handling is
reminiscent of that of such Venetian artists as

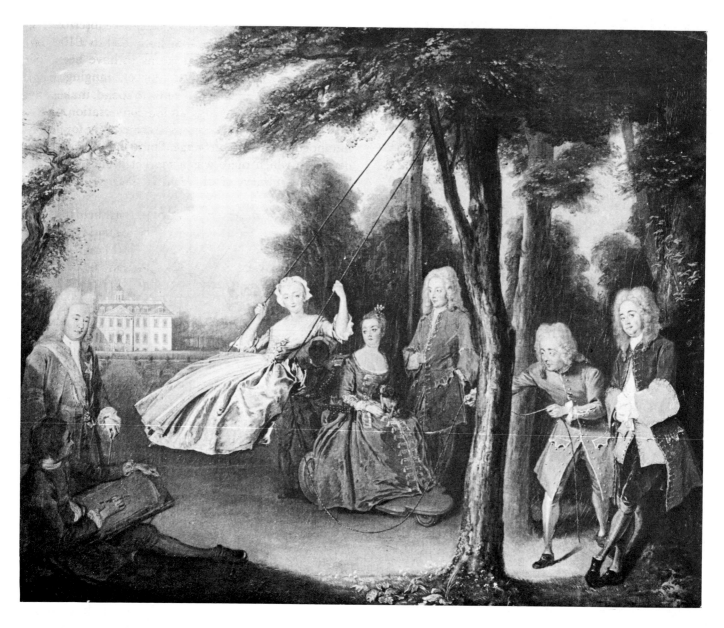

*fig. 4* Philippe MERCIER
*Viscount Tyrconnel and his Family*
Grantham, Belton House, collection of Lord
Brownlow.

The outdoor conversation piece adapted the
*fête galante* to the portrait, and in this painting
Mercier, a Frenchman, practised the genre in
a piece directly comparable to such works of
Hogarth as *The Fountaine Family* (Plate II).

Sebastiano Ricci. His depiction of a performance at the
theatre at Drury Lane means that Hogarth was
representing the stage scenery, itself painted in turn to
represent a prison. The picture's incident is, therefore,
at one remove from life, and illusion is engaged on
several levels of meaning. In this picture the audience is
actually on stage, thus participating in the action, and
the way Polly Peachum, played by Lavinia Fenton,
gazes at her real-life lover, the Duke of Bolton,
identifiable from Hogarth's accurate portraiture, fur-
ther blurs the distinction between play and reality.
This illustrates Gay's original point, Hogarth having
been entirely in sympathy with the former's irony.

Painting a scene from a play automatically creates a
composition with particular dramatic potential. The
realization of this must lie behind the 'staging'
apparent in Hogarth's later series.

By looking at this late version of *'The Beggar's Opera'*
we can see the extent to which Hogarth's skill had
increased. In January 1730 George Vertue gave an
account of the artist's progress: '... he ... by the force
of Judgement a quick & ready conception & an exact
imitation of Natural likeness became surprisingly
forward to be the master he now is.' Of course any artist
able to catch a likeness is bound to be popular,
particularly in an age when most portraitists made
their sitters look like horses, and following *'The Beggar's
Opera'* Hogarth painted dozens of 'conversation pieces'
(Plates 6, 11 and II), a genre derived from Flemish art
and in England transmitted directly through the
example of the Frenchman, Philippe Mercier (fig. 4),
who had arrived in 1719. The conversation piece was
usually a small picture depicting a group of people in
their normal surroundings, either outdoors or indoors.

With *The Fountaine Family* (Plate II) Hogarth painted a bourgeois *fête champêtre*. Sir Andrew Fountaine was vice-chamberlain to Queen Caroline and Warden of the Mint. He was also a famous connoisseur. In this picture he admires a painting of nymphs playing around a fountain, an example of Hogarth's visual punning, while women sit around a table. Everything points to the patron's taste, elegance and sophistication, while the setting indicates an intelligent appraisal by Hogarth of Watteau: there were several pictures by Watteau in the collection of Dr. Mead and Hogarth's colleague Mercier also painted in this style. Despite his oft-expressed insularity Hogarth was alive to French art, and his artistic milieu, then including Mercier and later to involve Roubiliac and Gravelot, was always at least slightly francophile. In the late 1720s and early 1730s it is also clear that in cultivated society a taste for French modes had developed. John Thomson, a member of the Commons Committee on Prisons (see Plate 6), commissioned the outdoor versions of *Before* and *After* (Plates III and 32), although his fleeing the country with embezzled money meant that he never actually received them. To appreciate these pictures fully it is worth knowing that the French *fête galante* normally showed an elegant, usually pretty couple indulging in the gambits of courtly love. Hence in *Before* Hogarth's youth postures inanely, the position of his left leg belying what one assumes to be a professedly honourable suit, while in *After* the state of post-coital collapse suffered by both serves to point up how flimsy former pretensions had been. The delightful painting in both works also contrasts with the actions they show. Hogarth hated hypocrisy, and here he exposed the unreality of this French genre as well as its implicit pornographic element. *Before* and *After* are paintings where 'truth' is paramount. They are also 'special commissions' to which the proper response is a loud guffaw. With the indoor versions of 1736–37, engraved to reach a larger audience (Plates 30 and 31), numbers of pictorial clues, such as the paintings on the wall, help the 'reading' of the prints in a way impossible with the outdoor scenes. Hogarth used humour to make a point about human behaviour: his seriousness was that of the man who appreciates irony, and he expanded the potential of the genre beyond the merely erotic.

By the time of *Before* and *After*, Hogarth was becoming successful, and although he was still producing conversation pieces, it seems to have been in the early 1730s that he conceived of an entirely different venture. Vertue described a Hogarth drawing of '. . . a common harlot . . . just rising about noon out of bed . . . the whore's deshabillé careless and a pretty countenance . . .' An erotic sketch, probably intended as an exercise, proved so popular that Hogarth was asked to provide a pair to it, and eventually he made six paintings, his purpose becoming more serious in the process. He engraved them (Plates 12–17) and opened a subscription for the prints, delivered to subscribers in April 1732. This brought him from £50 to £100 per week, and in view of what seems to have been the chance discovery of a mass market, ranging from artisans to aristocrats, with money to spend, makes one wonder if the decision to abandon conversation pieces was not the result of his having accidentally found an untapped source of patronage. Some indication of the degree to which there was a market is shown by the large-scale piracy of *A Harlot's Progress* by other printsellers.

One reason for the prints' success was their topicality. They featured recognizable figures and related to contemporary scandals. The first plate (Plate 12) shows the notorious procuress Mother Needham, while in the doorway lurks the infamous Colonel Chatteris. In the third plate (Plate 14) the portrait of Macheath on the left-hand wall and James Dalton's wigbox above the bed combine references to the fictitious and real highwaymen, while through the door enters the legendary whore-hunter, Sir John Gonson. The fourth plate (Plate 15) shows Moll beating hemp in Bridewell and doubtless displays accurately to us conditions inside that establishment. The series operates on several levels. On the one there is the narrative of the rise and downfall of a harlot. Yet she never makes a reasoned choice, and the 'villains' she admires, Macheath and Dalton, display qualities which would become virtues in, say, a general, thus creating an underlying irony of the same kind as Gay's in *The Beggar's Opera*. Hogarth makes us seek the explanation for her fall in factors outside her own personality. She provides a focus but not a heroine. Once we realize this the series' is expanded, and we can begin thinking about its morality not only on the simple level of the virtue-vice opposition but also on the more complex one of various shades of each. Single plates hold their interest by forming hermetic tableaux, themselves full of interest. In the sixth plate (Plate 17) the whores are grouped around the coffin almost as in the finale of a play, and in an intermediate episode, such as the second, we may observe a similar theatricality. Moll causes a diversion by kicking over the table to facilitate the escape of her lover. The only world shown is defined by the room with its exit much as it would be in a stage set. Details tell within both the individual plate and the series. Some, such as the boggle-eyed page, are intended for amusement only. Others are relevant to the 'plot'. The facial resemblance between the duped Jew and the monkey refers to the way he is 'being made a monkey of' while Moll's mask on the dressing-table points to her own duplicity. Here she is still pretty and desirable, but in the third plate her face has filled out and her expression has turned from coy to slatternly, thus there is a progression. Hogarth's series engages throughout the sympathy of the audience and runs it through a gamut of responses ranging from amusement to

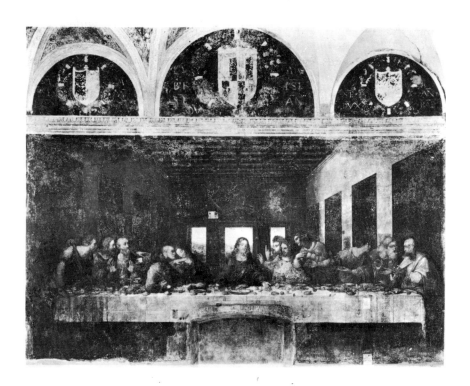

*fig. 5* LEONARDO da Vinci
*The Last Supper*
Milan, Church of Santa Maria delle Grazie.

It was from this celebrated fresco that Hogarth developed the composition for his recurrent theme of a conversation round a table (Plates 25, 28, 67 and 80).

concern. All are intended to lead to the one moral conclusion and to provoke contemplation upon it. His humanity displays itself in a willingness to be equivocal; despite his own moral stance he was able to see both sides of the argument. What Hogarth was doing was quite original. In a sense this was history painting, with men's actions shown to a moral end. However, history painting usually employed a formal idealism in realizing approved tales from sacred or classical literature. Hogarth's *modern*, or documentary, history was meant to be taken with the same seriousness, and this, the artist realized, was a breakthrough.

With the *Harlot's* success, Hogarth was on the crest of a wave. His elation must have been fanned by commissions from the aristocracy for conversation pieces, such as *'The Conquest of Mexico'* (Plate 11), ordered on 22 April 1732, or *The Cholmondely Family* (collection of the Marquess of Cholmondely), another ambitious work, featuring, curiously, the portrait of the late viscountess, who had died in 1731.

Hogarth's industry cannot be in doubt, and following this sustained burst of energy it is not surprising to find him relaxing in May 1732 when he embarked with some cronies on a 'peregrination' of Kent of which *An Account* was made. Its first entry reads:

SATURDAY May ye. 27th. Wee sett out with the Morning and took our Departure from the Bedford Arms Tavern in Covent Garden to the Tune of — Why shou'd wee Quarrell for riches.

The location, hour and tendency to sing suggest that it was not sober reasoning which inspired this jaunt. Hogarth's companions were the painters John Thornhill and Samuel Scott, the cloth merchant Ebenezer Forrest, who wrote the memoir, and William Tothall, an attorney. For five days they wandered through Kent, seeing the sights, having fights, throwing dung, playing practical jokes on one another and getting drunk. As his illustrations to *An Account of Five Days' Peregrination* show, Hogarth thoroughly enjoyed himself. In the drawing of the group embarking from Grain (Plate 10) he burlesqued both himself, crawling clumsily on to the boat, and the reluctant marine painter Scott having to be pushed on to it. These boisterous high spirits were an important feature in Hogarth's character. Indeed this sense of fun informs such prints as *A Midnight Modern Conversation* (Plate 28) of March 1733, in which one suspects that the exaggerated and uncompromising portrayal of the various stages of drunkenness was possible mainly because of the artist's own experience. The picture has a moral aspect, a 'conversation' being, after all, the enlightened discourse or meeting of rational humans, and the derivation of its composition from Leonardo's *Last Supper* (fig. 5) adds further point to the irony. Hogarth's satire depended on his knowledge and acceptance of the world he inhabited, and this makes our reading of the print slightly ambiguous. Certainly we ought to condemn morally the subject, yet to depict drunkenness accurately Hogarth had to have seen and to have experienced it, and if we are to appreciate his accuracy the same applies to us. Therefore we become ourselves involved in his satire.

In general, Hogarth was prospering. In October 1733 he had received permission to paint both a conversa-

tion piece of the Royal Family and the marriage ceremony of Anne, Princess Royal. This was a real fillip, and meant that having breached the ultimate source of patronage he could confidently anticipate a period of favour and riches. He signified his increasing prosperity by moving his family to Leicester Fields, calling his establishment 'The Golden Head', after the sign of Van Dyck which hung outside the door to denote the painter inside the house. Yet it was in painting the royal wedding, a project that was never realized, that Hogarth's luck with officialdom broke. Possibly certain parties felt him to be unsuitable because of a purported similarity between the figure of Princess Huncamunca in his frontispiece to Fielding's *Tragedy of Tragedies* (Plate 8) and that of Princess Anne. Huncamunca was distinguished both by Fielding and Hogarth for her 'pouting breasts, like kettledrums of brass', and the Princess Royal was acknowledged no beauty. Furthermore William Kent was Master Carpenter in the Office of Works and in charge of certain of the wedding arrangements. It is not surprising that he would not have tolerated Hogarth playing any part whatever in the proceedings.

Finding the avenues to higher patronage blocked, Hogarth turned his attention to other matters. Late in 1733 he announced the subscription for another set of prints (see Plate 18), this time describing the natural sequel to the story of the harlot, the downfall of a rake. Although he worked on it throughout 1734, Hogarth had good reason not to publish *A Rake's Progress* (Plate 20–27) until 21 June 1735. His profit on *A Harlot's Progress* had been reduced by a spate of cheaper piracies. In response Hogarth was the moving force behind The Engraver's Copyright Act, eventually passed on 21 June 1735. By allowing authors fourteen years' exclusive copyright over their own productions, it eliminated the pirates' main impulse. Nevertheless they did try to pirate *A Rake's Progress*. Hogarth's original paintings were on show at The Golden Head, and spies were dispatched to memorize their details, so that prints might be designed from their subsequent reports. The results were bizarre and demanded a high degree of public gullibility. Their very existence, however, is some measure of the degree of anticipation aroused by the prospect of something new from Hogarth.

In painting and engraving *A Rake's Progress*, except in the second scene (Plate 21), Hogarth was apparently unconcerned by the inevitable compositional reversal from canvas to the print of a copper plate. Both media allowed him different expressive opportunities. With the paintings, high-quality works in their own right, he was able to depict each scene in terms of its general drama and expressive possibilities. The prints, with their plethora of detail, permit a far more detailed reading of his narrative. It was through them, of course, that Hogarth presented himself to his public. Engrav-ings were relatively inexpensive and had a wide appeal in an age which, more than our own, acknowledged wide-spread illiteracy. In the provinces they were available from selected booksellers or printsellers and would have found their way into the hands of the squires, yeomanry and clergy. In fact, the exact nature of Hogarth's audience remains to be discovered. It was certainly socially wide and to a degree sophisticated. He shared with it an essentially protestant moral outlook and knew it would understand and appreciate his typical themes, which, up to a point, guaranteed his prints' appeal.

As, in *A Harlot's Progress* the rake follows a downhill progression. When Tom Rakewell receives his inheritance from a miserly father (Plate 20) he immediately sets off on the road to ruin by rejecting the girl Sarah Young, who is pregnant by him. The succeeding scenes show him succumbing to the blandishments of 'taste', losing himself in debauchery, falling into debt, attempting to alleviate it and finally dying in Bedlam. Sarah Young's calculated reappearances emphasize that redemption is open to him throughout his progress. Within the sequence individual scenes again have a hermetic quality, and their complexity makes the cumulative impression very rich indeed.

Hogarth used detail to telling effect. Even in a relatively simple scene, such as the second (Plate 21) with the rake surrounded by sycophants, the incident in the left background relates in its theme of choice of new clothes, a metaphor for a changed way of life, to Tom deciding whether to pay attention either to Bridgeman, the landscape gardener, or to the pugilist. The pictures on the wall further assist our reading. In the centre *The Judgement of Paris* echoes the idea of the choice of the most 'beautiful' or 'pleasing', although the grotesque goddesses indicate a bad taste in Old Masters and cast doubts upon the very nature of the choice, in practical terms the rake choosing between the various professors of the polite arts. The flanking of *The Judgement of Paris* by two canvases of fighting cocks shown so as to appear to be bridling at one another is Hogarth's means of indicating that the intentions of the various sycophants are less altruistic than they first appear. There is a similar complexity in other scenes, the fifth (Plate 24), for instance, in which the rake marries an old maid for her money. Certainly it is another stage in his downfall, yet the church itself is in ill repair, and a cobweb over the poor box is a self-explanatory condemnation. Hogarth thereby commented on contemporary religion, implying that the *malaise* is something of which the rake is a symptom. He is as much a 'victim' as the harlot. Hogarth's work constantly points to the general. The way in which Rakewell's pose in the final plate (Plate 27) broadly imitates those of Caius Gabriel Cibber's statues of *Raving Madness* (fig. 6) and *Melancholy Madness* at Bedlam connects the individual with an idea of

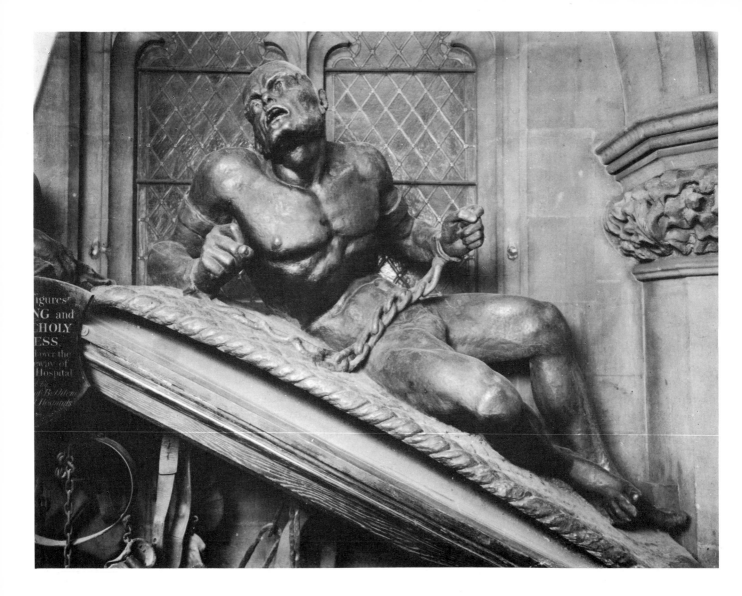

insanity. Contemplation of the morality of the series
emphasizes its complexity.

While engaged on *A Rake's Progress* Hogarth's life was
both extraordinarily busy and involved. His artistic
activities were multifarious. He published such indi-
vidual prints as *Scholars at a Lecture* (Plate 29), which
made their point through a satire verging on the
burlesque. The text 'Datur Vacuum' indicates the
mental capacities of those to whom it is being read.
This is, however, only too apparent from their
expressions which, *en masse*, provide a brilliant sum-
mary of the physiognomies of stupidity. The humour
depends on the cumulative study of the design; it makes
its point by basing its caricature in reality but also
ensuring that the general effect is one of complete

burlesque. This was one of various trends in Hogarth's
art in the late 1730s. He was at that time experimenting
with the potential of groups of pictures, or works
thematically connected, rather than with the series *per
se*. For example *The Distressed Poet* (Plate 33), *The
Enraged Musician* (Plate 41) and *Strolling Actresses
Dressing in a Barn* (Plate 40) all explore in some way the
relation between life and art. In the first the hero gropes
for inspiration for a poem about poverty, while a dog
steals a chop and the milkmaid demands payment, to
show that all he needs do is look under his own nose.
The musician is enraged by the racket of the streets, but
these are the sounds of life. *Strolling Actresses* is less
direct, with its reference to the 1737 Act against
Strolling Players, which, being aimed at actors alone,
explains why Hogarth shows only women and children.
Here the irony and humour emerge through the vast
contrast between the parts taken up by the women and
children, and the reality which is about to engulf them.
They are preparing to perform *The Devil to Pay in
Heaven*, decipherable on the playbill in the left
foreground, and are costumed as miscellaneous classi-
cal deities. So the goddess of chastity, Diana, stands in
the centre cheerfully displaying her charms, particu-

larly to a figure gazing through the rafters, while Ganymede feeds a baby. There is much visual wit, because the characters the actresses are about to play are those usually represented in conventional history painting. So while Hogarth plays with the metaphor 'all the world's a stage', the way that reality is about to overwhelm these 'classical' personages points not only to the limited relevance of their dressing up, but suggests further that paintings featuring a similar staffage are without great contemporary point. A classical altar serves as a table, washing is hung at random, and a monkey urinates in Jupiter's helmet. The incongruity is amusing and leads to speculation on the actual interrelation between these figures and their world as being disorderly, in contrast to the orderliness of the play. Hogarth makes the comment that reality provides all the materials one needs for high art, and that the comic is worth taking seriously. Comedy is also important to *The Four Times of Day* (Plates 34–37), finished and engraved by 1738, versions of which by Francis Hayman hung at Vauxhall Gardens. There is no narrative, although there are connective elements. There are, however, compositional links. Each scene is set in a London location. The first shows Covent Garden with the coffee house abutting Inigo Jones's church; the second, somewhere in Soho near the Church of St. Giles-in-the-Fields; the third, the rural Sadler's Wells; and the fourth, somewhere in the region of Charing Cross; so that they form a repository of scenes from eighteenth-century London. Within the group there is a temporal progression, from morning to night, while the seasons move from winter through spring to autumn and early summer. Whereas our previous examples had been obviously concerned with art and life, Hogarth did not indicate any 'correct' way of reading the series. Nevertheless the subjects are clear. In *Evening* (Plate 36) there is a theme of feminine persecution, and on the adults' faces expressions of blank misery. The cow behind the husband creates a visual joke about his being cuckolded. *Night* (Plate 37) is chaotic and disorderly, whereas in *Noon* (Plate 35) the contrast between the polite French couple with their grossly dandified infant issuing from the church and the scenes of English greed and debauchery on the other side of the gutter is intentionally strong. Similarly in *Morning* (Plate 34) the natural and the artificial are contrasted, with the expressions on the faces of the frozen page and the amorous couple enabling us at least to judge which is to be preferred. It appears that, as in *The Enraged Musician* (Plate 41) or *Strolling Actresses* (Plate 40) Hogarth continued to explore the opposition between naturalness and artificiality or restraint. In the late 1730s he developed an increasingly complex notion of art, while retaining such valuable qualities as his sense of the ridiculous and his ability for characterization.

While this was partly a consequence of his natural artistic progression and development, there were other factors involved. At this time Hogarth was not only becoming a central figure in the world of London artists, but also was expanding his range of genres. Indeed, his activities were so multifarious that we can only touch on them here. On 11 January 1735 he was a founder of The Sublime Society of Beefsteaks, a theatrical club, which originated in the habit of George Lambert, scenery-painter at Covent Garden, of saving time by eating a beefsteak roasted on a fire while he worked in his painting room and of his friends joining him in this. The members professed the motto 'Beef and Liberty' and indulged a great show of spoof ceremony. A more predominantly artistic milieu was created by Hogarth's reopening in 1735 of the St. Martin's Lane Academy. This not only gave older artists somewhere to draw from the model and discuss art but also provided them with the opportunity to pass on their wisdom to younger painters. The academy was to become a focal point for English painting, particularly with the involvement of many of its participants in the decorations at Vauxhall Gardens.

Jonathan Tyers (fig. 7), often dubbed an 'impresario', took over Vauxhall in 1728 and in 1732 reopened it as a pleasure garden. Here Londoners could listen to music or just parade themselves. The idea to fill the establishment with statues and paintings was almost certainly Hogarth's. The actual gardens were accordingly provided with sculpture and over fifty supper-boxes with painted decoration. Thus Roubiliac made his name with a statue of Handel playing the lyre (see fig. 8) at Vauxhall while from the mid-1730s Hayman and his workshop of painters were kept busy. Their subjects covered a wide range, from scenes from novels and plays to the illustration of rural festivals and sports. Although Hayman did most of the work, we find at Vauxhall the same association of artists as at St. Martin's Lane. Hayman, Hogarth and the Frenchman Gravelot were boon drinking partners, and with others, such as Highmore, formed at least a nucleus for discussion about art. Gravelot, for instance, had come to England as an engraver working in a developed rococo style which he prosecuted with notable skill. His way of seeing nature was to have some influence on his English contemporaries (fig. 9). For Hogarth, Vauxhall's chief importance was in providing a venue where, in an age bereft of exhibitions, the works of English artists could be seen in public. Knowledge of this preoccupation helps one understand much of his activity at this period of his life.

The French portraitist Jean-Baptiste van Loo arrived in London in December 1737 and immediately became successful with the wealthy classes (fig. 10). Hogarth's response to the Gallic challenge was to return to portraits, and although the earlier ones of this period retain the stiffness of his conversation-piece figures, by the 1740s he was producing figures of an

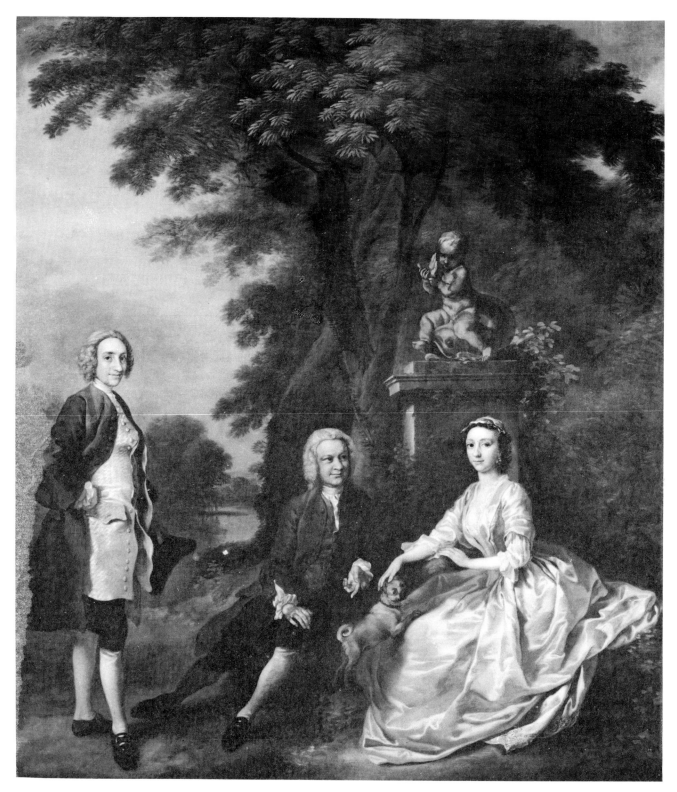

*fig. 7* Francis HAYMAN
*Jonathan Tyers of Vauxhall Gardens with his
Daughter, Elizabeth, and her Husband, John Wood*
New Haven, Yale Center for British Art (Paul
Mellon collection).

Hayman, one of Hogarth's intimates and a
notorious *bon viveur*, was also competent at the
outdoor conversation piece. He portrayed his
sitters with a directness he must have learned
from Hogarth, and in this painting we can see
his development of the genre, clearing the way
for paintings such as Gainsborough's *Mr. and
Mrs. Andrews* (London, National Gallery).

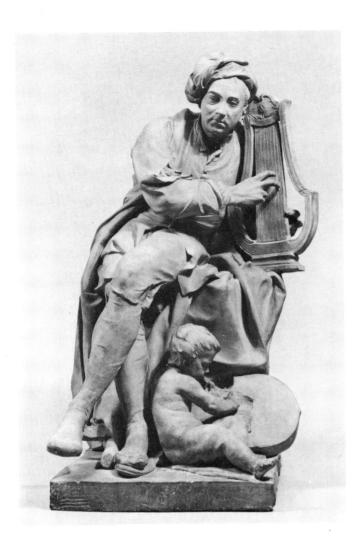

*fig. 8* François ROUBILIAC
Model for a Statue of George Frederick
Handel
Cambridge, Fitzwilliam Museum.

Roubiliac's terracotta model for the statue of
Handel has that informality which allows us
to associate its aesthetic with the St. Martin's
Lane group of artists, and also to see why the
finished statue should have provoked such
contemporary approbation.

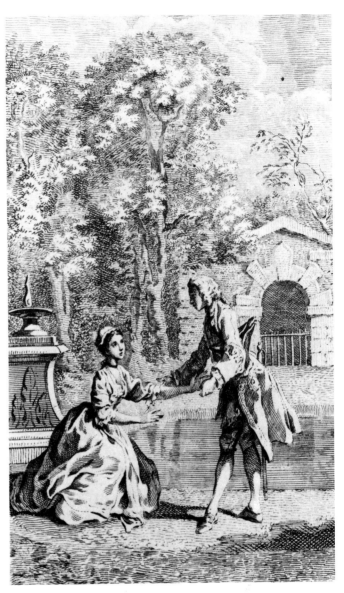

*fig. 9* Hubert GRAVELOT
Scene from *Pamela*
London, British Library.

Such engravings as this one, an illustration to
the 1742 edition of Samuel Richardson's
*Pamela or Virtue Rewarded* depicting an encoun-
ter between the eponymous heroine and the
lascivious Mr. B., were readily available to the
inspection of the curious. Some scholars think
that Gravelot's prints had a decisive influence
on developments in English painting, citing
his skilled draughtsmanship and total
assurance of conception.

admirably realized solidity and directness (Plates 38
and 39). George Arnold (Plate IV) was a retired
merchant who had through his own efforts attained the
kind of prosperity that Hogarth admired. He was
painted in his ordinary dress and displays no wish to
ingratiate himself with the onlooker. With regard to the
Arnold portrait one must risk dealing in unproven
clichés of social history and speak of a 'middle class', a
group who were making wealth through, among other
pursuits, trade and farming, and, having done so, were
establishing themselves as an important social and
economic force. One must also suggest that Hogarth
was as much in sympathy with their commercial and
protestant outlook as were Fielding and Richardson,
authors whose novels were avidly read by this group.
The rise of this middle class seems to have been largely
an urban phenomenon, although with both provincial
and rural outposts. Captain Thomas Coram (Plate 39)
was another of these self-made men. In 1740 Hogarth
painted his portrait in deliberate rivalry to Van Dyck
and 'found it no more difficult than I thought it'. This
great painting indeed is an exercise in the Grand

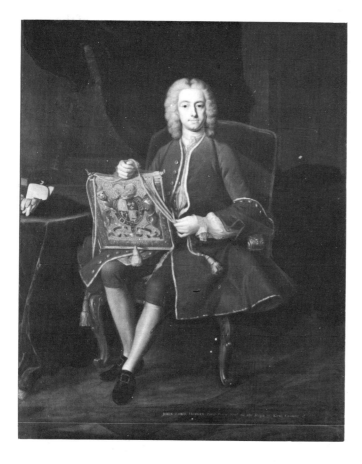

*fig. 10* Jean-Baptiste VAN LOO
*John, Lord Harvey as Lord Privy Seal*
ickworth, Ickworth House.

Although Van Loo's paintings seem to some
twentieth-century eyes almost as stiff as those
by such contemporary Englishmen as
Jonathan Richardson, his Gallic elegance was
appealing and led him to achieve, for
Hogarth, the status of a threat.

Manner and employs, in the column and sweeping curtain, trappings typical of baroque portraiture. Furthermore the sitter is 'qualified' through his 'attributes': the sextant and globe connect with the marine background, thereby informing as to his achievement, while in his hand he holds the seal of the Royal Charter for the Foundation of The Foundling Hospital. Therefore we discover the sitter to have been a successful seaman, and, one imagines through the dearth of martial encumbrances, a merchant. The Foundling Hospital was his brainchild, provoked by the sight of babies abandoned to perish, and Hogarth was involved with him in the pursuance of this unusually philanthropic venture. In fact, one can tell more about the nature of the institution from Nebot's portrait of Coram (fig. 11), which shows the honest sailor pointing with one hand to a baby in a basket and displaying with the other the Royal Charter, than from Hogarth's heroic portrait. 'Heroic' is here a key word, because all Coram's attributes have direct relation to his life and achievement. Yet there in no glamour in this portrait, for, although Hogarth employed a

baroque formula designed to engrandize the sitter, he nevertheless, insisted on modernity by refusing to paint much more than documentary fact: Coram did dress in the way he appears in Hogarth's portrait and he had directed the voyages of merchant vessels. The portrait hung in the hospital, and although Hogarth's first intentions in being connected with the institution were charitable, it was not long before he realized that here was another place for artists to display their works publicly. In the minutes of the meeting of the Governors of The Foundling Hospital for 31 December 1746 the secretary noted that several artists, including, besides Hogarth, Highmore and Hayman, had presented history pieces to be hung in the Court Room.

It is a salient fact that these donations should have been history paintings, works involving serious themes designed to elevate the thoughts of the beholder. Hogarth's *Moses Brought to Pharaoh's Daughter* (Plate 45) portrays an early foundling in a pathetic scene against a background out of Poussin. His attempt at history pieces is important in respect of his intentions at The Foundling Hospital, for by undertaking work in the most respected genre, the history picture, Hogarth and his fellows were implying that English art was now worth taking very seriously indeed. In fact Hogarth's first venture into history painting dated back to 1734 when, hearing that an Italian, Jacopo Amigoni, was being commissioned to decorate the stairwell at St. Bartholomew's Hospital, he volunteered to do the same for no payment, an offer which was taken up. After three years he completed the enormous murals of *The Pool of Bethesda* (Plate 43) and *The Good Samaritan* (Plate 44). Although critical approval has generally been qualified, these are extraordinary productions for an artist who had never previously painted on anything near this scale. Hogarth may have been fired by charitable motives in the *gratis* decoration of a hospital. However, one must also note that the hard-headed artist would not have a foreigner paint, particularly in the higher walks of art, what was perfectly easy for an Englishman. Furthermore, these works were displayed in a location open to the gaze of the politer part of society, that is, potential patrons.

All this action denotes a continuing growth of artistic self-awareness, besides a conscious move into the centre of the London art-world. The former point is illustrated by Hogarth's deliberate rise from engravings, through genre paintings, to history pieces, while there are various ways in which one can define Hogarth's new public position. On one level it stemmed from a simple desire to promote English art and its patronage, thus his reaction to the threat of Van Loo and his signing one portrait 'William Hogarth Anglus'. This is a subject which we may appreciate in greater detail by looking at Hogarth's essay *Britophil*, published in 1737 to answer an attack on Thornhill. It begins by blasting connoisseurs who condemn a history piece through

*fig. 11* Balthasar NEBOT
*Captain Thomas Coram*
London, Thomas Coram Foundation for
Children.

Nebot's portrait of Coram is self-explanatory,
its prosaic quality posing an obvious contrast
to the 'epic' masterpiece of Hogarth (Plate 39).

deficiencies in the parts rather than the success of the
whole, but makes its main point half way through:

> There in another set of Gentry more noxious to the art than these,
> and those are your *Picture-Jobbers from abroad*, who are always ready to
> raise a great cry in the Prints whenever they think their Craft is in
> Danger; and indeed it is their Interest to depreciate every *English*
> Work, as hurtful to their Trade, of continually importing Ship
> Loads of dead *Christs*, *Holy Families*, *Madona's*, and other dismal
> Dark Subjects . . . on which they scrawl the terrible Cramp Names
> of some *Italian* Masters and fix on us poor *Englishmen* the Character
> of *Universal Dupes*.

This attitude is rooted in Hogarth's earlier antipathy
towards Kent and the Burlingtonians, although in
*Britophil* he took a public stance as the defender of
English art. As any individual who refuses to fit any
particular niche will, Hogarth caused a degree of
consternation. He was, after all, an artist who special-
ized in the comic series and whose gifts were more for
the burlesque than for history painting. That he
succeeded in the latter had to be generally admitted,
and Vertue recorded the general wonderment at
Hogarth's progress.

In the 1740s one has an impression of confidence.

Hogarth's portraits literally record the faces of the time,
so that we see with a rare immediacy the most news-
worthy rebel of the Jacobite rising of 1745, Simon, Lord
Lovat (Plate 60), caught in an informal moment and
etched quickly for a cheap print. Hogarth was
naturally capitalizing on Lovat's notoriety but the
print shares with the original drawing a spontaneity
and genuine interest in the individual. The same is true
of Hogarth's depiction of Garrick in the rôle that made
him famous, Richard III (Plate V). While this is a
dramatic portrait of the latest theatrical sensation at
the climactic moment of the play which made him
famous, it is also a kind of history painting, concerned
with an individual and the consequences of ambition.
Hogarth constantly elevated the mundane, in this case
a theatre scene, which normally would have been
treated as a genre scene, and this combined with his
growing self-awareness and artistic expertise in render-
ing his popular art far more than just a moral series.
*Marriage à la Mode* (Plates 50–55) demonstrates this to
the full.

*Marriage à la Mode* always was intended to be a
prestige production. The paintings must have been
finished by April 1743 when Hogarth announced the
subscription for the prints and shortly afterwards left
for Paris in search of engravers. This was a calculated
move. He knew not only that French engravers were
supremely skilled (Gravelot's example was enough to
show him that) but also that their association with his
works would boost the pictures' reputation. In the
event, war with France in March 1744 delayed the
engraving considerably and it was finally carried out in
England, with the prints being delivered in May 1745.

The superbly painted *Marriage à la Mode* differs in
character from Hogarth's previous series. Although it
does engage a narrative sequence, each scene elucidates
a virtually unchanging state of affairs. In the eigh-
teenth century arranged marriages, the subject of the
pictures, dominated family relations. An impoverished
aristocrat would welcome marriage with a merchant's
daughter because a large dowry was the norm. For the
merchant, the title's charm was the way it helped fulfil
the social aspirations that normally developed with the
acquisition of wealth. So in the first scene (Plate 50) we
not only discover 'trade' facing 'blood' and much legal
wrangling over mortgages and marriage settlements,
but also the two who are to suffer its consequences
sitting in a corner, indifferent to one another. One must
point out that Hogarth was here painting recognizable
scenes from daily life and keeping a tight rein on his
burlesque. His exaggeration never exceeds natural
possibility, so that the comedy suggested through
various gestures in the second scene (Plate 51)
contributes to a picture intended mainly to amplify the
indifference shown us in the first one. Indeed, we may
here discern an irony. The viscountess is attractive, and
her intentions towards her exhausted husband unam-

biguous. This means that a happy and successful conclusion to their relations is possible, and only his apathy prevents it. The first two scenes conjoin to explore the various aspects in the arranged marriage, while the next two provide an insight into the reality. *The Visit to the Quack Doctor* (Plate 52) has the viscount, in his finery, obtaining a cure for the syphilis he has visited on a child whose distress affects him not at all. In *The Countess's Morning Levee* (Plate 55), the countess, her husband having succeeded his father as earl, fosters an intrigue while surrounded by fashionable company which ignores her as much as she ignores it. So the paintings in the middle of the series elucidate further the first two. The final ones are concerned with consequences. The earl duels with his wife's lover and loses (Plate 54), while she, reading that the latter has been executed, commits suicide by taking an overdose of laudanum (Plate 55). Her father, salvaging the rings from her fingers, reminds us of the causes behind this vain wastage of human life. The series now creates a whole. Where there is humour, as in the characterizations in *The Countess's Morning Levee*, this is subsidiary to the general intention. *Marriage à la Mode* must be considered as an entirety, and its formal resonances and repercussions emphasize this. On a simple level, the parallel compositions of the first and last scenes create a symmetry to reinforce the notion that the protagonists are no wiser at the end than at the beginning. In individual works we comprehend the constituent factors behind the whole, so that the viscount's boredom is not only a symptom of the weakness of inbreeding but also part of a coherent moral universe. And because this universe is inverted, we can suggest that there ought to be a converse. Hogarth made no anti-capitalist statement, but did imply that there *is* a way in which riches can be properly used.

In *Marriage à la Mode* it is fair to say that the artist, while learning from them, produced works of a greater seriousness than in his earlier series, *A Harlot's Progress* and *A Rake's Progress*. One point in which this shows quite simply is his dropping overt burlesque for comedy, and here we know one source for his thinking, Fielding's 1742 *Preface* to *Joseph Andrews*, which may anyway have been the fruit of discussion between the two men. Fielding contended that the 'comic epic' and the 'tragic epic' were equally worth consideration and distinguished the former from burlesque because it involved a 'just imitation' of nature. In the expansion of the argument to include painting he differentiated similarly between 'comic history painting' and 'caricatura'. His explanation cites Hogarth directly:

He who should call the ingenious Hogarth a burlesque painter, would, in my opinion, do him very little honour: for sure it is much easier, much less the subject of admiration, to paint a man with a nose, or any other feature of a preposterous size, or to expose him in some absurd or monstrous attitude, than to express the affections of men on canvas. It has been thought a vast commendation of a painter to say his figures seem to breathe; but surely it is a much

greater and nobler applause that they appear to think.

Hogarth's comic histories, then, are as important as exalted subjects from the classics or the Bible. Furthermore, because of their general comprehensibility, their relevance is arguably far greater: they draw a moral from modern life. Hogarth's thinking was close to Fielding's. The subscription ticket to *Marriage à la Mode, Characters and Caricaturas* (Plate 45), refers to Fielding's *Preface* for an explanation. Hogarth was self-consciously producing a new kind of art. The closest, albeit superficially, equivalent, seventeenth-century Dutch and Flemish scenes of low life, were valued not for their moral but their humorous qualities. Although Hogarth's awareness that he was an innovator seems to have left him feeling no less cocksure, he also experienced a new sensation of slight alienation both from the public and his fellow artists. His detachment, which was to develop eventually into paranoia, first manifested itself in the 1745 admission ticket for the sale of his comic histories. In *The Battle of the Pictures* (Plate 56) not only did Hogarth define the nature of his public relation to the Old Masters, but he also depicted them winning the fight.

Although Hogarth was not to become obviously isolated until the 1750s one can, in the late 1740s, discern changes in his art. In 1746 he painted, and in 1750 published as a print, *The March to Finchley* (Plate 48), a relatively large work which developed from his recent paintings. The English army is shown moving off to protect London from the rebels of 1745, with a strong contrast between the disorder splayed across the foreground and the neat ranks of troops marching off into the distance. This regimentation jars with the unruliness and debauchery of the main group of soldiers, drunk or otherwise insensible to the call of patriotism, the apparent meaninglessness of their task encapsulated in the glum soldier to the left of centre. The picture operates on many levels. It commemorates an event, it permits us to laugh at the ridiculous and gives an opportunity to muse on regimentation versus chaos, or art and life. In this it is a development of something like *The Four Times of Day*. Furthermore, one may observe throughout the painting serpentine 'lines of beauty', similar to the one he had depicted on his palette in 1745 (*frontispiece*). These were designed to tantalize. As a well painted modern history *The March to Finchley* is a development from *Marriage à la Mode*, yet the publication in October 1747 of twelve plates of *Industry and Idleness* (Plates 57–59) represented a break with his public. In 1745 it seems that the poor prices fetched at his sale of paintings, and, apparently, his withdrawal of the *Marriage à la Mode* canvases from it, led him to feel that his self-valuation was neither widely accepted nor understood (see Plate 56). This may have been one reason for *Industry and Idleness* not only being based on preparatory drawings rather than on time-consuming high-quality paintings, but also being

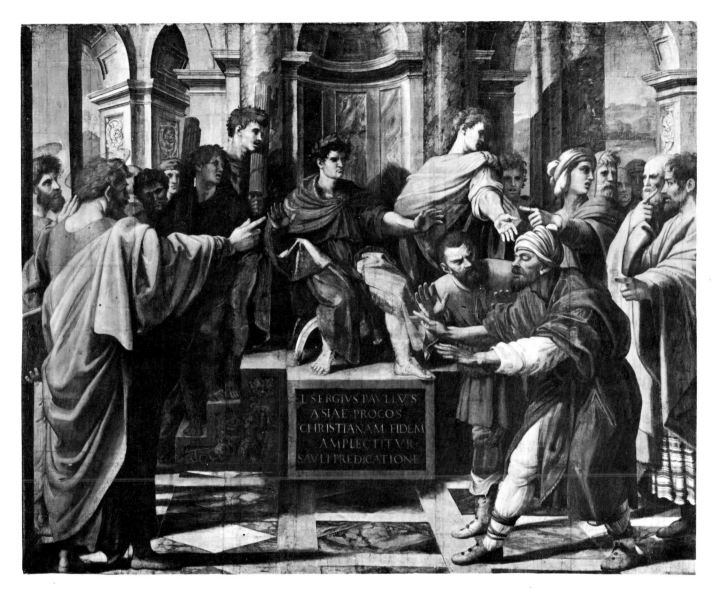

*fig. 12* RAPHAEL
*Paul and Elymas*
London, Victoria and Albert Museum.

Raphael's *Paul and Elymas*, one of ten tapestry
cartoons commissioned by Pope Leo X in 1515
and one of the seven surviving ones acquired
for the English royal collection in 1623, was
the basic and, for Hogarth's contemporaries,
instantly recognizable source for *Paul before
Felix* (Plate 46) and its burlesque (Plate 47).

simpler in style, narrative technique and moral. As
with earlier series there is a clear progress. The stories of
Goodchild and Idle provide an effective contrast, and
the message that with industry the individual thrives
and without it does not is illuminated almost ingenu-
ously: Goodchild marries his employer's daughter and
becomes Lord Mayor of London (Plate 59), while Idle
sleeps with whores and is hanged (Plate 58). This is a
simplified middle-class morality, designed, as Hogarth
specified, to reach the audience that bought cheap
prints rather than the sophisticated public at which he
had aimed with *Marriage à la Mode*. He increased the
salience of his tale by locating it in London so that
people would recognize Goodchild at Divine Service at

St. Martin-in-the-Fields or perhaps imagine themselves
in the Tyburn crowd enjoying Idle's execution. Despite
the simplicity and stern morality there are moments
almost of levity. Idle looks a little like Hogarth himself,
while in the first plate (Plate 57) the pipe, tankard and
page from *Moll Flanders* show that he, like Hogarth
during his apprenticeship with Gamble, loves his
pleasures too much. While *Industry and Idleness* formu-
lated a print type which subsequently was to be
important to Hogarth, in the late 1740s he had a variety
of schemes on hand. In 1747 he received a commission
from the Benchers of Lincoln's Inn for a painting, *Paul
before Felix* (Plate 46), in which, by having his
composition echo that of the *Paul and Elymas* cartoon
(fig. 12), he put himself in conscious rivalry with
Raphael.

In August 1748 Hogarth journeyed to France with
some friends, including Hayman. They visited Paris,
and on their return, as Hogarth was sketching the
fortifications at Calais, he was arrested for spying. The
incident was commemorated with *Calais Gate* (Plate
VI), from which a print was published in the spring of
1749. Whereas Hogarth had previously manifested

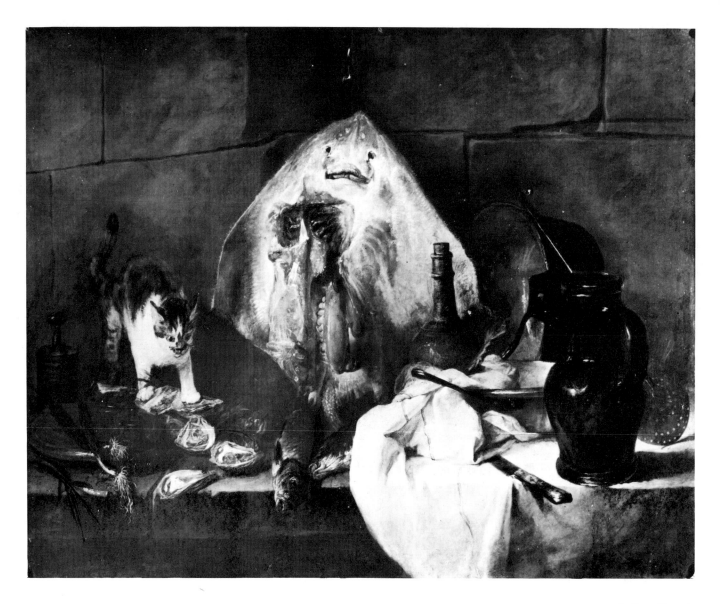

*fig. 13* Jean-Baptiste CHARDIN
*Rayfish, Cat and Utensils*
Paris, Musée du Louvre.

Hogarth may have had Chardin's superb still-life, one of the French artist's two *morceaux de réception* of 1728 at the Académie, in mind when he introduced a similar motif into *O the Roast Beef of Old England* (Plate VI) of 1748.

merely a typically English dislike of foreigners, *Calais Gate* displays roaring xenophobia and refuses neither Frenchmen nor Catholics any quarter. The centrepiece is a huge sirloin of beef, intended for the English garrison. It provokes a grotesque array of reactions among the French, while the foreground is flanked by fishwives guffawing at a skate, perhaps a glancing shot at Chardin (fig. 13), and a highlander left over from 1745. The figure sketching is Hogarth, the hand on his shoulder commemorating the moment of arrest. The contrast between the healthy, beef-fed Englishmen we are supposed to imagine and the curious foreigners whom Hogarth painted is almost too stark, and what is here jingoism became later a refusal to consider anything beyond the tried and safe. It was also in 1749

that he published his oil *Self-portrait with Pug (frontispiece)*, with its tantalizing 'line of beauty', as the print *Gulielmus Hogarth* (Plate 85), in which he emphasized nothing so much as his ordinariness.

Hogarth now developed the genre he had created in *Industry and Idleness* by publishing in 1751 *Beer Street and Gin Lane* (Plates 71 and 72) and *The Four Stages of Cruelty* (Plates 73–76). These sets share a stylistic directness. *Beer Street* and *Gin Lane* link with the efforts of such magistrates as Henry Fielding to curb the moral depravity of the poor at its source; a new Gin Law was subsequently passed later in 1751. However, Hogarth's message exists outside any contemporary context and deals in terms of the moral opposition between gin and beer originally posited in Defoe's *Augusta Triumphans*. In *Gin Lane* usury thrives while the rest of the City has already become ruinous, so as to emphasize the larger consequence of the ruin that Hogarth shows. His imagery is savage here, but, by the same token, overwhelmingly cheerful in *Beer Street* and, incidentally, full of 'lines of beauty'. This is an English prosperity. In the second state of the print a cooper manhandles a scrawny Frenchman, while in the third

(Plate 71) the same enormous figure brandishes a leg of beef. In *Beer Street* everything, save usury, flourishes. Only the sign-painter is in rags, perhaps an allusion to contemporary patronage of the arts although more probably the result of his drinking gin, as the bottle hanging from the sign shows. *Health to the Barley Mow*, the legend on the bottom of the sign, has obvious links with brewing, but its subject, the end of harvest, a traditional time of social jollity, also connects with the concord one sees in the print. Hogarth was abandoning subtlety in the hope of reaching a larger audience, and, although the contemporary series of *The Four Stages of Cruelty* was eventually engraved in a simplified style on copper plates, he had had John Bell make woodcuts of the last two scenes in an attempt to capture the immediacy of popular prints. With reference to his new brutally direct style, Hogarth wrote that

... neither great correctness of drawing or fine Engraving were at all necesary ... However, what was more material ... viz the Characters and Expressions—are in these prints taken the utmost care of and I will venture to say further that ... precious strokes can be done with a quick Touch and would be languid or lost if smoothed out into soft engraving.

The expressionism is suitable to the barbarous subject, progressing through the maltreatment of animals to that of humans under the benign eye of a learned doctor (Plate 76) in a composition whose formal links with *A Midnight Modern Conversation* (Plate 28) only increase its force. Hogarth thought that by exhibiting barbarity so starkly he might check it, and his prints gain thereby a didactic function.

In a sense, he had moved from being the proponent of serious art, the modern history painting, although he was changing his style to suit his audience. It is fair to conclude that he was no longer able to dictate both to artists and public on his own terms: in anticipating a demand he laid aside his more 'serious' art. Similarly he was, in the London art-world, gradually becoming a peripheral, although still respected, figure. Indeed his position was virtually idiosyncratic. In 1751 he colluded with Benjamin Wilson in producing a couple of 'Rembrandt' prints and gulling such connoisseurs as Hudson, the portraitist, in an attempt to expose the hypocrisy of 'taste'. By the same token, in the subscription ticket to his print after *Paul before Felix* (Plate 46), he burlesqued his own composition (Plate 47) in a purported parody of Rembrandt. He emphasized the 'earthy' details sometimes perceived in Dutch art, and the print relies on such caricatures as the bloated angel concussed with boredom. Accordingly it not only triggers a laugh at the improprieties of Dutch history painting, but also raises the spectre of self-condemnation, mainly because this is auto-burlesque. Considering that Hogarth had attempted and would continue to attempt the Grand Style, this cocking of snooks at the Establishment, even in an attack on bad taste, may seem slightly suspicious. On reflection it

appears as a symptom of Hogarth's gradual acceptance of what was becoming an isolated position.

On no occasion was this so apparent as in June 1751. Having failed to sell the paintings of *Marriage à la Mode* in 1745, he now offered them at auction with disastrous results. They fetched only £120, a ludicrously low price for works that their author considered to be on the highest levels of art. Vertue recorded Hogarth's reaction: '... this so mortified his high spirits & ambition that threw him into a rage curst and damnd the publick. and swore that they had combined together to oppose him ... and that day following in a pet. he took down the Golden head that staid over his door ...' This extreme rancour doubtless pleased the many who had been constantly irritated by the pretensions of the strutting little man. Taking down The Golden Head may be seen as a 'symbolic gesture'. At least, it is not too much to suspect that Hogarth felt that the public no longer deserved him.

The public had failed to understand his comic histories, so while Hogarth maintained his belief in these pictures he had also turned to other modes. Despite the apparent change in direction, however, we can best understand *The Analysis of Beauty*, begun in about 1752, as a vindication of the kind of art he had, for the moment, laid aside. He announced the book's subscription in March 1752. The treatise originated from the enigmatic 'line of beauty' on the palette in the *Self-portrait with Pug (frontispiece)*: one suspects that Hogarth had tantalized the public to the extent that he needed to provide a practical sop to their curiosity. Vertue noted that 'Hogarth (in opposition to Hussey. scheem of Triangles) much comments on the inimitable curve or beauty of the S undulating motion line' and we have noticed how 'lines of beauty' had, since the late 1740s, been appearing in Hogarth's own productions. Indeed, the subscription ticket to *The Analysis*, *Columbus Breaking the Egg* (Plate 62), has prominent on the plate in the foreground two elvers, each draped in the 'S' curve. Its subject probably alluded to the way a genius is often required to demonstrate the obvious.

In his comic histories Hogarth had become increasingly unconcerned with story-telling. His interest was now with abstracting aesthetic values from subject-matter and, as with Fielding, whose definition of the 'only source of the true ridiculous' as 'affectation created a concept which demanded some natural norm. Hogarth, in painting modern life and gradually refusing, as in *The March to Finchley*, despite its documentary subject, to allow the work of art reference points outside its intrinsic content, was doing something similar. He had become concerned with the basic qualities of art itself hence the inclusion of the word 'beauty' in the treatise's title. His burlesqued *Paul before Felix*, apart from being extremely funny, protested against the absolute standards created through the unquestioning admiration of Raphael. The discussion

of his serpentine line in *The Analysis* also challenged theorists such as Jonathan Richardson who presupposed that standards in art had already been set.

Hogarth made formal values the basis of an aesthetic theory, in contradistinction to the notion that the 'nobility' (or otherwise) of its subject was vital in determining a picture's worth. The point is made clearly in the second plate to *The Analysis* (Plate 64). In this 'country dance' each couple, save the elegant leading pair, seems to a greater or lesser extent lumpish and clumsy. Therefore the first two have created, within the context of the print, a standard of beauty. The theory holds it as self-evident that the most graceful will also be the most beautiful, with it being implicit in this demand for discrimination through aesthetic discovery that you go to nature and see with your own eyes. Humour or other interest lies in deviations from the natural: '. . . for tho' in nature's works the line of beauty is often neglected, or mixt with plain lines, yet so far are they from being defective on this account, that by this means there is exhibited that infinite variety of human forms which always distinguishes the hand of nature from the limited and insufficient one of art . . .' The major flaw in Hogarth's argument, as Reynolds gleefully illustrated in his first *Idler* (1759), was that works of art could still be successful without any sign of the 'line of beauty'. Reynolds imagined himself observing to a 'connoisseur' that a Van Dyck portrait of Charles I was

. . . a perfect representation of the character as well as the figure of the man: He agreed it was very fine, but it wanted spirit and contrast, and had not the flowing line, without which a figure cannot possibly be graceful.

On the whole, though, *The Analysis* brought forth a favourable response. Opposition centred on a small group, including Reynolds, based on St. Martin's Lane. These artists had been making moves towards setting up an official public academy on the French model, a concept Hogarth had attacked violently because he felt that it would mean both regimentation of artists and the imposition of absolute critical standards. The notion of academies was very popular from this time on, but Hogarth maintained his opposition. This individualistic point of view tended to exacerbate his artistic isolation. It was largely through his efforts at St. Martin's Lane, Vauxhall and The Foundling Hospital that English artists could begin to contemplate consolidation. Thus in the 1750s, with his eminence undiminished, his opposition to the scheme of an official academy only irritated more those with whom he would not be associated.

The practical and serious consequence of *The Analysis* is displayed in the four paintings of *An Election* (Plates 67–69 and VII) which Hogarth probably finished by the early months of 1754, although the prints, after all bar the first painting, were delayed for another four years. Hogarth is here at his greatest. In the context of

his subsequent history the *Election* series is the culmination of a major line of development. The canvases are superbly painted, extremely funny and brilliantly constructed, besides, one imagines, showing in an extreme sense what eighteenth-century parliamenteering was like. They also have some contemporary relevance, being based on the Oxfordshire contest of 1754 in which, for the first time for years, there had been a Whig-Tory opposition. This stemmed from the uproar created by the 1753 Whig 'Jew Bill' which had naturalized Jews then living in Britain. The Tory business interest saw this as part of a Zionist conspiracy by which the English merchant classes would be ultimately ruined. Thus 'Jew' came to equal 'Whig' in Tory propaganda, and the song 'O the Roast Beef of Old England' was transformed into 'O the Roast Pork'. Hogarth was not blind to the reality of politics and in the second scene (Plate VII) the Tory candidate has no scruples over buying from a Jewish pedlar trinkets with which to bribe two ladies, while in the fourth (Plate 69) he is led in short-lived triumph by a Jewish fiddler and a herd of pigs. The irreconcilability of pretensions with actuality informs the whole *Election*. In the polling scene (Plate 68) the candidates abuse one another and among the voters are both an idiot and a corpse. The wreck of Britannia's coach through the coachmen's apathy is a paradigm for the greater consequence of what has to be seen as lunatic behaviour. Hogarth's attitude to politics was severely rational, although his pessimism spread to his view of life itself.

In *An Election Entertainment* (Plate 67), a further variant on *A Midnight Modern Conversation* (Plate 28) is part of a scene in which the overwhelming detail makes for fragmentation rather than coherence. The notion of this being momentary is emphasized through bricks, one having knocked a character senseless, being painted in flight. All is about to change, confusing further the randomness of what we see. The eye focuses equally on a figure at the right suffering from an overdose of oysters, a small orchestra in full swing and a freeholder stonily asking God's aid in refusing bribes. Any connection between incidents is compositional and at times stems simply from the enclosure of the figures by the picture frame. There is an inherent anarchy, with the chaos scarcely under control. In *Canvassing for Votes* (Plate VII), sandwiched between the foreground frieze and sunlit landscape there is a brawl outside The Crown Inn, while in *The Polling* (Plate 68) the mob swarms across the bridge. Throughout the paintings social order is either a mockery or has collapsed entirely: a knowledge of actual events not only helps make full sense of the pictures but also adds to their poignancy. Now, in one important respect, Hogarth departed from his previous ideas in this series. When before he had shown nature warped or deformed, there had always been some implicit opposite, some social or moral structure in terms of which action

could be judged and the existence of which allowed the world a degree of comprehensibility. Put crudely, this was the idea of man as the 'measure of all things' which lay behind the Augustan attitude, and it was the large amount of immediate significance permitted within this epistemology which had so committed Hogarth to the genre of modern comic history, as against the conventional idea of history painting which relied for its effectiveness on its audience's education. This position was abandoned. Hogarth displayed the ridiculous, but we must intuit the norm. The humour has very much a sardonic edge. In *An Election* Hogarth depicted chaos, but apart from appealing to general good sense did not postulate some alternative to it. Although he produced some fine work from this time, he seems to have found consistency of purpose elusive. He continued to oppose artists' plans for an official academy and was moving increasingly outside the mainstream of artistic progress. In the 1756 *Invasion*, two prints celebrating the outbreak of the Seven Years War, his jingoistic message has a directness verging on crudity, and his performance is notably backward-looking in style and subtlety of sentiment. The altarpiece he was painting at the same time for the Church of St. Mary's, Bristol, another of his enormous history paintings, also harks back to his earlier work. It is known that the failure of his attempts to create an alternative to an official Academy of Arts through the Society of Arts led him to withdraw from that latter body in 1757 and increased his introspection. There is an air of finality about his *Self-portrait Painting the Comic Muse* (Plate 70) in which, as Paulson has pointed out, Hogarth's Comic Muse, by holding the book of Polyhymnia, the Muse of Rhetoric, emphasizes the seriousness of the comic histories. The engraving after this painting eventually served as the frontispiece to Hogarth's collected prints, and in the print his face appears more aged, while *The Analysis of Beauty* has been propped against an easel leg. The *Self-portrait with Pug* (*frontispiece*) demanded a direct and unequivocal response to his own self-assessment. Now his concentration on the canvas within his picture allows no contact with his personality.

This painting is the conscious closing of a career. In 1758 he had shown how much he valued his old aspirations by succeeding his brother-in-law John Thornhill as Serjeant-Painter, an acceptance of a sinecure which provoked justified accusations of hypocrisy. Already in February 1757 he had announced that he would paint no more histories, but only portraits with their sure pecuniary gains. From these years date not only such very fine public works as *David Garrick and his Wife* (Plate 61) or the Rembrandtesque and slightly earlier portrait of the engraver *John Pine* (Fredericton, New Brunswick, Beaverbrook Art Gallery) but also such informal and presumably private studies as *The Shrimp Girl* (Plate 65) or that of the heads of his servants

(Plate 66). All the same it was only to be expected that the great comic master should have been approached to paint one last canvas in the mode he had created. *The Lady's Last Stake* (Plate VIII) was commissioned by a young member of Parliament, Lord Charlemont. As it was near finishing in November 1758 Hogarth confided to a friend 'I grow indolent and strive to be contented with with [sic] what are commonly call'd Trifles...' Yet *The Lady's Last Stake* does not show this weariness and is of as high a quality as anything he had previously done. He described the subject as that of '. . . a virtuous married lady that has lost all at cards to a young officer wavering at his suit whether she should part with her honour or not to regain the loss.' The painting is replete with the symbolism of passing time. The clock stands at 4.55, and there is a sickle moon in the sky. The nosegay at the lady's breast will wilt and lose its bloom much as she will with encroaching age. Compared with similar confrontations in either version of *Before* (Plates 30 and III) this composition is hermetic; there is no inherent consequence, and it was the necessity to speculate about the outcome which delighted those who saw the painting. One has the impression that Hogarth enjoyed this subject most of all for the number of readings it offered.

The painting was well enough liked for Sir Richard Grosvenor to commission another canvas, the subject to be of Hogarth's own choosing. He must have felt a renewed optimism. His decision to paint Sigismunda with her lover's heart (Plate 77) marked an old obsession rearing its head for the last time. Hogarth's impulse was annoyance with a painting of the same subject by Furini which had been foisted on the public as by Correggio, and Hogarth asked the same price for his own work as the deception had fetched. *Sigismunda* was painted, therefore, in direct rivalry with the Old Masters, or in practical terms, with the taste of dealers and connoisseurs. It failed to have the response the artist craved. Grosvenor reneged, in a gentlemanly fashion, on the commission, and after some well-mannered manoeuvring the canvas eventually went to the banker Henry Hoare. Hogarth held his performance in high esteem. Furthermore he mentioned that the affair had provoked 'anxiety' and 'the recollection of ideas long dormant'; it had also renewed his ambition. Wilkes's later and not unbiased comment that the 'favourite *Sigismunda*, the labour of so many years, the boasted effort of his art, was not *human*' typified its reception, and Hogarth's disappointment was bitter. From now on, when he appeared in public it tended to be in opposition to the rest of the world. His dealings with artists and their academies were marked by an increasing ill-feeling, and the attempted subscription to a print of *Sigismunda*, for which *Time Smoking a Picture* (Plate 78) was the subscription ticket, came to nothing. By 1764, when he was preparing the fourth state of *The Bench*, Hogarth was relying conspicuously

on prose to explain his imagery. Similarly he was turning increasingly to language to vindicate his own position. 'I do confess I fancied I saw delicacy [in] the life so far surpassing the utmost effort of imitation that when I drew the comparison in my mind I could not help uttering Blasphemous expressions' he wrote in explanation of why he never believed a reverence for past art to be an end in itself. Previously he had found the painted or engraved image self-sufficient, now it could not carry his meaning. Horace Walpole recorded a clash with the increasingly paranoiac artist during which the latter was desperate to make sure justice to James Thornhill would be done in Walpole's forthcoming *Anecdotes of Painting*.

In the 1760s Hogarth's artistic ventures were sporadic. In 1762 he attacked Methodists with *Credulity, Superstition and Fanaticism* (Plate 79) and became involved in politics through publication of *The Times I* and *The Times II* (Plates 81 and 82). In these two plates Hogarth emerged as a committed reactionary, and it was through this alignment that he became embroiled in the convoluted Wilkes scandal. Wilkes had erupted onto the political scene in 1762 and in *The North Briton* launched sustained and unsubtle attacks on George III and the Bute ministry, thought by some, including Hogarth, to be bringing peace to England with their attempts to conclude the Seven Years War. *The Times I* featured Wilkes and his associate the satirist Charles Churchill trying to block the government saving England from the flames of war. In *The Times II* the squinting Wilkes, labelled 'Defamation', was displayed in the pillory, with *The North Briton* slung round his neck. It was in this periodical that Wilkes subsequently berated Hogarth for misusing his talents. The artist's response was the 1763 *John Wilkes* (Plate 83). Full justice was done to its subject and his squint, with the wig curved to resemble the devil's horns. Hogarth thought that 'A Brutus, a saviour of his country with such an aspect was so arrant a joke that, though it set everyone else a-laughing it galled him . . . to death . . .' It is salutary to recall that in the 1742 *Preface to Joseph Andrews* Fielding had written 'Surely he hath a very ill-framed mind who can look on ugliness, infirmity, or poverty as ridiculous in themselves . . .' Hogarth's reliance on ugliness as proof of the ridiculous shows just how much fire his art had lost. Similarly, after the midsummer 1763 *Epistle to Mr. Hogarth* by Churchill the response was *The Bruiser* (Plate 84). Hogarth took up an old copper plate, effaced his self-portrait and replaced it with a clerical bear, plus foaming tankard, who gazes with stupid benignity at a pug whose paw is not accidentally over the 'E' of the *Epistle to Mr. Hogarth*. Although the print is amusing, the satire is empty. One suspects that Hogarth knew this. He merely adapted an old plate for convenience, whereas previously he would have been likely to have invented an entirely new composition. That the plate had been that of *Guglielmus Hogarth* (Plate 85) fits what we know of his mood.

After Wilkes's initial attack on *The Times I* and *The Times II* Hogarth suffered a severe physical relapse and had withdrawn from public life. His autobiographical notes reveal him exalted with persecution, in convoluted explanations of his own art and relations with artists. In September 1764 he was too ill to carry out his duties as Serjeant-Painter, and on the night of 25–26 October he died.

Hogarth was one of the greatest English artists. The works of his last years reveal a crisis that was to dog many individuals from the second half of the eighteenth century onwards. In discussing *An Election* we discerned a chaos just held at bay suggesting that in Hogarth's world any 'Augustan' comprehensibility had vanished, and, accordingly, that the artist had lost, or was losing, faith in humanity. In November 1759 he had published his most terrifying print. *The Cockpit* (Plate 80) was his last variant of the conversation round a table. All irony and humour has disappeared and this is now a practically incomprehensible *mélange* of bodies locked in non-directed energy, the only object of attention a couple of birds about to tear each other apart. This view of humanity is despairing, and, through the 1760s, persistent. The same nihilism informs Hogarth's last print, *The Bathos* (Plate 86), with a title based on Pope's *Peri Bathous*, which he intended as the endpiece to his collected engravings. Although still full of 'lines of beauty' the world is no longer fit for them. It is collapsing. Both Father Time and Apollo are breathing their last, the moon is about to vanish, and the inn sign of The World's End is on the point of tumbling down. It is almost as though Hogarth were testing his recent record—*The Times I* is torn and burnt by a candle—in this context of destruction and found it wanting. In his old age he discovers that his errors and wrecks lie about him and he cannot make his world cohere. The imagery is peculiarly reminiscent of Pope's at the close of *The Dunciad*:

> Lo! thy dread Empire, CHAOS! is restor'd;
> Light dies before thy uncreating word:
> Thy hand, great Anarch! lets the curtain fall;
> And Universal Darkness buries All.

Hogarth has been a sporadically popular subject both with critics and historians. His own *Analysis of Beauty* has been recently published in an edition edited by Joseph Burke. Nichols's *Biographical Anecdotes of William Hogarth* was first published in 1781, expanded and last made available in 1817. The sections dealing with *Marriage à la Mode*, Georg Christoph Lichtenberg's five-volume study (1794–99) of Hogarth, are available in *Hogarth on High Life* (Middletown, Connecticut, 1970), edited by A. S. Wensinger and W. B. Coley. The most distinguished modern studies are by Ronald Paulson. This is particularly the case with two of his publications, to both of which other scholars must be heavily indebted. His catalogue raisonné of the engravings, *Hogarth's Graphic Works* (London and New Haven, revised edition 1970) is a goldmine of information and has high-quality illustrations. *Hogarth: His Life, Art and Times* (London and New Haven, 1971) is that rare thing, a long and meticulously researched book which is also very readable. It is also the best biography of any eighteenth-century English artist and contains much that is useful on the London art-world of the period. There is an abridged version, but this is not as good. The best modern short introduction to the artist is Lawrence Gowing's catalogue to the 1972 Tate Gallery exhibition.

1   Hogarth's Shop Card
LONDON, British Museum, Department of Prints and Drawings. April 1720. Engraving
7·6 × 10 cm.

The card was intended to announce to the world at large Hogarth's availability as a tradesman. 'Engraver' meant someone skilled at work on metal, which Hogarth continued to do throughout the 1720s. The card shows that he had attained a proficiency in dealing with conventional decorative motifs, while he was handling allegorical figures with confidence. The figures he chose, however, representing history and art, with a cherub signifying design, imply pretensions beyond those of the normal tradesman.

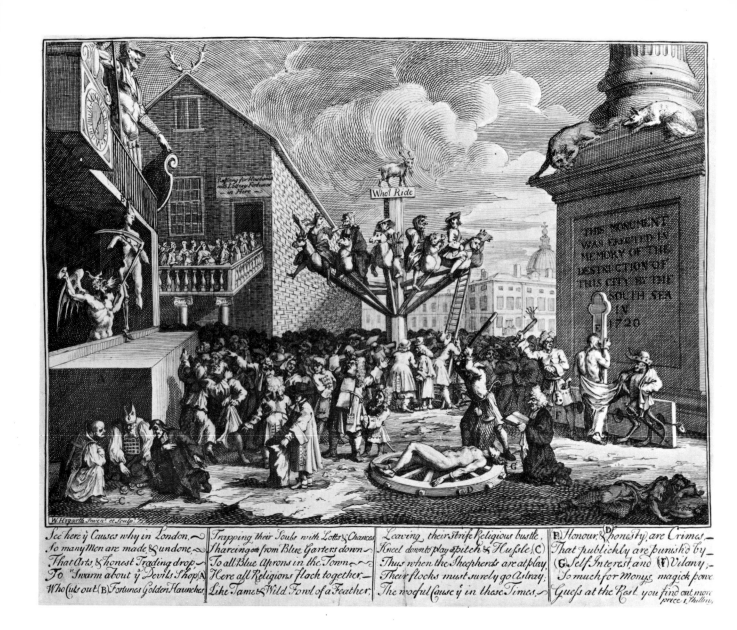

The caption beneath the engraving reads:

*See here ŷ Causes why in London,*
*So many Men are made & undone,*
*That Arts & honest Trading drop,*
*To Swarm about ŷ Devils Shop,(A)*
*Who cuts out (B) Fortunes Golden Haunches,*

*Trapping their Souls with Lotts & Chances,*
*Shareing oft from Blue Garters down*
*To all Blue Aprons in the Town.*
*Here all Religions flock together,*
*Like Tame & Wild Fowl of a Feather;*

*Leaving their Strife Religious bustle,*
*Kneel downto play at pitch & Hussle;(C)*
*Thus when the Sheepherds are at play,*
*Their flocks must surely go Astray,*
*The woeful cause ŷ in these Times,*

*(E) Honour, & honesty, are Crimes,*
*That publickly are punish'd by*
*(G) Self-Interest and (F) Villany;*
*So much for Monys magick powe*
*Guess at the Rest you find out more*
*price 1, Shilling,*

2 · *The South Sea Scheme*

LONDON, British Museum, Department of Prints and Drawings. 1721. Etching and engraving (first state) 21·6 × 30·7 cm.

The print's subject is the economic 'bubble', created by wild and irresponsible speculation in the South Sea Company, which had burst by August 1720 with a corresponding economic disruption. Hogarth's was one of many 'bubble' satires published in 1721. Pictorial 'reading' of the print was made easier by the artist's verse caption, which begins:

> See here ye Causes why in London,
> So many Men are made, & undone,
> That Arts, & honest Trading drop,
> To Swarm about ye Devils Shop, (A) . . .

It goes on not only to identify the emblematic motifs but also to clarify Hogarth's Augustan morality. The assistance of words is necessary to clarify a composition in which a general lack of artistic skill confuses what is an already crowded composition. There is a haphazard combination of mytnical (the devil), allegorical (trade) and actual figures, and an extensive caption is required to help us distinguish them.

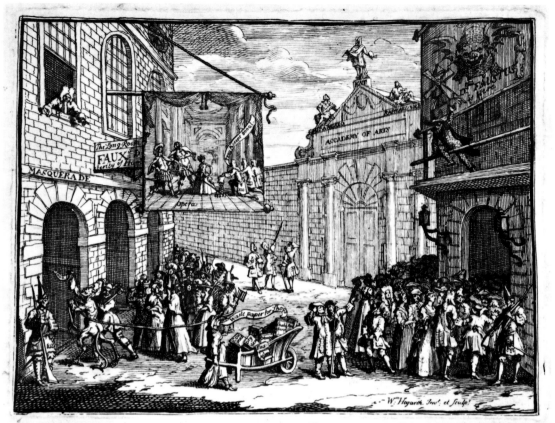

Could new dumb Faustus, to reform the Age,
Conjure up Shakespear's or Ben Johnson's Ghost,
They'd blush for shame, to see the English Stage
Debauch'd by fool'ries, at so great a cost.

What would their Manes say? should they behold
Monsters and Masquerades, where usefull Plays
Adorn'd the fruitfull Theatre of old.
And Rival Wits contended for the Bays.

*Price 1 Shilling. 1724*

## 3 *Masquerades and Operas*

LONDON, British Museum, Department of Prints and Drawings. February 1724. Etching and engraving (first state) 12·7 × 17 cm.

In the same way as in *The South Sea Scheme* (Plate 2), Hogarth not only relied on language, both within the print and as a caption, to explain his imagery, but also attacked false standards. In the wings of the composition are two theatres. On the left-hand side a crowd is being herded into a masquerade, signs advertise both the opera and the performances of the conjuror Fawkes or Faux, while the notoriously ugly Swiss impresario Heidegger leans from a window. On the other Harlequin points to a sign advertising the pantomime *Dr. Faustus* to which an elegant crowd is flocking. In the foreground the 'waste paper for shops' includes volumes by Congreve, Dryden, Otway, Shakespeare, Addison and Jonson. In the background is Burlington House, with three gentlemen admiring a pediment on which recumbent figures of Michelangelo and Raphael gaze in admiration at the crowning statue of Kent. This print is an attack on false taste. The works of the great British dramatists are fit only for waste paper, because nowhere is left for their performance. Pantomime proved so popular that Drury Lane, which had previously specialized in native plays, turned to it in the autumn of 1723, with masquerades and operas attracting equal crowds. Heidegger provided not only such masquerades but had also, with Handel, produced operas. Hogarth's opinion of the latter which, with imported Italian singers, had become the rage in the 1720s is clear from the sign on which three noblemen beg three singers 'pray accept 8000L', a ridiculously large sum. The irony was that the opera was both ostentatious and, being sung in Italian, incomprehsible. In the background, or 'behind all this', is Burlington House where one sees the false elevation of the Italianate Kent. Certainly Burlington supported the opera. Citing his influence as a 'cause' of what Hogarth saw as bad taste may have had its origins in Gay's description of Burlington House in *Trivia* of 1716:

> Yet Burlington's fair Palace still remains;
> Beauty within, without proprrtion reigns,
> Beneath his eye delcining art revives...

Hogarth may well have been pointing to his view of the nature of this artistic 'revival', thereby expanding the influence of false taste to cover everything of which he disapproved, such as Thornhill's eclipse.

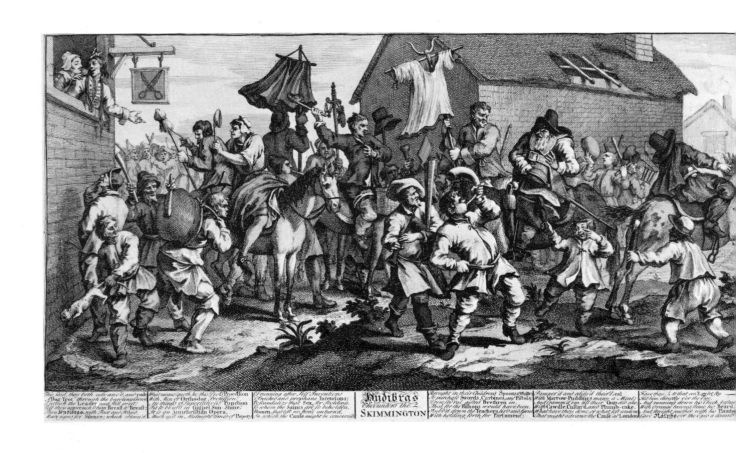

4 *Hudibras*, part II, canto II: *Hudibras and the Skimmington*
LONDON, British Museum, Department of Prints and Drawings. February 1726. Etching and engraving (first state) 24·8 × 50·6 cm.

This is one of twelve illustrations Hogarth made of Samuel Butler's *Hudibras* for publication as a set. He produced a further series of smaller prints as book illustrations, first published in 1726. The larger plates were the consequence of an understanding with Överton the bookseller and were an attempt to capitalize on the fame of a very popular author. Besides being large these twelve plates were prestige productions, carefully worked and printed on high quality paper. Hogarth's increased grasp of the essentials of art is apparent throughout. His perspective is surer than in *Masquerades and Operas* (Plate 3), and he was able to draw figures to a fairly convincing scale. Resemblances between this and a bacchanal by, say, Poussin or Carracci merely meant that Hogarth had learned from the Old Masters which pictorial formulae, for instance the manipulation of light and shade and the presentation of the composition as a frieze, best suited his purpose. The caption to the print is a careful compilation from lines 753 to 832 of the second canto of *Hudibras*. They emphasize that the print sold on the fame of Butler and is a close illustration to his poetry. The Skimmington was a burlesque procession celebrating nagging wives and their suffering husbands by putting them in effigy on horseback.

A The Dancing Master or Praeternatural Anatomist.

B An Occult Philosopher searching into the Depth of things.

C The Sooterkin Doctor Astonish'd.

Cunicularii
or
The Wise men of godliman in Consultation
They held their Talents most Adroit
For any Mystical Exploit. Hudib.

D The Guilford Rabbet-Man Midwife.

E The Rabbet-getter.

F The Lady in the straw.

G The Nurse or Rabbet-Dresser.

5   *Cunicularii or the Wise Men of Godliman in Consultation*
LONDON, British Museum, Department of Prints and Drawings. December 1726. Etching
16 × 24 cm.

This celebration of one of the more entertaining scandals of 1726 was produced to sell on the notoriety of the subject it satirizes. Mary Toft of Godalming in Surrey had apparently been giving birth to rabbits, so convincingly that not only did she fool a number of physicians, but she was also eventually ordered to London by the king. When the truth emerged, that she had been supplied with rabbits which she then concealed beneath her skirts, there was much embarrassment among the experts. Hogarth, the apostle of commonsense, could not have been expected to miss the opportunity for satire thus provided. As with earlier prints he relied on the written word, both in the form of 'speech bubbles', with the rabbit-catcher making a knowing gesture as he is told that his offering is 'too big', and captions to explain the figures. The composition is simple and the action more self-explanatory than previously in Hogarth's work. Both of these qualities assist the print in being more direct.

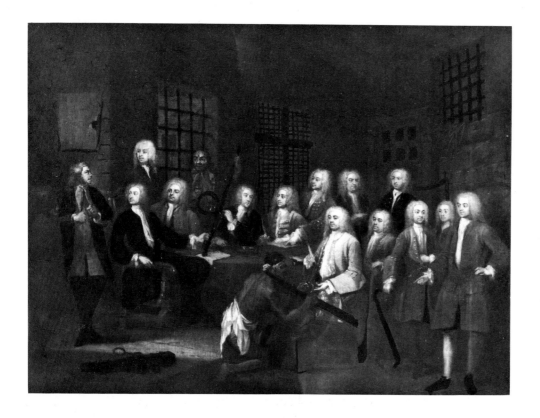

6    *The Committee of the House of Commons*
LONDON, National Portrait Gallery. 1729. Oil on canvas 51 × 68·5 cm.

By the late 1720s Hogarth had taken to producing conversation pieces notable for the large
number of portraits, inevitably on a small scale, that they contained. This painting is in one sense
a typical instance of the genre, showing a number of individuals, each differentiated, in a typical
setting. In another sense, however, it does not belong to the tradition of commissioned conversation
pieces, for Hogarth, with his own painful memories of the Fleet Prison, would have followed the
proceedings of the committee with a lively interest. In eighteenth-century gaols, inmates paid for
such privileges as food. This led to much exploitation by warders, and the wardenship of the Fleet
prison was bought in August 1728 by Thomas Bambridge and one Dougal Cuthbert for £5000, a
sum in itself a measure of the pickings that they anticipated. Bambridge conducted his affairs with
a lack of diplomacy. In 1728 Robert Castell, the architectural theorist and associate of the
Palladians, refused to pay exorbitant fees at the Fleet Prison, was confined to a spunging house
wherein raged smallpox, caught it and died. He was a friend of the member of Parliament James
Oglethorp. Bambridge then tangled with a baronet. The consequence was the appointment of a
Commons committee under Oglethorp to enquire into conditions in English gaols. In March 1729
Bambridge was called before it, and Hogarth recorded one of the confrontations in the oil sketch
(Cambridge, Fitzwilliam Museum) on which he based this painting. In the sketch he identified the
satanic figure to the left as 'Huggins the Keeper' and the man in the centre foreground as 'a
Prisoner'. Hogarth would have sympathized with the prisoners through his own experience.
However it is not unlikely that his work was also informed by an humanitarian belief that the
distinction between crime and punishment was not so clear cut and that penalties tended to the
inhuman.

(*opposite*)
I    *The Carpenter's Yard*
LONDON, collection of Sidney F. Sabin. c. 1725. Oil on canvas 59·7 × 94 cm.

This work is attributed to Hogarth on the grounds of a stylistic similarity between it and a *Sign for
a Paviour* (New Haven, Yale Center for British Art, Paul Mellon collection), after which an
engraving appeared in Samuel Ireland's *Graphic Illustrations to Hogarth* of 1794. It is important not
only in showing the artist struggling with the 'superior' medium of oil paint, in a style reminiscent
of that of Watteau's master, Claude Gillot, but also in his choice of a sign-painting which includes
townscape. The picture is virtually diagrammatic in its descriptions of the appearance and jobs
typical to the carpenter's yard. The wood is being stacked, shifted and worked in various ways, and
besides this, one has a notion of the social context of the labourers' activity. They are distinguished
both in dress and degree of action from two gentlemen to the left who, having apparently observed
the men, comment upon their work. They wear suits and wigs, while the labourers have shirts and
breeches and, to varying extents, their own hair. Hogarth was intent here to record this activity
accurately, and we can assume that his picture gives a reasonably correct idea of the way that such
a scene would have looked.

*32*

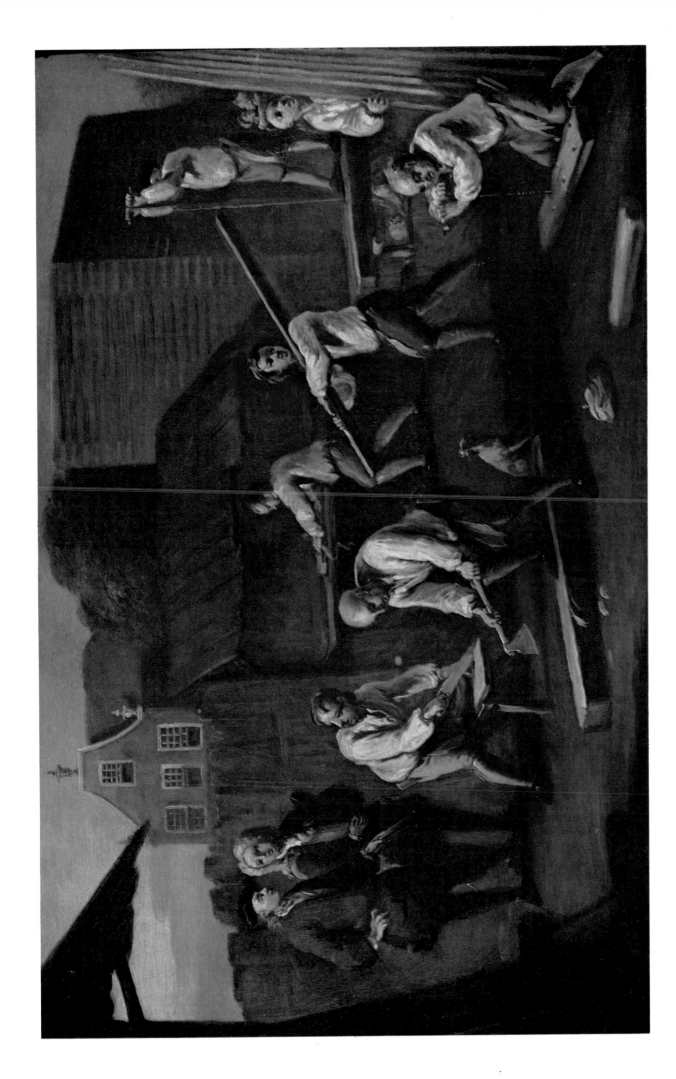

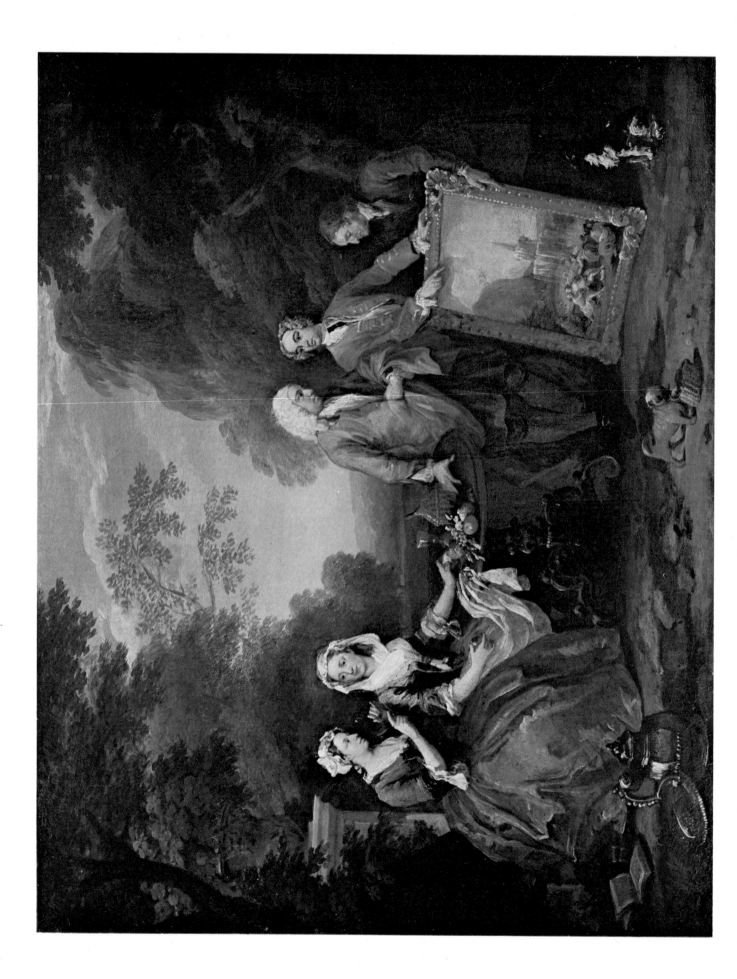

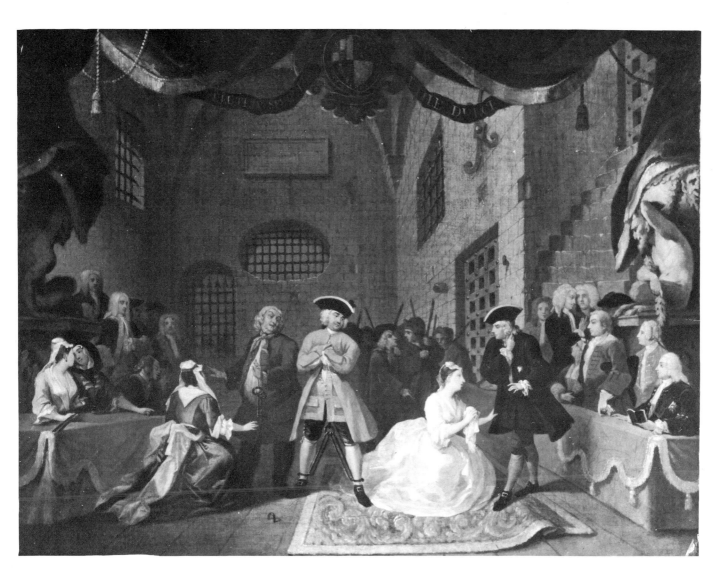

7 *'The Beggar's Opera'*
LONDON, Tate Gallery. 1729–31. Oil on canvas 56 × 72·5 cm.

Hogarth found that *The Beggar's Opera* was a pleasingly popular subject. John Rich's production of
Gay's play ran in 1728 for sixty-two consecutive nights. Hogarth's first version of the scene, now in
an English private collection, seems to have effected an introduction to Rich and to have started a
friendship which was to endure, despite Hogarth's earlier satire of this theatre manager in
*Masquerades and Operas* (Plate 3). By studying the various versions of the painting one can see
Hogarth growing in artistic fluency and competence, increasingly able to grasp, by this, the sixth
and final version, the pictorial opportunities for stressing dramatic interrelationships afforded by
the theatre. The Tate picture is a replica, painted for Sir Archibald Grant, of the original owned
by Rich.

II *The Fountaine Family*
PHILADELPHIA, Philadelphia Museum of Art (John Howard McFadden collection).
c. 1730–32. Oil on canvas 47·5 × 60 cm.

Hogarth painted large numbers of these small-scale conversation pieces, adapting the type of *fête
champêtre* in which Watteau specialized and in the production of which Mercier (fig. 4) was making
a living. The purpose of the conversation piece was to provide a favourable image of its subjects
and their world. Placing figures in this Watteau-esque landscape would, presumably, have
emphasized their taste and sophistication. The balance between glamour and truth of portrait
demanded a nice judgement. The outdoor conversation piece was to be a genre of surprising
longevity and later examples include such works as Gainsborough's *Mr. and Mrs. Andrews* of c. 1751
(London, National Gallery).

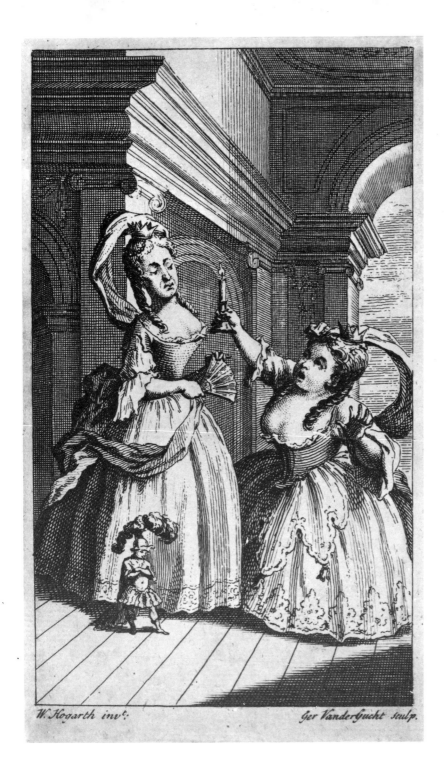

8　Frontispiece to Henry Fielding's *Tom Thumb* or *The Tragedy of Tragedies*
LONDON, British Museum, Department of Prints and Drawings. March 1731. Etching and
engraving 15·7 × 9·4 cm.

This print, etched and engraved by G. Vandergucht after Hogarth's design, is an instance of the
artist turning his hand to working for booksellers. It was one way of making money without too
much exertion and something which Hogarth did throughout his life. In 1759–60, for instance, he
consented to Sterne's expressed wish and provided an illustration of Corporal Trim reading the
sermon for *Tristram Shandy*. By 1730–31 Fielding and Hogarth had become acquainted and aware of
a certain commonality of aim. *Tom Thumb* had appeared in 1730 and proved enormously popular,
with its characters instantly recognizable satires of the Court party. In his amended version, to
which Hogarth provided this frontispiece, Fielding made his allusions even more obvious. Paulson
has pointed out how contemporaries would have identified Huncamunca with the Princess Royal,
who was noted for her obesity, a factor that Hogarth accentuated:

> Thy pouting breasts, like kettledrums of brass,
> Beat everlasting loud alarms of joy;
> As bright as brass they are, and oh, as hard;
> Oh Huncamunca, Huncamunca! oh!

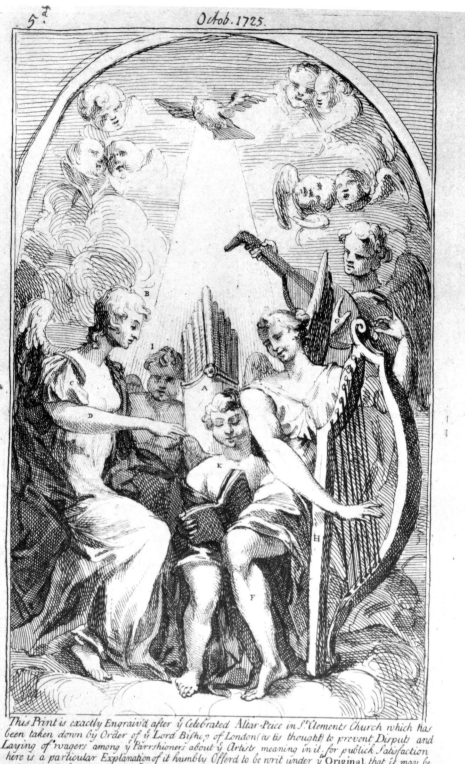

This Print is exactly Engraiv'd after ẙ Celebrated Altar-Peice in Sᵗ Clements Church which has been taken down by Order of ẙ Lord Bishop of London (as tis thought) to prevent Disputs and Laying of wagers among ẙ Parrshioners about ẙ Artists meaning in it. for publick Satisfaction here is a particular Explanation of it humbly Offerd to be writ under ẙ Original, that it may be put up again by which means ẙ Parish'es 60 pounds which thay nisely gave for it. may not be Entirely lost
1 ˢᵗ Tis not the Pretenders Wife and Children as our weak brethren imagin
2 ᵗʰ Nor Sᵗ Cecilia as the Connoisseurs think but a Choir of Angells playing in Consort

A | an Organ
B | an Angel playing on it
C | the shortest Ioint of the Arm
D | the longest Ioint

E | an Angel tuning an harp    the other leg judiciously Omitted to
F | the inside of his Leg but whether    make room for the harp
    right or Left is yet undiscoverd
G | a hand Playing on a Lute    smaller Angells as appears by their Wings

9   *A Burlesque on William Kent's Altarpiece at St. Clement Danes*
LONDON, British Museum, Department of Prints and Drawings. October 1725. Etching
27·7 × 17·8 cm.

Kent's painting, now lost, showed singing angels, cherubs and a dove symbolizing the Holy Ghost, so Hogarth's print looks to follow closely the original. The caption provides most of the necessary explanation and combines with the appalling draughtsmanship and deliberately slipshod etching to produce a work in which the humour remains far more forceful than in prints such as *Masquerades and Operas* (Plate 3) which rely for their effect on our understanding complex contemporary allusions.

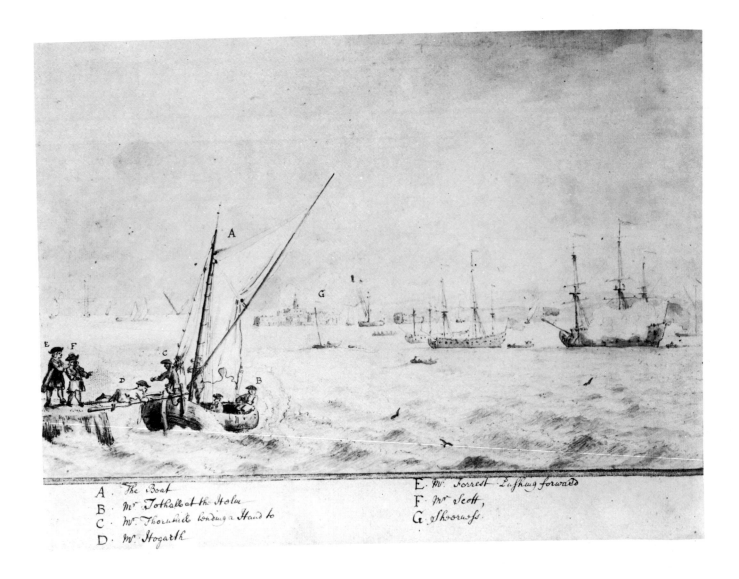

A. The Boat
B. Mr Tothall at the Holm
C. Mr Thornhill lending a Hand to
D. Mr Hogarth

E. Mr Forrest Lufhing forward
F. Mr Scott,
G. Sheerness.

10    *An Account of Five Days' Peregrination: Embarking from Grain*
LONDON, British Museum, Department of Prints and Drawings. June 1732. Pen and wash
20 × 30·5 cm.

One of the literary aims of Ebenezer Forrest's *Account*, a parody of antiquarianism and archaeological voyages, was reflected in Hogarths's illustrations. He enjoyed providing the scholarly apparatus of a key to identify what he depicted, obviously with humorous intent. Thus 'A' is 'The Boat' and 'G' locates 'Sheerness'. There is the same delight in the ridiculous in such details as a man-of-war firing a broadside at Hogarth's party.

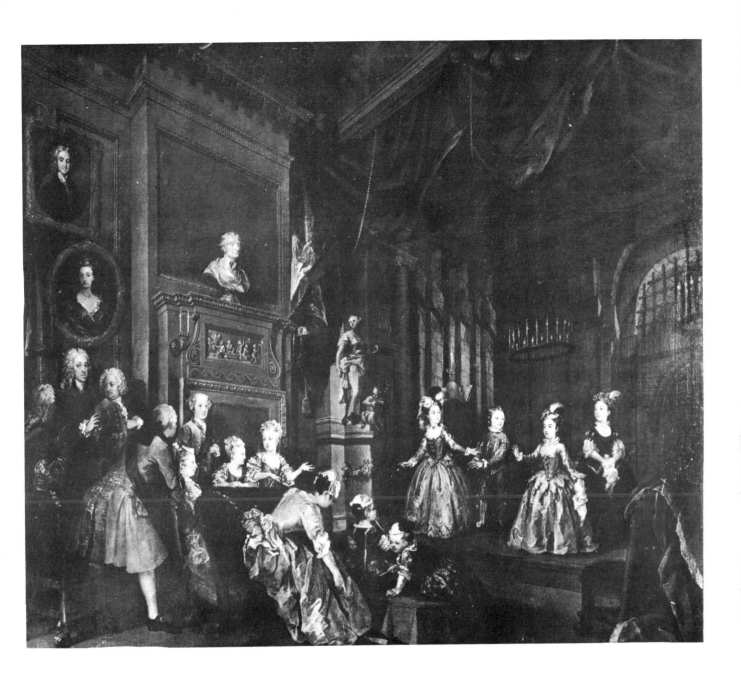

11   *A Scene from 'The Conquest of Mexico'*
DORCHESTER, Melbury House, collection of Lady Teresa Agnew. 1732. Oil on canvas
131 × 146·5 cm.

This painting is, for Hogarth, an extremely large conversation piece and was commissioned in 1732
by John Conduitt, Master of the Mint. Dryden's play, *The Indian Emperor or The Conquest of Mexico*,
was revived in 1731 at Drury Lane by Theophilus Cibber, who was engaged by Conduitt to stage a
children's performance of the play in the Conduitt home. Hogarth's painting, which depicts this
amateur performance, shows a distinctly upper-class audience, including at least three of George
II's children, Princess Mary, Princess Louisa and the Duke of Cumberland. Cumberland was
apparently so impressed that he ordered a repeat performance of this version at St. James's Palace.
Conduitt felt that such a glittering theatrical occasion in his own house was worth commemorat-
ing, and it is a measure of Hogarth's reputation that he was the automatic choice for painter. He
worked on a larger scale than in his usual conversation pieces and was required to concentrate on
the portraits of children rather than those of adults. The patron and his wife are featured in
portraits hanging on the wall, while a bust of Isaac Newton, Conduitt's predecessor at the Mint
and Mrs. Conduitt's uncle, is on the mantelpiece. The action on the stage has reached the fourth
act, with the chained Cortez standing between two rival princesses, not unlike the fettered
Macheath bracketed by Lucy Lockit and Polly Peachum in Hogarth's treatment of a scene from
*The Beggar's Opera* (Plate 7). Hogarth executed an informal painting of an informal occasion. While
the physical isolation of the children ensures concentration on their performance, there are also
diverting details. To the left gentlemen are in conversation, while in the centre foreground a child
is being asked to retrieve a dropped fan. This skilfully wrought picture is evidence that the artist
was beginning to break through to the upper reaches of patronage.

*A Harlot's Progress* (Plates 12–17)

The paintings after which these prints were made no longer exist. The subscription for the plates was opened by March 1731, but there were delays before their eventual delivery some time around mid-April. Their success was such that they provoked a spate of cheaper piracies. Hogarth produced in 1744 a second impression, with alterations, of the series. The story is the simple one of the young girl from the country who falls into immoral ways, enjoys a certain success for a time, but having been arrested embarks on the road to ruin, catching the pox and dying young. It is obvious that Hogarth was now confident of his ability to let the image 'speak for itself'. He abandoned captions, and legends written on motifs within each print are intended as clues only to his meaning.

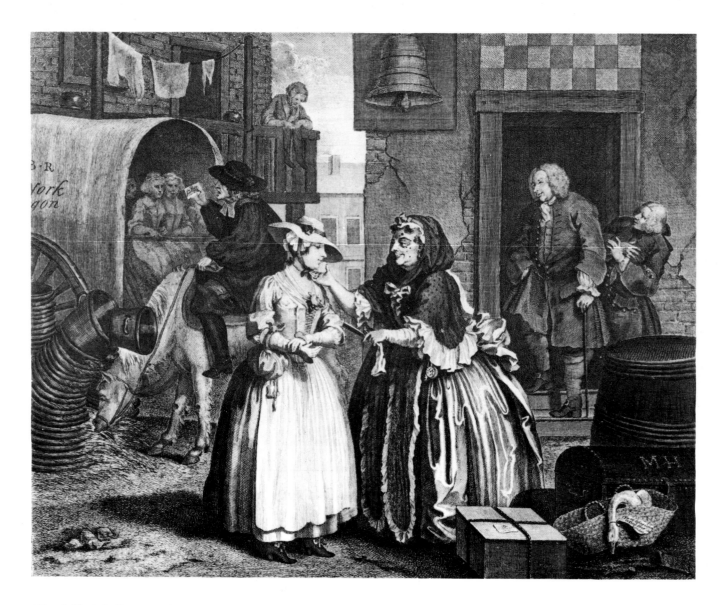

12   *A Harlot's Progress*, plate one
LONDON, British Museum, Department of Prints and Drawings. April 1732. Etching and engraving (first state) 30 × 37·5 cm.

The harlot, identified in the third and sixth plates as 'M. Hackabout', is introduced as a simple country girl just come off the York wagon and bringing with her baggage a goose 'For my Lofing Cosen in Tems Stret in London'. The girl, customarily known as 'Moll', has been sent on a visit she is destined not to make, the wagon on which she arrived drawing off, apparently on its return journey. She is being approached by the procuress Mother Needham, famous in her time, while Colonel Chatteris, notorious for lurking around inns, in this case The Bell, and corrupting young girls, stands in the doorway. Pope described him as 'a man infamous for all manner of vices' at whose funeral 'the populace . . . rais'd a great riot, almost tore the body out of the coffin, and cast dead dogs, &c. into the grave along with it.' The clergyman to the left is so blind to his pastoral duties that he becomes a social menace, his horse knocking over buckets while stealing straw. Moll's downfall, then, is not entirely her fault, because the agent of salvation has shown no interest in her fate.

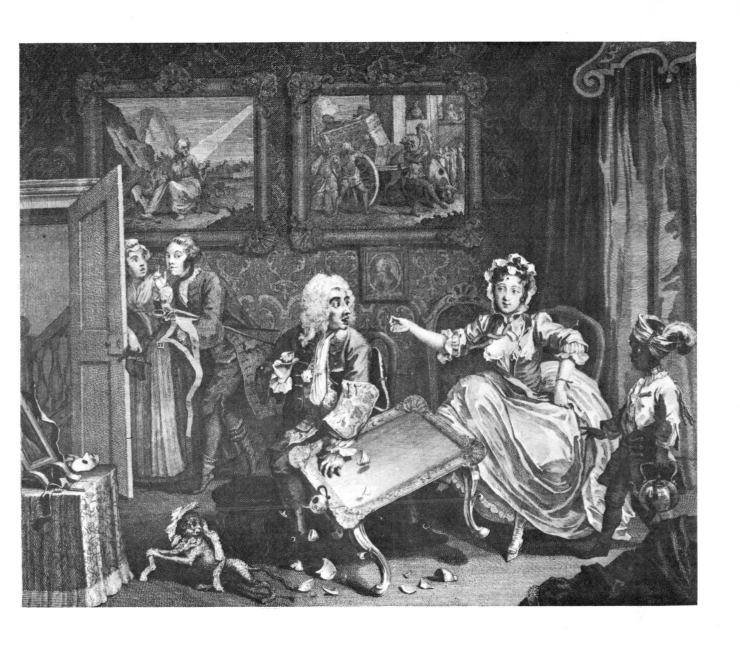

13   *A Harlot's Progress*, plate two
LONDON, British Museum, Department of Prints and Drawings. April 1732. Etching and engraving
(first state) 30·2 × 37·2 cm.

Moll has now attained the position of kept woman, she is another of a wealthy Jew's fashionable
acquisitions. His financial position is signified by, besides Moll, a black page and a collection of
paintings. His arrival seems to have interrupted a liaison with the young man who is making, with
the assistance of the maidservant, a furtive exit. Moll's means of diversion, baring a breast and
kicking over the table, are crude and emphasize how her 'success' is due to her physical
accomplishments. Paulson states that the subjects of the paintings on the wall, showing Jonah on
the left and Uzah reaching for the Ark of the Covenant on the right, deal with severe divine
justice, thus implying that when Moll's duplicity, symbolized by the mask on the left-hand table, is
discovered, her keeper will not be lenient.

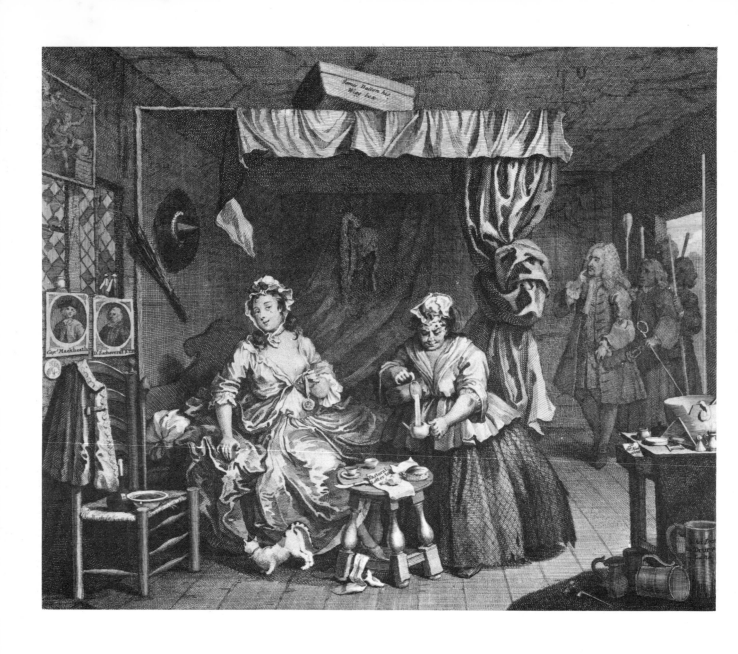

14   *A Harlot's Progress*, plate three
LONDON, British Museum, Department of Prints and Drawings. April 1732. Etching and engraving
(first state) 27·8 × 37·8 cm.

The harlot is having to make her own way in the world, having exchanged the Jew's apartment for
a single room and a young maid for an older, less fashionable one, whose nose displays the ravages
of syphilis. Moll retains an essential innocence, however, reinforced by the kitten, and she is eating
breakfast when Sir John Gonson comes in to make his arrest. The wrapping of the butter in a
'pastoral letter' from the Bishop of London again suggests that her downfall might have been
averted had the Church been paying more attention to its duties.

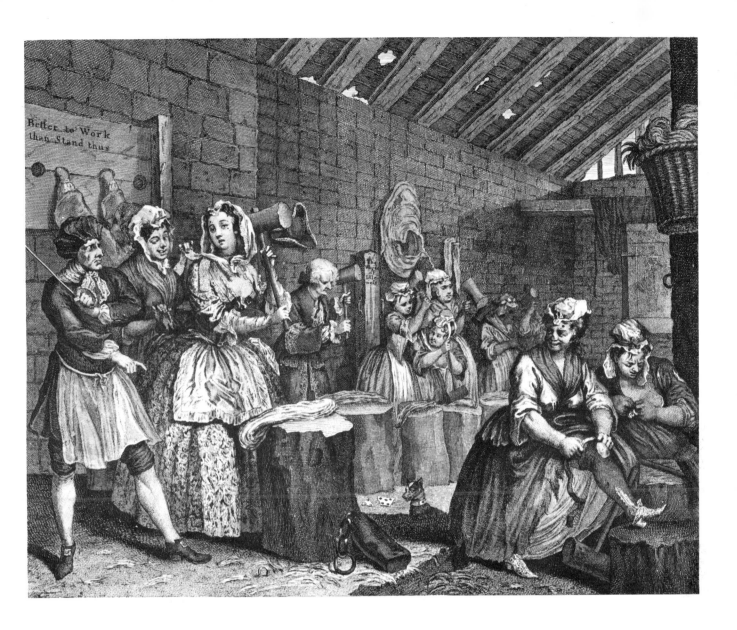

15 *A Harlot's Progress*, plate four

LONDON, British Museum, Department of Prints and Drawings. April 1732. Etching and engraving (first state) 30·2 × 37·9 cm.

Gonson apparently gave Moll time to change her clothes before committing her to Bridewell to beat hemp, along with her servant in the right foreground. The company is largely prostitutes on a still lower level than she has reached, one of whom examines her finery. The torn playing-card on the ground indicates that the man to her left is a card-sharp. Moll is being told to work harder. The punishment for idleness is either the stocks, with the legend 'Better to Work than Stand thus', or the whipping post, inscribed 'The Wages of Idleness'. The scene rings a theatrical bell with the Constable's singing to Mrs. Novel in Fielding's *Author's Farce* (1730)—

> I fancy you'll better know how to speak
> By that time you've been in Bridewell a week,
>     Have beaten good hemp, and been
>         Whipped at a post;

And two years later impetus went the other way when in *The Lottery* Fielding knew his audience would get the point of Lovemore's statement "some bawd has made prize of her as she alighted from the stagecoach.—While she has been flying from my arms, she has fallen into the Colonel's."

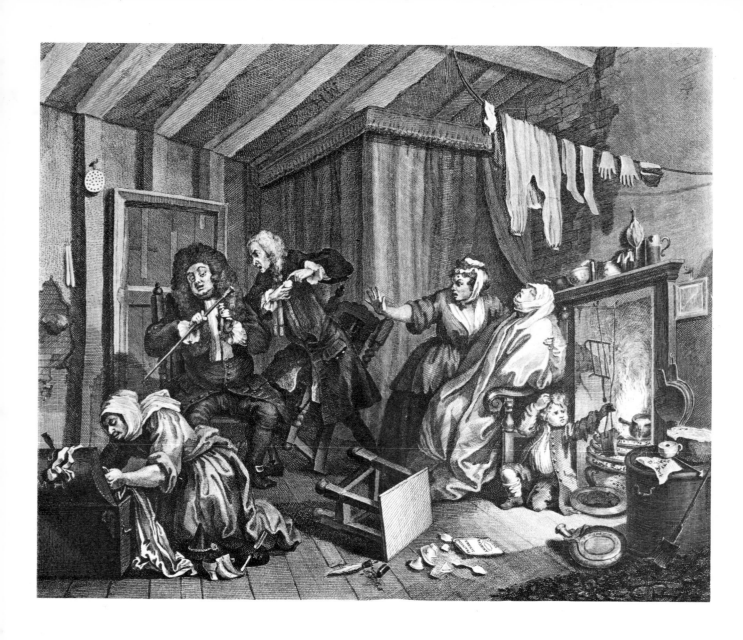

16  *A Harlot's Progress*, plate five
LONDON, British Museum, Department of Prints and Drawings. April 1732. Etching and engraving (first state)  30·5 × 37·5 cm.

This plate shows Moll dying from syphilis. The two quacks to the left are too busy disputing the relative merits of their patent cures to pay any attention to the patient, who is undergoing a sweating treatment under the care of her old servant. The small boy by the fire must belong to Moll, and Hogarth thereby demonstrates not only that several years have passed but also that the servant must feel strong ties of loyalty. We therefore have a member of the 'criminal classes' displaying virtue, which again emphasizes that Moll's downfall is the fruit of circumstances rather than her own evil character. She retains the trunk with which she came to London and which contains such things as the masquerade costume from the third plate, indicating how little she has gained from her life. Conversely to Richardson's *Pamela* whose tenacious hold on her virtue was to be rewarded by a marriage well above her station, Moll has not only squandered her only asset, but also, by having a lover while being kept by the Jew, shown herself lacking in the prudence which would pay off so well for Pamela. To the mercantile mind, Moll could be seen to deserve all that befell her.

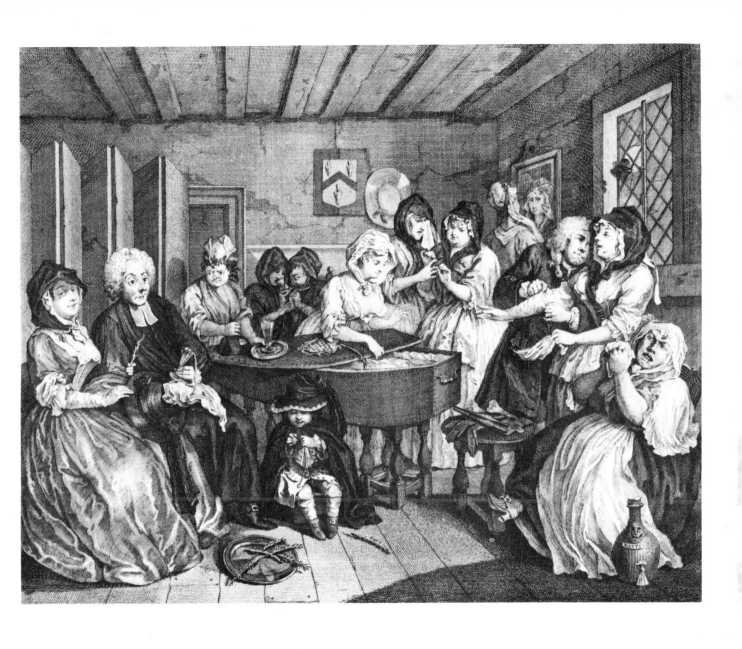

17　*A Harlot's Progress*, plate six
LONDON, British Museum, Department of Prints and Drawings. April 1732. Etching and engraving
(first state) 30·2 × 37·8 cm.

Moll has died at the age, so the plaque on her coffin tells us, of twenty-three. The wake is attended
by a motley company, Moll's small boy, sitting in front of her coffin. Behind it and to the left her
old servant reappears, while a younger whore is taking a look at Moll, perhaps to show that her
fate need not be repeated. The parson again emphasizes Hogarth's low opinion of the Church: his
left hand, hidden by a hat, is exploring the person of his neighbour with effects so distracting that
he has spilled his brandy. The undertaker is more concerned with seducing a member of the
company than anything else, so that at the end, as at the beginning, Moll is surrounded largely by
those whose interest is largely for self.

18   *The Laughing Audience*

CAMBRIDGE, Fitzwilliam Museum. December 1733. Etching (first state) 17·8 × 15·9 cm.

This was the subscription ticket both to *Southwark Fair* (Plate 19), delivered to subscribers in January 1734, and to *A Rake's Progress* (Plates 20–27). It is an unambitious but enjoyable work, showing the orchestra, audience and dallying fops. Hogarth mainly studied the physiognomy of amusement, implying that this was how his subscribers would themselves react when they had the prints.

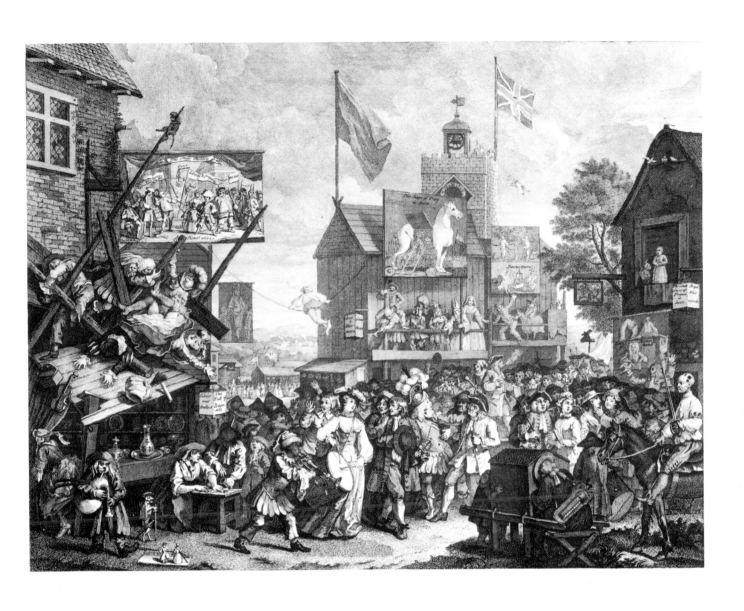

19   *Southwark Fair*
LONDON, British Museum, Department of Prints and Drawings. January 1734. Etching and engraving 34·3 × 35·1 cm.

Hogarth's original title on the subscription ticket (Plate 18) was 'A Fair'. As was his custom he based the print on a preparatory painting (Nassau, the Bahamas, collection of Lady Oakes). The composition is the simple, stage-like one with which he had first experimented in *Masquerades and Operas* (Plate 3), although the action in *Southwark Fair* is far more diversified and confused. Paulson has identified the various individuals and plays involved in an exhaustive account. Doubtless the print shows, though in a concentrated form, the appearance of the typical eighteenth-century fair. It is notable for the way in which Hogarth began to play with the idea of 'freezing' a moment. To the left the stage in front of a sign advertising Theophilus Cibber and William Bullock in *The Fall of Bajazet* is in the process of collapsing onto a china shop. A rope-walker connects this part of the picture with the booth, standing in front of the church, which shows *The Siege of Troy*. The rope-flyer, caught in mid-descent from the tower, is indulging in a popular, although dangerous, amusement of the period. In the foreground the girl literally is 'drumming up' interest in her show, while one of her actors is being arrested by bailiffs. Hogarth was intent to capture a split second of all the activity at the kind of fair which he enjoyed himself.

*A Rake's Progress* (Plates 20-27).

With this series Hogarth exploited the popularity of the genre he had invented with *A Harlot's Progress* (Plates 12-17). Expanding the number of scenes from six to eight suggests that he wanted to develop the narrative potential of the comic series. The rake receives his inheritance from a miserly father and immediately sets off on the path to disaster by ignoring his responsibilities and, in an attempt to ape aristocratic habits, spending the money rather than using it wisely. In the end he pays the debt of his foolhardiness by dying in Bedlam. As the harlot earns a premature death for giving up her virtue too cheaply, so the Rake commits the equal crime of wasting his inheritance.

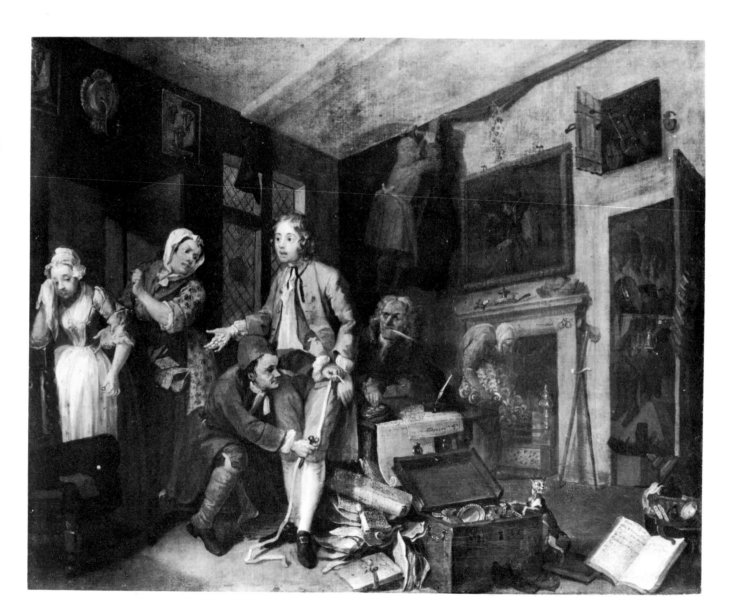

20　*A Rake's Progress: the Young Heir Taking Possession*
LONDON, Sir John Soane's Museum. c. 1733. Oil on canvas 62·5 × 75 cm.

Tom Rakewell starts badly by rejecting Sarah Young and her irate mother, whose gesture makes it clear that the girl is pregnant. That she has cause for concern over Rakewell's behaviour is shown by Sarah holding an unused wedding ring. Rakewell's late father is present in the form of a portrait over the fire, and his miserliness is emphasized both by the ill-repair of the house, leading to a workman repairing the cornice and dislodging a store of hidden coin, and the half-starved condition of the domestic animals. Rakewell himself is intent on being measured for new breeches, his gullibility suggested by the way the clerk has already taken to stealing under cover of momentary confusion.

21  *A Rake's Progress: Surrounded by Artists
and Sycophants*
LONDON, Sir John Soane's Museum. c. 1733
Oil on canvas 62.5 × 75 cm.

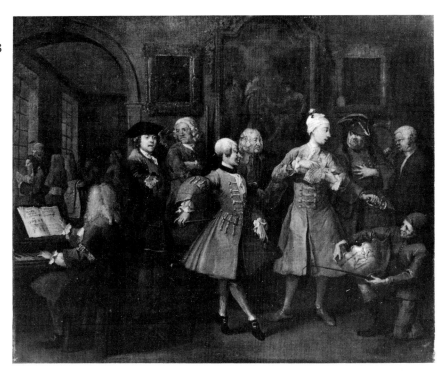

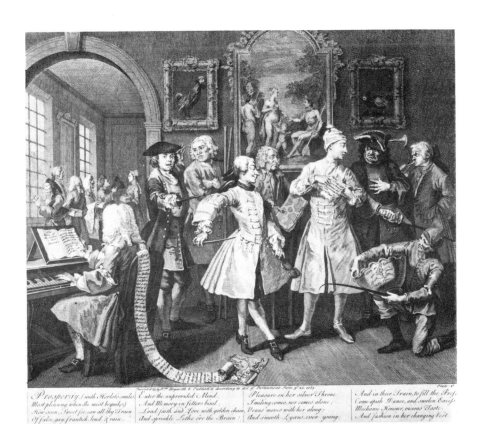

21a  *A Rake's Progress: Surrounded by Artists and Sycophants*
LONDON, British Museum, Department of Prints and Drawings. June 1735. Etching and engraving
(third state) 31·4 × 38·7 cm.

Clearly the rake's largesse has attracted a large crowd of admirers anxious to benefit from it. The
harpsichordist playing a new *opera* is enough for anyone familiar with the Hogarthian moral
universe to judge him. The paintings, besides alluding to Rakewell's situation, also show that he
has become a connoisseur. The pose of the swordsman is a parallel to that of the intentionally
ridiculous violin-teacher.

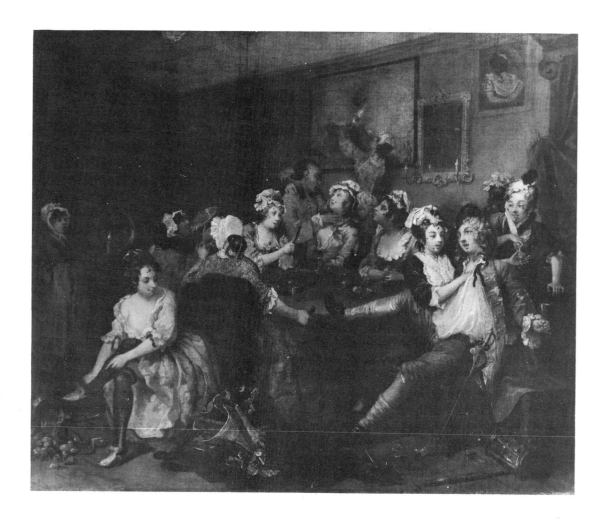

22 *A Rake's Progress: the Tavern Scene*
LONDON, Sir John Soane's Museum. c. 1733. Oil on canvas 62·5 × 75 cm.

There is an oil sketch for this composition in the Nelson-Atkins gallery, Kansas City. Links with *A Midnight Modern Conversation* (Plate 28) were deliberate. Rakewell is continuing to spend his inheritance unwisely. He indicates by his pose that he has taken a large quantity of drink, the smashed lantern on the floor suggesting an assault on a night watchman. While he enjoys the caress of a whore, she removes his watch and hands it to an accomplice. Hogarth's contemporaries would see in this motif a cliché of whorish behaviour, exemplified for example in one of Edward Ward's aphorisms from *Female Policy Detected* (1722), "She will take thee about the neck with one Hand, but t'other shall be diving into thy Pocket". The large plate being brought in through the door will be used to dance upon by the girl stripping in the left foreground. Rakewell is enjoying a debauched evening; one character swigs from the punchbowl direct, while another reduces her argument to spitting across the table.

III *Before I*
CAMBRIDGE, Fitzwilliam Museum. 1730–31. Oil on canvas 35·5 × 44·5 cm.

The first versions of paintings on the themes of *Before* and *After* were executed for a John Thomson, who fled England with funds embezzled from the Charitable Corporation for the Relief of the Industrious Poor. As with *The Fountaine Family* (Plate II), *Before* and *After* respond to a particular French genre, showing its 'private' rather than its 'public' face. These are superbly painted works in which an advanced degree of artistic attainment is apparent. They are of the sort one would label 'special commissions', pornographic or *risqué* pictures designed for the gaze of their owner and a few select friends only. Hogarth produced such works, for instance *Sir Francis Dashwood at his Devotions* of 1742–6 (private collection), from time to time as, presumably, did other artists. The painted image had a far greater erotic charge before photography.

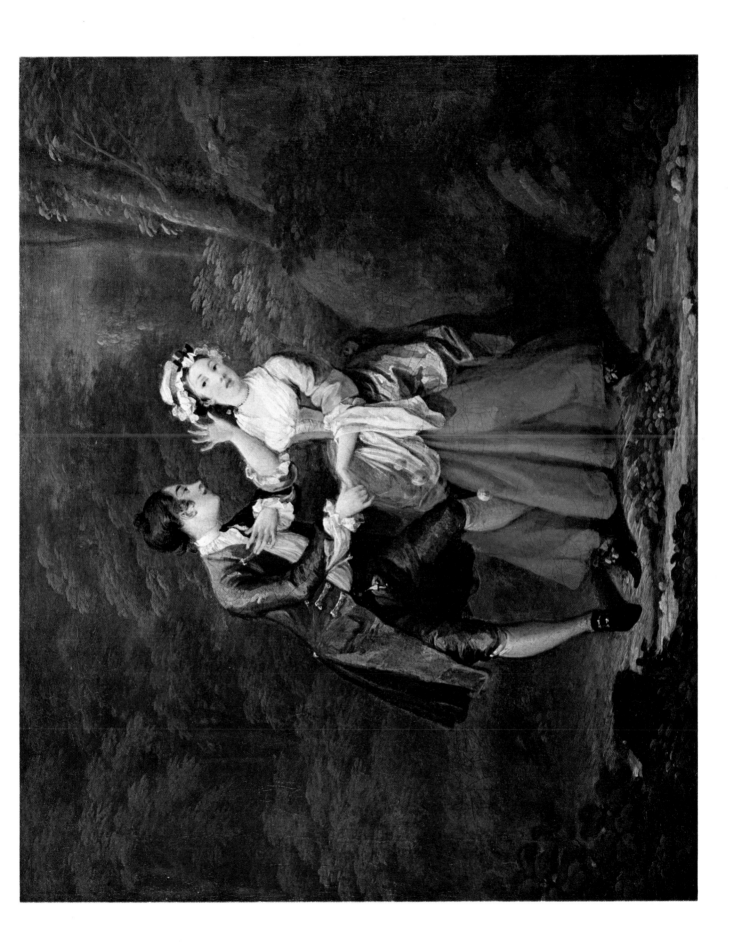

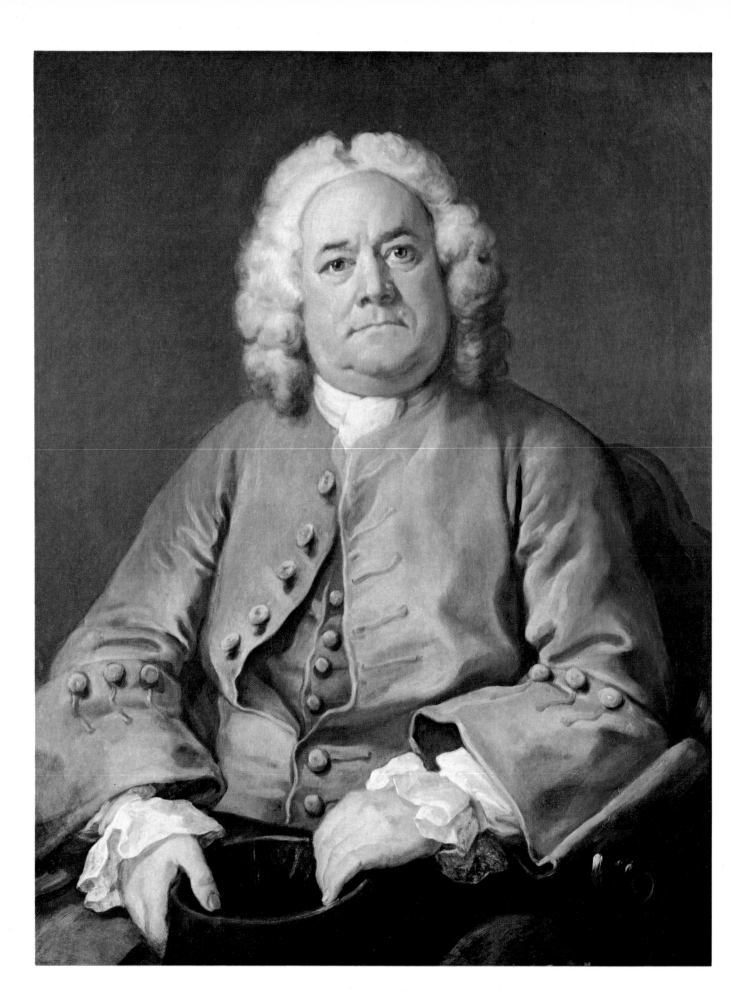

O Vanity of youthfull Blood, | Approaching views the Harpy Law, | Ready to seize the poor Remains | Cold Penitence, lame After Thought, | Call back his guilty Pleasures dead,
So by Misuse to poison Good: | And Poverty with icy Pan- | That Vice hath left of all his Gains. | With Fears, Despair, & Horrors fraught, | Whom he hath wrong'd, & whom betray'd.
Reason awakes, & views unbard | | | |
The sacred gates he watch'd to guard; | Invented Painted & Engrav'd by Wᵐ Hogarth, & Publish'd June yᵉ 25 1735, according to Act of Parliament. — | | Plate 4.

23  *A Rake's Progress: Arrested for Debt*
LONDON, British Museum, Department of Prints and Drawings. June 1735. Etching and engraving
(first state) 31·8 × 38·7 cm.

Rakewell is on his way to St. James's Palace, attempting to stop his financial rot by seeking royal
favour. Welshmen wearing leeks mean that it is St. David's Day, 1 March, also Queen Caroline's
birthday. The sedan chair is stopped by a couple of bailiffs with a warrant, but Sarah Young,
playing a rôle similar to that of the harlot's faithful servant, steps in with a purse of money. This
emphasizes that the rake can still save himself. Hogarth produced several versions of this print. In
the second state of c. 1745 the sky has darkened and lighting is striking a building near the palace
gates, labelled as 'White's', the famous gaming club. The foreground is filled with a group of
gambling urchins, one in the front suffering from hereditary syphilis. In the third state of c. 1763
Hogarth made everything considerably darker.

(*opposite*)
**IV**  *George Arnold*
CAMBRIDGE, Fitzwilliam Museum. c. 1740. Oil on canvas 89 × 68·5 cm.

Arnold had made a fortune which he had spent on a collection of Old Master paintings and on
building Ashby Lodge in Northamptonshire. Hogarth painted both Arnold and his daughter
Frances, whose portrait is also in the Fitzwilliam, apparently during a visit to the mansion.
Arnold's portrait is distinguished both for its brilliant technical accomplishment and the exercise of
this in portraying such an unglamorous figure. Hogarth was fascinated by the man's appearance
and set himself to describe it. The unselfconsciousness of his doing this is a contributing factor to
the painting's greatness.

24    *A Rake's Progress: Marries an Old Maid*
LONDON, British Museum, Department of Prints and Drawings. June 1735. Etching and engraving (first state) 31·9 × 39·05 cm.

In a ruinous Marylebone church, Rakewell marries a one-eyed old maid to recoup his losses, their future figured by the two chained dogs, one of which is also half-blind. The rake suggests the fate of the marriage by casting sidelong glances at the bridesmaid. Sarah Young, her child and her mother create an altercation at the church door as they attempt to force entry. The church is in notoriously bad repair. A notice on the gallery states that the churchwardens had beautified it in 1723, and further evidence of the degree to which religious duties are being neglected is shown by the torn creed. Implicit in this plate is an attack on the Church for permitting such a marriage to take place anyway.

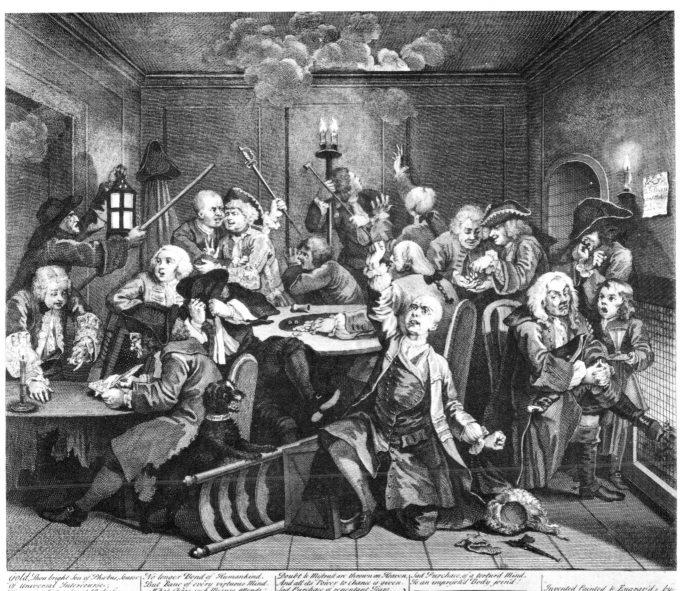

Gold, thou bright Son of Phœbus, Source | No longer Bond of Humankind. | Doubt & Mistrust are thrown on Heaven. | Sad Purchace, of a tortur'd Mind.
Of Universal Intercourse: | But Bane of every virtuous Mind. | And all its Power to Chance is given. | To an imprison'd Body join'd.
Of weeping Virtue Sweet Redress: | What Chaos such Misuse attends! | Sad Purchace, of repentant Tears. | Invented Painted & Engrav'd by
And blessing those who live to bless: | Friendship stoops to prey on Friends: | Of needless Quarrels, endless Fears. | Wm Hogarth, & Publish'd June ye 25 1735 according to Act of Parliament.
Yet oft behold thee Sacred Trust! | Health, that gives Relish to Delight. | Of Hopes of Moments, Pangs of Years. | Sold at ye Golden Head in Leicester Fields Lon: Plate 6.
The Tool of avaricious Lust. | Is wasted with ye Wasting Night.

25  *A Rake's Progress: Scene in a Gaming House*
LONDON, British Museum, Department of Prints and Drawings. June 1735. Etching and engraving
(second state) 31·9 × 38·7 cm.

Hogarth again used the 'conversation' around a table to stress the unnaturalness of the behaviour
he showed. Such is the general obsession with gambling that the fact that the house is burning
down is noticed only by those close to the fire. The rake has lost his new wife's fortune and strikes
an attitude of despair, its dramatic suddenness suggested by his wig having fallen off. Next to him
a highwayman is taking his losses so badly that he is oblivious even to an offered drink.

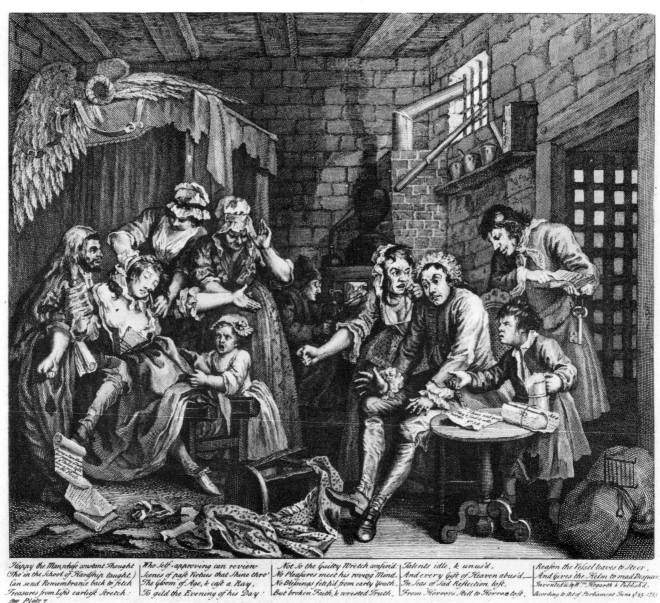

Happy the Man,whose constant Thought | Who Self-approving can review | Not So the Guilty Wretch confin'd; | Talents idle, & unus'd, | Reason the Vessel leaves to Steer,
(Tho' in the School of Hardship taught,) | Scenes of past Virtues that Shine thro' | No Pleasures meet his roving Mind, | And every Gift of Heaven abus'd.__ | And gives the Helm to mad Despair.
Can send Remembrance back to fetch | The Gloom of Age, & cast a Ray, | No Blessings fetch'd from early Youth, | In Seas of Sad Reflection lost, | Invented & by Wm Hogarth & Publish'd
Treasures from Life's earliest Stretch: | To gild the Evening of his Day! | But broken Faith, & wrested Truth, | From Horrors Still to Horror tost, | according to Act of Parliament June 25, 1735.
Plate 7

26   *A Rake's Progress: the Prison Scene*
LONDON, British Museum, Department of Prints and Drawings. June 1735. Etching and engraving (third state) 31·8 × 38·6 cm.

The rake is now in the Fleet Prison. His wife harangues him, while the note on the table is from Rich the impresario, rejecting his play. The impossibility of alleviating his debt creates a misery enhanced by the two characters on the right pressing for payment and on the left by his daughter and a swooning Sarah Young.

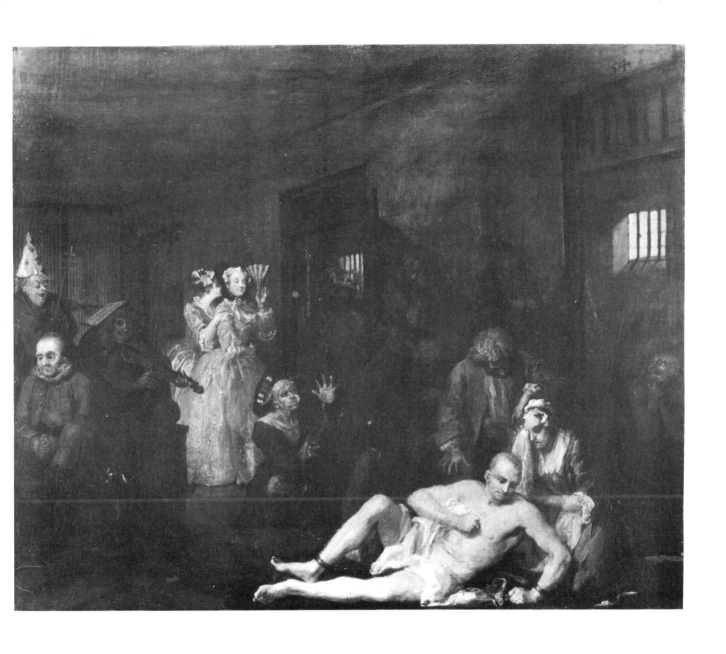

27 *A Rake's Progress: Scene in a Madhouse*
LONDON, Sir John Soane's Museum. c. 1733. Oil on canvas 62·5 × 75 cm.

Rakewell, shown despairing in the seventh scene (Plate 26), has now succumbed to lunacy and is shown in Bedlam. His pose, following those of Caius Gabriel Cibber's statues of *Raving Madness* (fig. 6) and *Melancholy Madness* would have been recognized and associated with his disorder by most Londoners. Sarah Young proves her worth by being distraught at his fate. The place is full of madmen in various guises; the two elegant ladies in the background remind us that a visit to the lunatic asylum was, in the eighteenth century, a fashionable form of amusement.

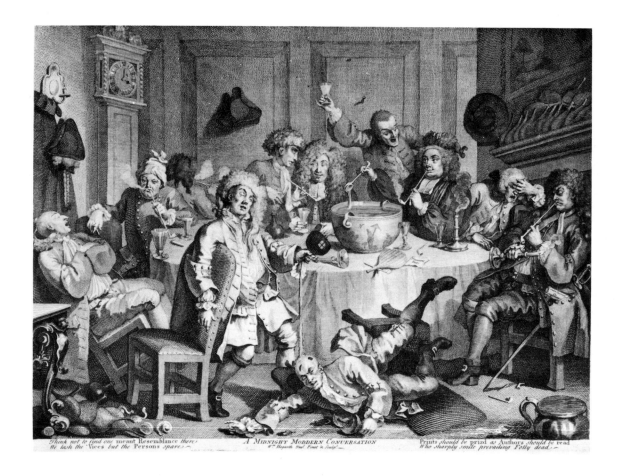

*Think not to find one meant Resemblance there*
*He lash the Vices but the Persons spare*     *A MIDNIGHT MODERN CONVERSATION*     *Prints should be prizd as Authors should be read*
*Wm Hogarth Invt Pinxt & Sculp*     *Who sharply smile prevailing Folly dead*

28   *A Midnight Modern Conversation*
LONDON, British Museum, Department of Prints and Drawings. March 1733. Etching and engraving
32·9 × 45·7 cm.

One of Hogarth's most popular prints, *A Midnight Modern Conversation* sold for five shillings. A painted version of the scene (New Haven, Yale Center for British Art, Paul Mellon collection) is looser and broader, with the figures independent of one another. Hogarth provided a verse caption, apparently not as a guide to the content of the print, but rather as to his intentions:

> *Think not to find one* meant Resemblance *there*
> We lash the *Vices* but the *Persons* spare.

This implies that it is a fruitless exercise to attempt to identify the participants, although Hogarth's admonition has not stopped people trying. The parson, for example, is commonly thought to be Orator Henley. This print is the first composition in Hogarth's work that was derived from Leonardo da Vinci's *Last Supper* (fig. 5), and for the artist the motif of a group around a table seemed to keep a stable satirical meaning throughout his career (Plates 25, 67 and 80). Both the composition and the verse, with its emphasis on the general, suggest that we 'read' this print with the same seriousness normally applied to history painting, deriving some timeless statement about the human condition. The irony is clear enough. Empty bottles attest to the quantities already consumed, while the punchbowl remains full even at four in the morning. The actual scene is not dissimilar to one James Thomson described in his poem *Autumn*, first published in 1730, in which a drinking party dissolves in chaos:

> Their feeble tongues
> Unable to take up the cumbrous word
> Lie quite dissolved. Before their maudlin eyes,
> Seen dim and blue, the double tapers dance,
> Like the sun wading through the misty sky.
> Then, sliding soft, they drop.
>
> Perhaps some doctor of tremendous paunch,
> Awful and deep, a black abyss of drink,
> Outlives them all; and, from his buried flock
> Retiring, full of rumination sad,
> Laments the weakness of these latter times.

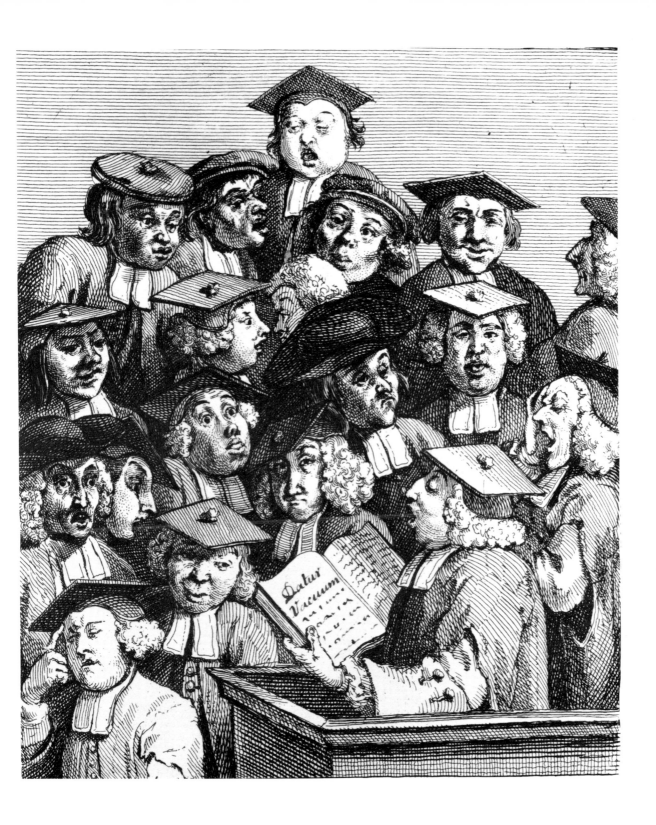

29   *Scholars at a Lecture*
LONDON, British Museum, Department of Prints and Drawings. January 1737. Etching and engraving (first state) 20·8 × 17·6 cm.

This sixpenny print is a satire upon the state of learning at the universities, establishments not noted in the eighteenth century for their fervid advancement of academic pursuits. The lecturer, William Fisher of Jesus College, Oxford, agreed to Hogarth's request to use him as a model. The undergraduates are therefore Oxford ones. Although the satire is simple, it was clearly not Hogarth's only concern. As in *The Laughing Audience* (Plate 18) he described a collection of people reacting to the same event. In this case the text 'Datur Vacuum' means that 'Leisure is given for', while 'Vacuum' itself is exemplified in the expressions on the various faces, whose general uninterestedness is a fairly typical response to the usual academic performance.

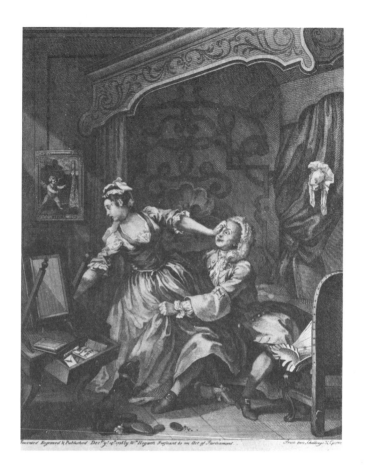 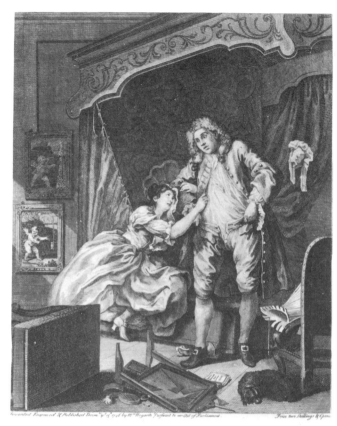

(*above left*)
30  *Before II*
LONDON, British Museum, Department of Prints and Drawings. December 1736. Etching and engraving (first state) 37·3 × 30·3 cm.

(*above right*)
31  *After II*
LONDON, British Museum, Department of Prints and Drawings. December 1737. Etching and engraving (first state) 37·3 × 30 cm.

These prints were executed after paintings of indoor versions of *Before* and *After* (Malibu, J. Paul Getty Museum) painted in c. 1730–31 for 'a certain vicious nobleman', the Duke of Montagu. Hogarth, enjoying great popularity, knew that he could sell anything that he produced and added interest by portraying the notorious rake Sir John Willes as the young man. In *Before* the momentary nature of the struggle is accentuated by the dressing-table being shown as it topples over. The poems of Lord Rochester on top of the table and 'novels' inside the drawer, together with *The Practice of Piety*, suggest that despite her resistance the girl is malleable material: she has after all removed her stays. The iconography of the paintings on the wall of the apartment, *Before* showing a cupid firing a rocket and *After* the same cupid with a descending rocket, needs no explanation. The dog's sprightliness in the first plate and exhaustion in the second also helps us to grasp Hogarth's point. In *After* the girl actually displays affection. The overturned dressing-table, exhausted dog, and shattered mirror, suit the theme. The girl was also reading Aristotle, her copy having fallen open at the passage 'Omne Animal post Coitum Triste'. The contemporary iconography of the lap-dog has been wittily discussed by Donald Posner*, and that such an iconography was available to Hogarth is suggested by an exchange like this, from Congreve's *The Old Batchelor*:

> Bellmour. . . . Who would refuse to kiss a lap-dog if it were preliminary to the lips of his lady?
>
> Sharper.  Or omit playing with her fan?

* See D. Posner *Watteau:  A Lady at her Toilet* London 1973

32  *After I*
CAMBRIDGE, Fitzwilliam Museum. 1730–31. Oil on canvas 35·5 × 44·5 cm.

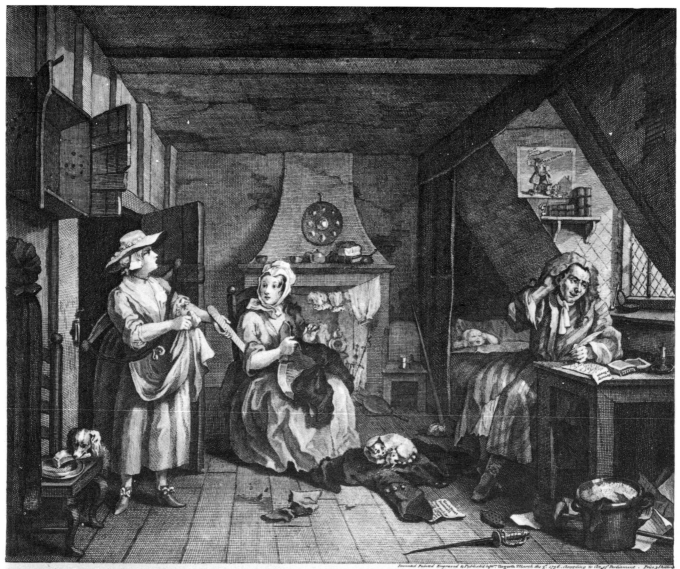

*Studious he sate, with all his books around,*      *Plung'd for his sense, but found no bottom there;*
*Sinking from thought to thought, a vast profund!*   *Then writ, and flounder'd on, in mere despair.*

DUNCIAD · Book I · *line* III.

33 *The Distressed Poet*
LONDON, British Museum, Department of Prints and Drawings. March 1737. Etching and engraving (second state) 31·9 × 38·9 cm.

This print reverses the composition of a painting of c. 1735 (Birmingham, City Museum and Art Gallery). Hogarth published it with a caption from Pope's *The Dunciad*, Book I, lines 3—6. These lines were very carefully chosen. The caption establishes a context for the print as being concerned with bad poets, although the visual point about life and art is Hogarth's own. The subject works on *Poverty a Poem* and seeks inspiration out of the window. He turns his gaze from the bare cupboard, the unpaid milk bill and the dog stealing a chop, all of which could make more than adequate subject-matter. His total lack of inspiration is evidenced by the pile of fruitless efforts lying under the table. Hogarth followed Pope in attacking hack writers through making it plain that his poet is ignoring his reponsibilities towards his wife and child. That Pope created the literary ideal is shown not only through the copy of the *Grub Street Journal*, which took Pope's side in the *Dunciad* controversy, on the floor, but also by the print above the poet's head, which shows Pope, the words 'Veni vidi vici 1735' issuing from his mouth, attacking the bookseller Curll. The latter had pirated Pope's letters in 1735; the piracy and the year, which was when Hogarth's Engraver's Copyright Act became law, combine to associate the artist and the poet. Hogarth reissued the plate in 1740, replacing the caption by the title *The Distrest Poet*. The poet was now writing *Riches a Poem* and the print of Pope changed to *A View of the Gold Mines of Peru*. The subject was now more emphatically the misuse of art, Hogarth revising the print to bring it into line with such works as *Strolling Actresses Dressing in a Barn* (Plate 40).

58

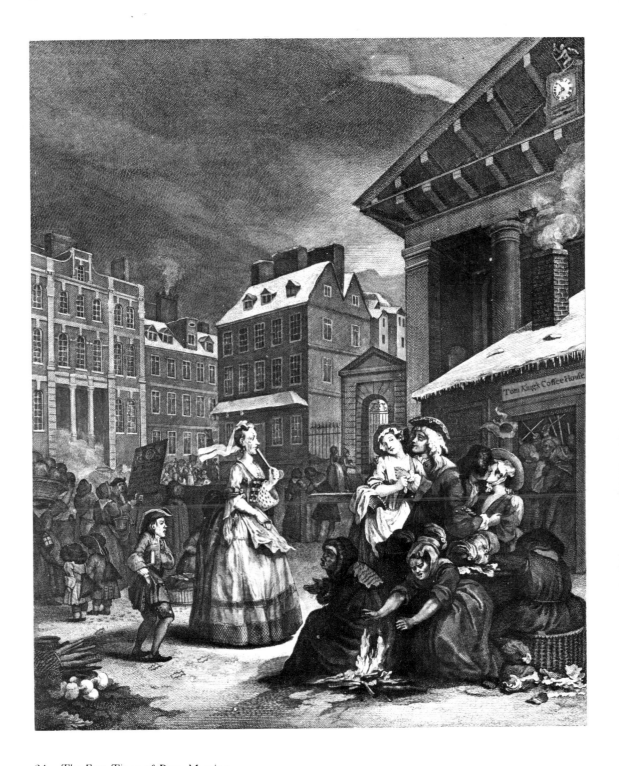

34  *The Four Times of Day: Morning*
LONDON, British Museum, Department of Prints and Drawings. March 1738. Etching and engraving (first state) 45·4 × 37·9 cm.

As was his custom Hogarth made the prints after paintings, copied by Hayman as decorations for supper boxes at Vauxhall Gardens. Hogarth's originals date from c. 1736 and are at present divided between the collections of Viscount Bearstead (*Morning* and *Night*) and the Earl of Ancaster (*Noon* and *Evening*). The series is held together by compositional similarities and pictorial echoes rather than by narrative. Each picture is divided vertically, while in terms of disposition of incident *Morning* and *Noon* together create a symmetry, with the two scenes of life and chaos becoming adjacent. Similarly with *Evening* and *Night* we find an ill-matched couple in the corresponding positions. Indeed, the motif of a couple provides a focus in each of the four scenes. It is a snowy and frozen winter's morning in Covent Garden. To the right is the giant Tuscan portico of Inigo Jones s church, in front of which stands Tom King's Coffee House, the door ajar to reveal the life within. In the right foreground a group is trying to warm itself by various means. Hogarth appears to have considered the embracing couple, as in *Noon*, the type of lusty normality. They are gazed at in disapproval by the lanky spinster, used by Fielding as a model for Bridget Allworth in *Tom Jones*, who is on her way to church. Her page seems so cold as to be scarcely aware of anything save his own discomfort.

**39** *The Four Times of Day: Noon*
LONDON, British Museum, Department of Prints and Drawings. March 1738. Etching and engraving (first state) 45 × 38·1 cm.

From the clock on the steeple of St. Giles-in-the-Fields we can tell that it has just passed midday. The gutter splits the composition, which is to a degree symmetrical. The couple emerging from the church are French; Hogarth exaggerated their courtliness and artificiality. The smug child with his walking-stick is both an exemplar of the unnatural being ridiculous and the antithesis of the wailing urchin across the way on the left. On this side of the composition the black man and the girl convey the idea of natural behaviour and the imagery of greed and lust is everywhere, although Hogarth did not dictate whether it is or is not to be preferred to control and formality.

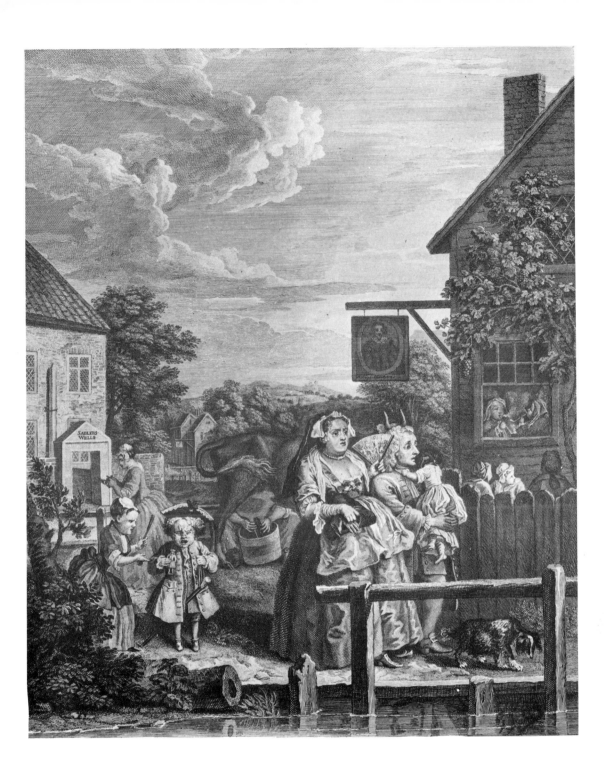

36    *The Four Times of Day: Evening*
LONDON, British Museum, Department of Prints and Drawings. March 1738. Etching and engraving (second state; engraved by B. Baron) 45·4 × 37·5 cm.

It is a hot evening at Sadler's Wells. Grapes on the vine show it to be early autumn, and the still water and gathering clouds indicate an approaching thunderstorm. A dyer and his wife have attempted but failed to escape the heat by going into the country. The way relief is denied is shown too in the hang-dog air of the pregnant spaniel gazing at the cool water. This lack of relief is also linked to the theme of feminine persecution. The dyer is encumbered with one heavy child in his arms and two more to the side as well as with a large wife. Hogarth positioned the cow being milked, and, as its tail shows, persecuted by flies, in such a way as to imply that the dyer is being cuckolded. His fate is anticipated in the bawling infant bullied by his sister. These children show us something both of the dyer's burden and his wife's sexual demands, amplified by her flushed face indicating that she is literally 'in heat'.

*61*

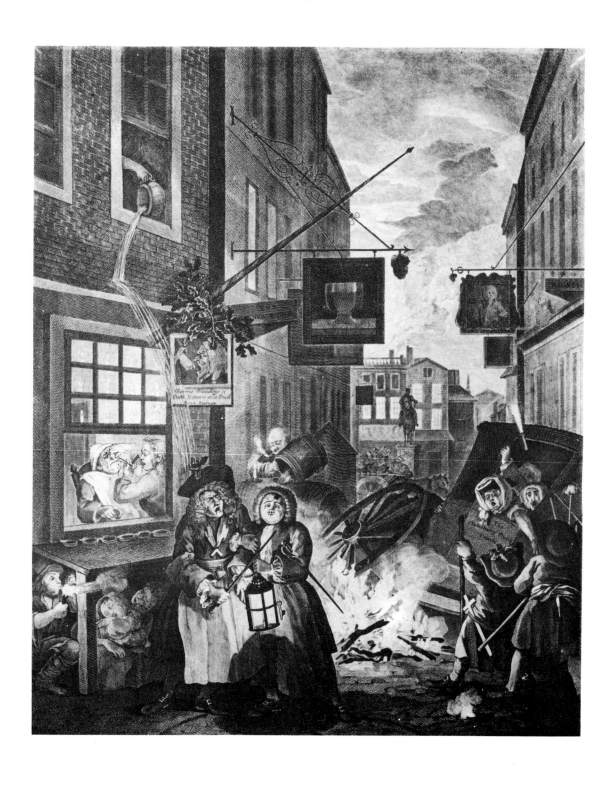

37  *The Four Times of Day: Night*
LONDON, British Museum, Department of Prints and Drawings. March 1738. Etching and engraving (first state) 44 × 36·8 cm.

*Night* shows a scene near the equestrian statue of Charles I at Charing Cross on 29 May, Restoration Day. The scene is chaotic. A fire is burning on the horizon and another blaze has caused The Salisbury Flying Coach, which did the journey in a day, to overturn. The buildings flanking the coach are brothels, translating the idea of 'heat' into another idiom. In the barber's shop its drunken owner is making a bloody job of shaving a customer. The two intoxicated Freemasons in the foreground are Sir Thomas de Veil and the doorkeeper of his Lodge. De Veil was the Bow Street magistrate so vehement in his condemnation of drunkenness, which he so well exemplifies, that the mob fired his house. The contents of the chamber pot cascading upon him refers to an occasion when de Veil, alerted by an informer to some illegal gin drinking, found on tasting them that the contents of a bottle had been substituted.

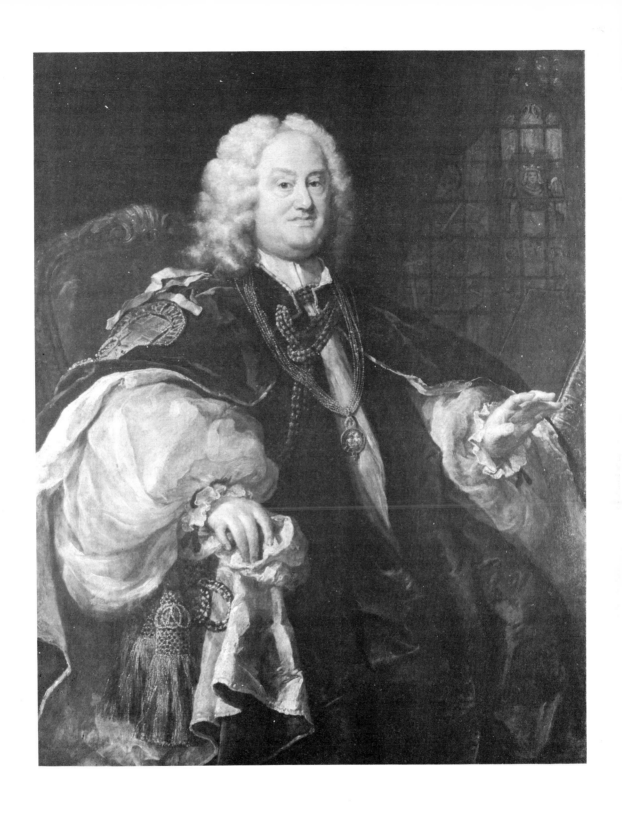

38   *Benjamin Hoadly, Bishop of Winchester*
LONDON, Tate Gallery. c. 1742–43. Oil on canvas 125 × 100·5 cm.

Benjamin Hoadly was one of Hogarth's friends, and this portrait, engraved by Bernard Baron and published in 1743, is a development from an earlier one of c.1738 (San Marino, California, Huntingdon Library and Art Gallery). The Tate portrait shows a variant of the Coram pose (Plate 39), taken from a closer focus which allows the figure of the sitter to fill the canvas and produce an almost overpowering effect. Hoadly was one of the most famous, or notorious, of contemporary churchmen, adept at place-hunting and well-known for living in ostentatious London luxury rather than at his bishoprics. Hogarth painted him in his robes as Chancellor of the Garter which, with the badge on the shoulder, created an opportunity to turn the picture into a colouristic exercise in reds, blacks and whites. Again the artist demonstrated his almost frightening objectivity. Hoadly is not an attractive figure, yet the composition does not allow us to escape him.

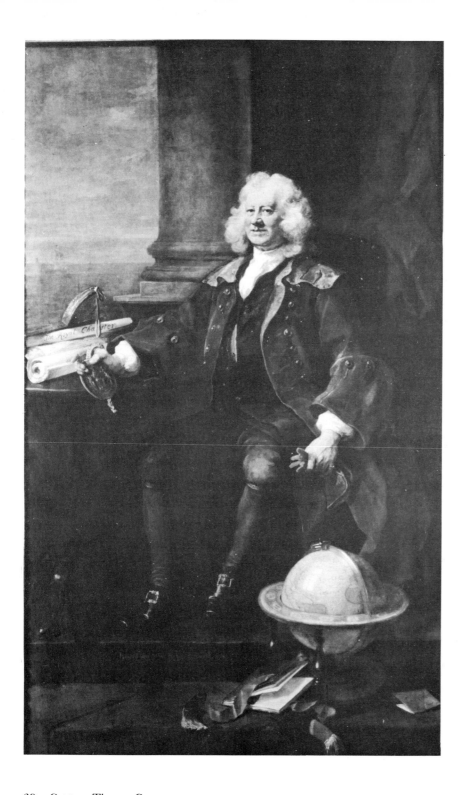

39 *Captain Thomas Coram*
LONDON, Thomas Coram Foundation for Children. 1740. Oil on canvas 239 × 147·5 cm.

Hogarth was acutely aware that this painting was a remarkable performance for an artist who had never before attempted life-size, full-length portraiture. He later wrote that he 'set about this mighty portrait, and found it no more difficult than I thought it' to show that there was no reason for Van Loo to monopolize the London portrait trade. It is uncertain whether he decided that he had equalled Van Dyck after painting it or had actually started with that specific artistic intention. Hogarth put the question to the St. Martin's Lane artists that 'if any at this time was to paint a portrait as well as Van Dyck would it be seen and the person enjoy the benefit? . . . The answer made by Mr. Ramsey [sic] was positively NO'. He continued, 'I resolved if I did do the thing I would affirm I had done it.' The painting rivals both Van Dyck and Allan Ramsay, the Scottish portraitist, in the brilliant handling of the drapery. Altogether it is a conscious exercise in the Grand Manner, thereby emphasizing Coram's qualities. The composition and emblematic attributes derive from a 1729 engraving after Rigaud's portrait of *Samuel Bernard*. Hogarth's knowledge of this print, incidentally, testifies to the degree to which he kept himself *au fait* with contemporary European art.

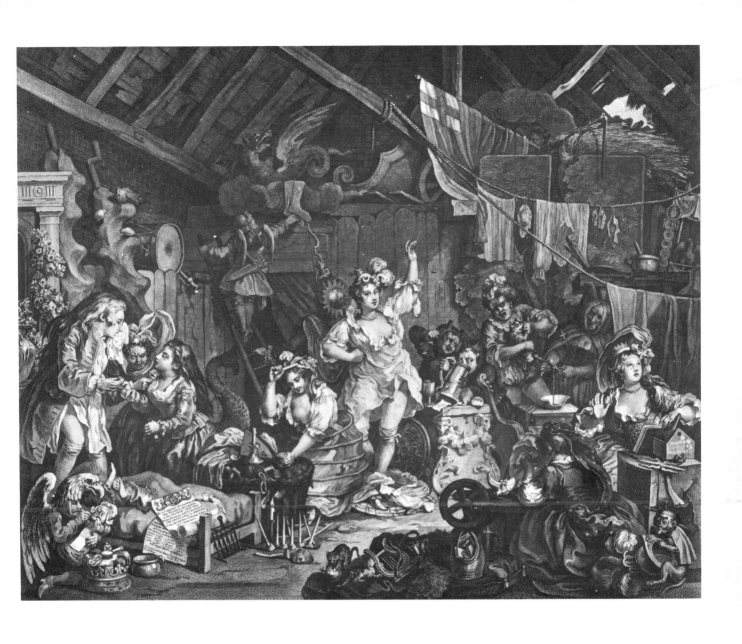

40 *Strolling Actresses Dressing in a Barn*
LONDON, British Museum, Department of Prints and Drawings. May 1738. Etching and engraving (second state) 42·5 × 54 cm.

This print again reproduces a painting which, however, was destroyed by fire in the nineteenth century. Strolling players were widespread in Hogarth's day, and it is such groups who are performing in the booths in *Southwark Fair* (Plate 19). Walpole's Act against Strolling Players was a political stratagem, designed to silence authors with whom the government found itself at odds.

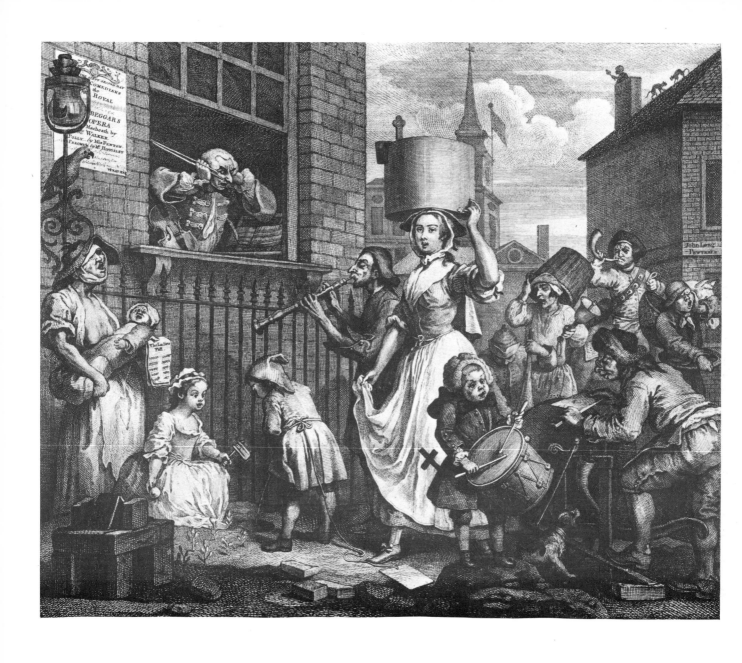

41 *The Enraged Musician*
LONDON, British Museum, Department of Prints and Drawings. November 1741. Etching and engraving (second state) 33·2 × 39·9 cm.

*The Enraged Musician* was published as a companion piece to *The Distrest Poet* (Plate 33), Hogarth intending to provide a third print about painting to complete the set. The painting for the composition is in monochrome and in the Ashmolean Museum, Oxford. Its subject is noise. A parrot squawks, various individuals are shouting, the small boy in the act of amazing the little girl with the rattle has a piece of tin plate tied to him, another child is banging a drum next to a barking dog and a knife-grinder, a hautboy is being played, horns blown and bells rung, with cats wailing on the rooftops. The noise has penetrated the musician's room and he has flung open his window to remonstrate with its perpetrators. The variety of the racket tempts us to speculate what intrinsic quality distinguishes his noise from the rest and makes it art.

42  *Satan, Sin and Death*
LONDON, Tate Gallery. c. 1735–40. Oil on canvas 62·5 × 74·6 cm.

This work was unfinished at the artist's death. It has a certain historical importance insofar as a posthumous print from it provided an impulse for variants of the theme by, among others, Fuseli and Barry. The subject was taken from the passage in *Paradise Lost* in which Milton described the figures before the gates of Hell. A quotation from his account of the appearance of Sin shows the difficulty of the artistic task facing Hogarth.

> The one seemed woman to the waist, and fair,
> But ended foul in many a scaly fold
> Voluminous and vast, a serpent armed
> With mortal sting. About her middle round
> A cry of hell-hounds never ceasing barked·
> With wide Cerberean mouths.

The picture may well have been unfinished because Hogarth intended it as a technical exercise only. There is possibly a connection with Jonathan Richardson's 1734 *Explanatory Notes on 'Paradise Lost'* in which this section was taken as the key to the poem's argument. Richardson read from the book at Slaughter's Coffee House, frequented by Hogarth, and *Satan, Sin and Death* could have had some basis in the discussions that ensued. It seems less likely, however, that it was inspired by Burke's later discussion of the passage as an instance of the sublime.

43    *The Pool of Bethesda*
LONDON, St. Bartholomew's Hospital. 1736. Oil on canvas 416·5 × 617 cm.

44 *The Good Samaritan*, detail
LONDON, St. Bartholemew's Hospital, 1737. Oil on canvas 415 × 615 cm. (overall measurement).

Because the damp English climate is unsuited to true fresco painting, both these works were executed on canvas which was then applied to the wall. Although Hogarth's motive in painting them was to deny a foreign artist an opportunity to outshine an English one, they are both notable also as attempts at history painting in the Grand Style. The canvases decorate the stair well at St. Bartholomew's Hospital, and the figures are over seven feet tall. He was not only rôle-playing in a conscious continuation of the Thornhill tradition but was also fulfilling Jonathan Richardson's advocacy of history painting as the ideal towards which artists should aim. *The Pool of Bethesda*, unlike *The Good Samaritan*, was not painted *in situ*. Hogarth evidently expended a great deal of care over its production, and the painting is a source-hunter's dream, deriving a wide variety of motifs from other art. The subject is suitable to a hospital, showing Christ healing various ailments: to the right, for instance, is a figure supported on a crutch, while behind him is an aged man with his arm in a sling. The composition is generally well-managed, largely through the judicious employment of highlighting. *The Good Samaritan*, while also being a subject suitable to the charitable and healing functions of the hospital, is altogether more summary in treatment. Hogarth took trouble mainly with the central group, although the scratching cur is the type of detail he was later to burlesque as being typically 'Dutch'. Any success is noteworthy for an artist who previously had never worked on anything near the scale of these two works. Hogarth stated that one of his purposes had been to bring to the attention of native artists the mere possibility of history painting as a viable genre. His pictures attracted some favourable critical notice and indeed became one of the things to admire on a visit to the hospital.

45 *Moses Brought to Pharaoh's Daughter*
LONDON, Thomas Coram Foundation for Children. 1746. Oil on canvas 178 × 213 cm.

It was on Hogarth's initiative that artists donated their works to The Foundling Hospital, thereby
turning it into a place of exhibition. This is one of four history paintings of subjects appropriate to
an institution the main concern of which is the care of abandoned infants. The others were
Hayman's *Finding of Moses*, Wills's *The Children Brought before Christ* and Highmore's *Hagar and
Ishmael*. Hogarth's figure painting is of uneven quality. Nevertheless the work is not uninteresting.
Moses hovers between his nurse, his real mother, and Pharaoh's daughter. There is a particular
poignancy in the way that the child, reluctant to leave his mother, clings on to her skirts. The
incident is arranged as a frieze against a vaguely 'Egyptian' architectural background, the location
being expressed through the random deployment of pyramids.

**46** *Paul before Felix*
LONDON, Honourable Society of Lincoln's Inn. 1748. Oil on canvas 300 × 426 cm.

Hogarth enjoyed doing history paintings on enormous canvases, such as this one, which measures ten by fourteen feet. It attests to his success in advancing himself as a master in this genre that when, in December 1747, the Benchers of Lincoln's Inn were left a legacy of £200 they asked him to provide them with a painting. It appears to have been completed by June 1748, although Hogarth made alterations both then and in 1751. He engraved the composition in 1752, altering both the figures and their expressions, and Luke Sullivan published a print after the painting in the same year. Hogarth's picture has clear compositional links with Raphael's *Paul and Elymas* cartoon (fig. 12). However there is none of the Italian's generalizing, and Hogarth's drama is largely reliant on our reading the different expressions on his highly particularized faces. This can appear an uneasy blend of High Renaissance compositional ordering and 'Dutch' concentration on the particular. The scene shows the judge Felix confronted with the accusations of Tertullus, on the left, against Paul, and finds for the wrong man. The subject, embodying abstract principles of justice, is in key with the location of the painting in an Inn of Court. Hogarth was by this date introducing lines of beauty into his works and they are evident in the scrolls to the left of Paul's feet. The painting attracted a favourable response. Vertue, noting that Hogarth desired 'to out vye. all other painters', was also moved to admiration: 'it is a great work. and shows the greatness and magnificence of Mr. Hogarth's genius... this really is a great work & much honor so that raises the character of that little man—tho not his person...'.

*Defign'd and fcratch'd in the true Dutch tafte by Wm. Hogarth.    Publifh'd according to Act of Parliament May 1. 1751.*

**47** *Paul before Felix Burlesqued*
LONDON, British Museum, Department of Prints and Drawings. May 1751. Engraving and some mezzotint (first state) 25·1 × 34·3 cm.

Hogarth first intended this parody as a subscription ticket to the prints after both *Paul before Felix* (Plate 46) and *Moses Brought to Pharaoh's Daughter* (Plate 45), but it was so popular that he issued it independently. His first publication line read 'Design'd and scratch'd in the true Dutch taste', changed in the second state to 'Designed & Etch'd in the rediculous manner of Rembrant', so that he ostensibly attacked a faulty or 'Dutch' conception of history painting, interesting in view of the way that his original composition itself has 'Dutch' stylistic characteristics. Apart from being populated by somewhat obvious Jews, the rest of Hogarth's characters in this burlesque are good Dutch folk. The print is, in fact, remarkably complicated. It satirizes the fashion for Dutch prints and in the grossness of many of the figures repeats the fault for which Rembrandt was most often castigated. Thus it is 'realism' that makes Paul so short that he has to stand on a stool, and the same is true of the way we learn precisely how the terrified Felix has reacted to the justness of Paul's speech through the gestures of those directly in front of him. On the other hand there are signs that Hogarth took this burlesque as something more serious. Certain details manifest the same delight in the ridiculous as his drawings for *Five Days' Peregrination* (Plate 10). The blowsy figure of Justice has slipped the blindfold to observe the scene, while in later editions a small devil is intent on sawing through a leg of Paul's stool. Furthermore, Hogarth's opinion of Rembrandt's etching was clearly not so damning as he would have had us believe. The passage of light streaming through the window may be a parody, but it is an appreciative parody, and the landscape background is very high quality work indeed. There is an ambiguity, Hogarth perhaps knowing in his heart of hearts that the Raphaelesque Grand Style would not serve his own, equally serious, ends.

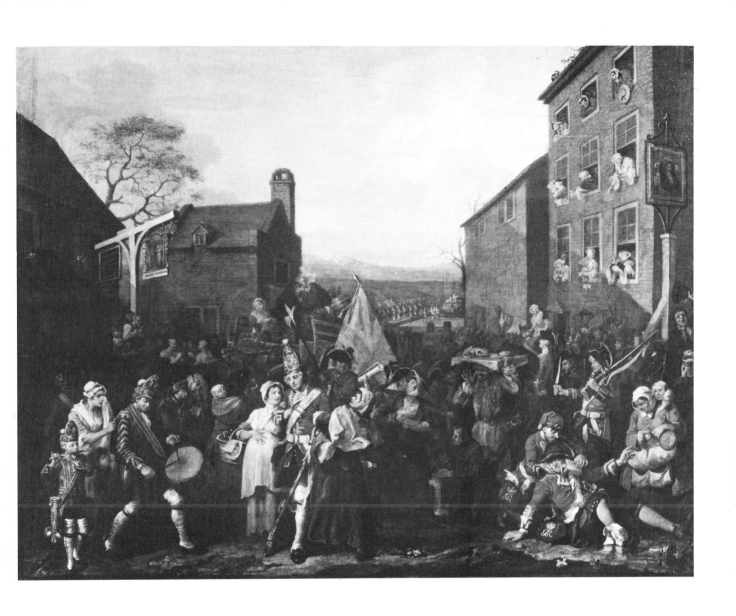

48   *The March to Finchley*
LONDON, Thomas Coram Foundation for Children. 1746. Oil on canvas 101·5 × 133·5 cm.

This crowded and confused painting is the subject of one of the famous anecdotes about George II.
Hogarth attempted to dedicate it to him, and the king, having remarked 'I hate *bainting* and *boetry*
too!', went on to observe that the artist deserved picketing for poking fun at a soldier. Hogarth
proceeded, therefore, to dedicate Sullivan's engraving of the composition to Frederick II, King of
Prussia. The print was used as a ticket in a lottery for the painting, which eventually went to The
Foundling Hospital. The painting not only contrasts chaos and order, but also stresses the
meaninglessness of regimentation. The glum soldier in the centre is flanked by two pregnant
women, one of whom pleads for his loyalty to the Hanoverian king and the other of whom urges
the Jacobite cause. Both mean nothing to him. Sunlit whores wave goodbye from the windows of
their brothel, a drunken soldier on the right leaves his wife and child despite their imprecations,
and to the left of centre a drummer gives the customary Hogarthian manifestation of animal high
spirits. Although Hogarth was not openly advocating anarchy he made no attempt to disguise its
existence. 'Lines of beauty' predominate, in rifle straps or webbing, in the disorderly foreground.

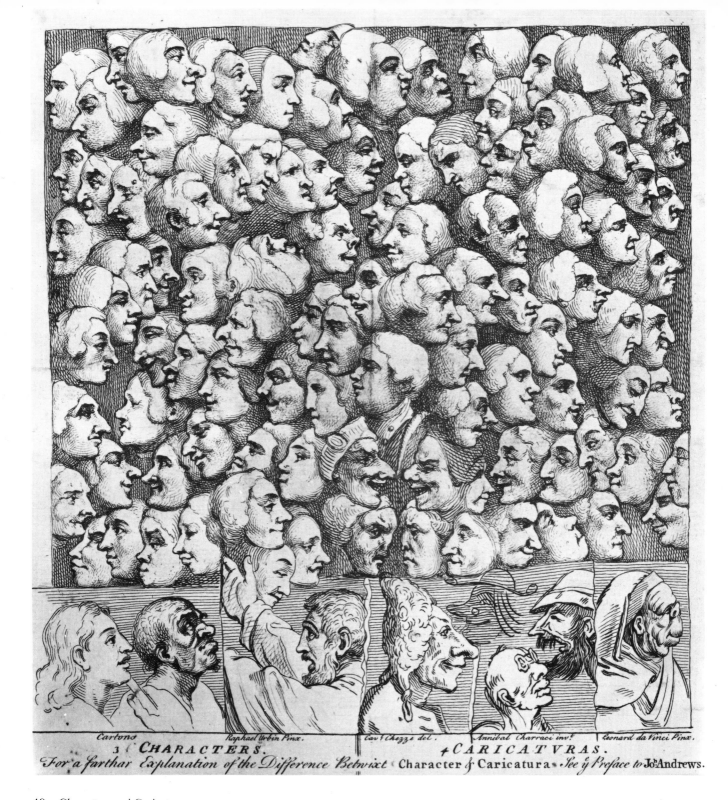

49 *Characters and Caricaturas*

LONDON, British Museum, Department of Prints and Drawings. April 1743. Etching (first state)
19·5 × 20·6 cm.

This plate was published as the subscription ticket to the prints after *Marriage à la Mode* (Plates 50–
55). Hogarth later explained his intentions in a note: 'Being perpetually plagued, from the mistakes
made among the illiterate, by the similitude in the sound of the words *character* and *caricatura*, I ten
years ago endeavoured to explain the distinction by the above print; and as I was then publishing
*Marriage A-la-Mode*, wherein were characters of high life; I introduced the great number of faces
there delineated . . . varied at random, to prevent, if possible, personal application . . .' Under his
mass of heads Hogarth illustrated variety in character by three heads from Raphael's cartoons
and the distortions of caricature by four heads from other artists, Ghezzi, Annibale Carracci and
Leonardo. Caricature was a recent Italian fashion which, to Hogarth, had little artistic value,
particularly in serious subjects. *Characters and Caricaturas* in conjunction with Fielding's *Preface* to *Joseph
Andrews* states the seriousness of the comic history paintings, in which mode a certain amount of
characterization is unavoidable.

*Marriage à la Mode* (Plates 50–55).

It is possible that the idea of satirizing fashionable false taste derived from Hogarth's *Taste in High Life* of 1742 (private collection) in which he had mocked the idiocy of the excesses to which fashion led people. *Marriage à la Mode* was an attempt to apprise the connoisseurs that here was a new and major genre of painting, of as much status as those executed in the Grand Style. Hogarth's 1743 trip to France meant that, as well as hiring engravers, he would have been able to look at recent French painting and judge his performance accordingly. No doubt it would have confirmed his opinion of his brilliance. The *Happy Marriage* series (Plate 64), also started at this time, did not reach completion.

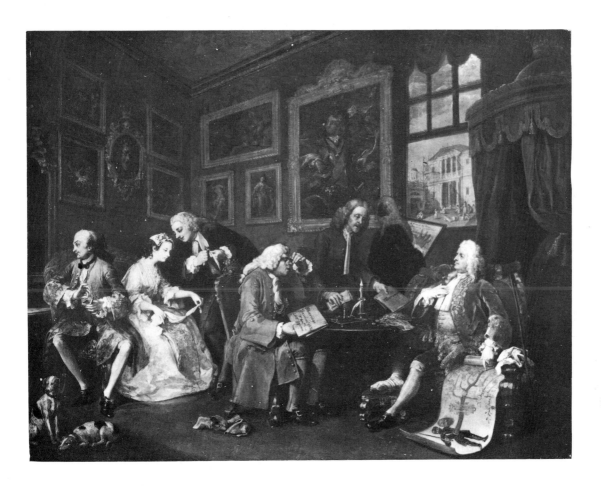

50  *Marriage à la Mode: the Marriage Contract*
LONDON, National Gallery. c. 1743. Oil on canvas 70 × 91 cm.

This plate opens the series in an apartment of Lord Squanderfield who has his coronet stamped on all the furniture. The "onomatopœic" names Hogarth's characters seem to be given reflects a habit of plays' authors for doing the same thing. "Squanderfield" indicates the careless waste of patrimony, and such is his poverty that his building project, seen through the window, has ground to a halt. As this house is based on Palladio's Villa Cornaro, one suspects that a neat piece of research permitted Hogarth another opportunity to present English Palladianism as one manifestation of a debauched or false taste in a context which includes the large numbers of dark paintings by Old Masters on the walls. The earl's extravagance, besides being manifested in mis-spending of money on works of art, shows, by means of his gouty foot, to have involved a degree of dissipation, and his family tree is all that he has to offer. He is confronted with his debts by the lawyer of the bride's father, the father being dressed in the plain clothes of a merchant. In a corner the viscount gazes at his own reflection, with an unambiguous index of his foppishness. In Mottley's *Widow Bewitch'd* (1730) for instance, the poetical fop Stanza can stand a long wait by being "mightily agreeably entertain'd between the two Peers and the Chimney glass." The viscountess-to-be, bored, threads a handkerchief through a ring, while one of the lawyers, Silvertongue, attempts to flirt with her. The boredom of the young couple is paralleled in the behaviour of the chained dogs, a motif used in the fifth scene (Plate 24) of *A Rake's Progress*.

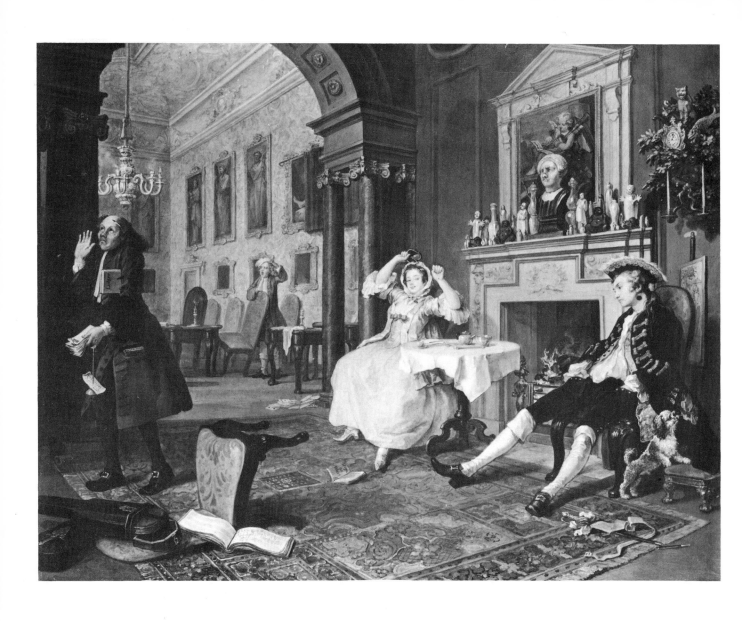

51 *Marriage à la Mode: Shortly after the Marriage*
LONDON, National Gallery. c. 1743. Oil on canvas 70 ×91 cm.

It is soon after one in the afternoon. The viscountess has finished breakfast, the viscount is
exhausted and unhappy. His sword is broken and a dog is sniffing the cap in his pocket, which
means that he has been fighting and visiting a brothel. From the wreckage on the floor we discover
that she has occupied her evening with music and card-playing. Wealth is again being used to
promote the dissolute living of which the main symptom is false taste: the steward exits with a pile
of unpaid bills, the works of art on the wall tend to the grotesque. One painting is so obscene that
a curtain covers all but a foot, and in front of a chimney-piece of a cupid playing the bagpipes is
an over-restored Antique bust.

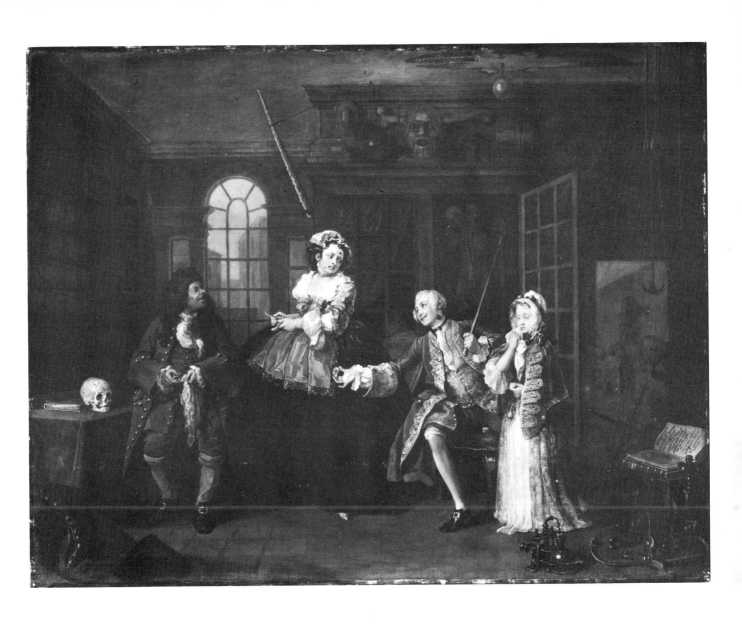

52 *Marriage à la Mode*: *the Visit to the Quack Doctor*
LONDON, National Gallery. c. 1743, Oil on canvas 70 × 91 cm.

This scene provides an insight into the viscount's behaviour. He has visited in the company of a young girl the house of Dr. Misaubin, a quack who provides 'cures' for social diseases. The girl is wearing a cap similar to the one in his pocket in the second scene (Plate 51), so we may suspect a continuing liaison. Around the room are the objects associable with quacks, with a skeleton apparently making advances to a stuffed human corpse. The viscount is good-humouredly attempting to procure treatment for the syphilis with which he has infected the girl. As he is returning the pills, the first cure has not worked. There is some scholarly debate over whether he himself has caught it from the older woman. This aside, the main point is that he should be completely indifferent to feminine reactions; it is one way of hinting at his weakness of character.

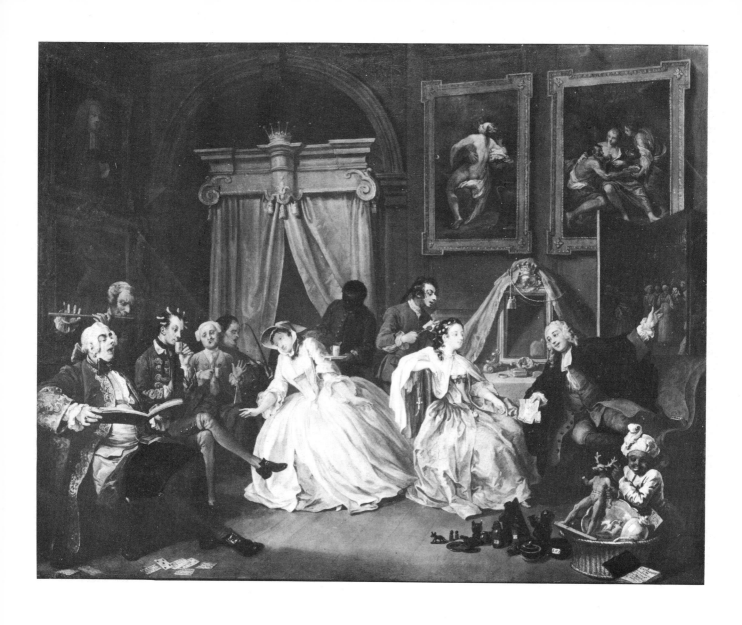

53  *Marriage à la Mode: the Countess's Morning Levee*
LONDON, National Gallery. c. 1743. Oil on canvas 70 × 91 cm.

In the absence of her husband, who has succeeded to his father's title, the countess surrounds
herself with company. A flautist plays to a castrato singer who sits next to a fop with his hair in
curling papers. The floor is layered with invitations to various functions. The countess is also
having her hair done, while listening to Silvertongue explaining, through pointing to the picture,
how they can go to a masquerade as a monk and nun. She has been buying rubbish at an art sale.
One of her negro servants points to a statuette of Acteon to suggest that the young earl is being
cuckolded, and this ties in with other images of sexual licence. The book by Silvertongue's feet is
the *Sopha*, a fashionable pornographic nove by Crébillon fils, and the paintings on the wall show
the rape of Ganymede, the rape of Io, after Correggio's composition, and Lot's daughters preparing
to seduce him through getting him drunk.

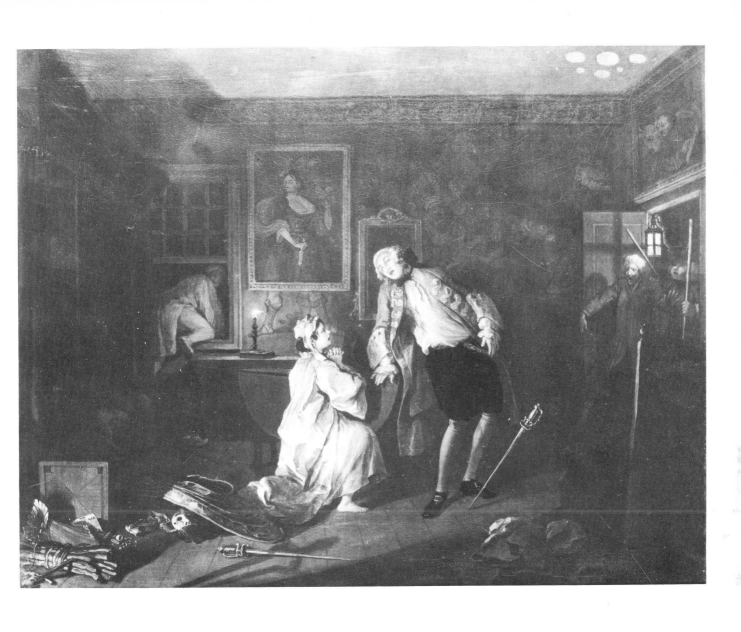

54   *Marriage à la Mode: the Killing of the Earl*
LONDON, National Gallery. c. 1743. Oil on canvas 70 × 91 cm.

The masquerade has been visited, and the countess and Silvertongue have retired to a bagnio. In
this scene the earl, presumably having followed them, has lost a sword-fight with Silvertongue, who
is escaping through a window. The clumsiness of the earl's pose is due to Hogarth having derived it
from the figure of Christ in a *Descent from the Cross*, an attempt to point up the irony of the scene.

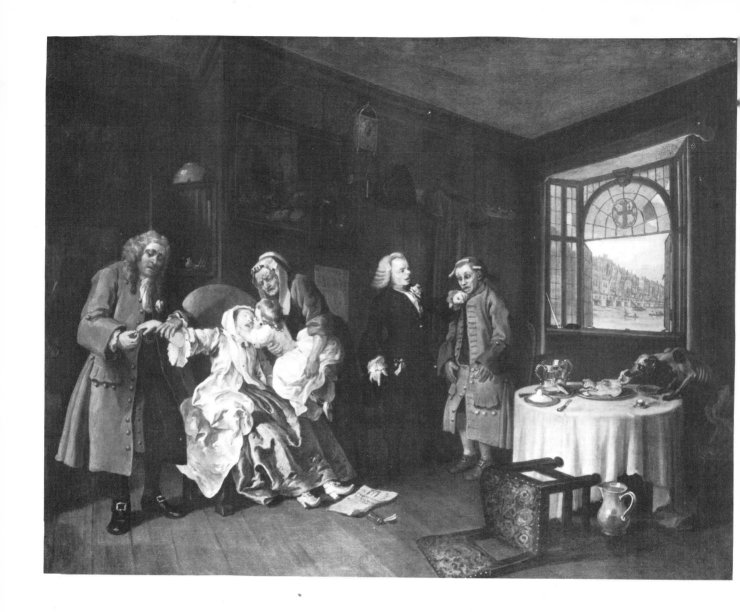

55 *Marriage à la Mode: the Suicide of the Countess*
LONDON, National Gallery. c. 1743. Oil on canvas 70 × 91 cm.

The location of the final scene is the apartments of the countess's father, overlooking the Thames. The poverty of the furnishings, with a starved dog stealing a half boar's head, indicates his miserliness, and the paintings on the wall the general level of his taste. They are Dutch genre scenes, one, for example, showing an individual lighting his pipe on his companion's red nose. The broadsheet on the floor informs us of Silverstongue's hanging, in response to which the countess has taken an overdose of laudanum. Her child, female, hence the extinction of the Squanderfield line, and crippled, embraces her, while her father cold-bloodedly removes the ring from her finger.

*(opposite)*
**V** *David Garrick as Richard III*
LIVERPOOL, Walker Art Gallery. c. 1745. Oil on canvas 190·5 × 250·2 cm.

This painting, after which Hogarth published a print in 1746, was a commissioned portrait for which a Mr. Duncombe paid £200. The painting's size and price remained a matter of pride to the artist. Garrick was his close friend (he bought the *Election* paintings) and the greatest and, incidentally, most often portrayed actor of the age, famous for the variety of facial expressions he could assume. He was successful in 1741 as Richard III, and Hogarth would no doubt have seen this revival of Shakespeare as a hopeful sign for English arts in general. This picture shows the actor as the king dramatically starting from his dream before the battle at Bosworth Field, flanked by his armour and his crucifix, perhaps to indicate the necessity of a choice between an active and contemplative or religious lives. We are forced to concentrate on Garrick's gesture and expression, Hogarth having transcended the limitations of individual portraiture in a study of the Shakespearian character.

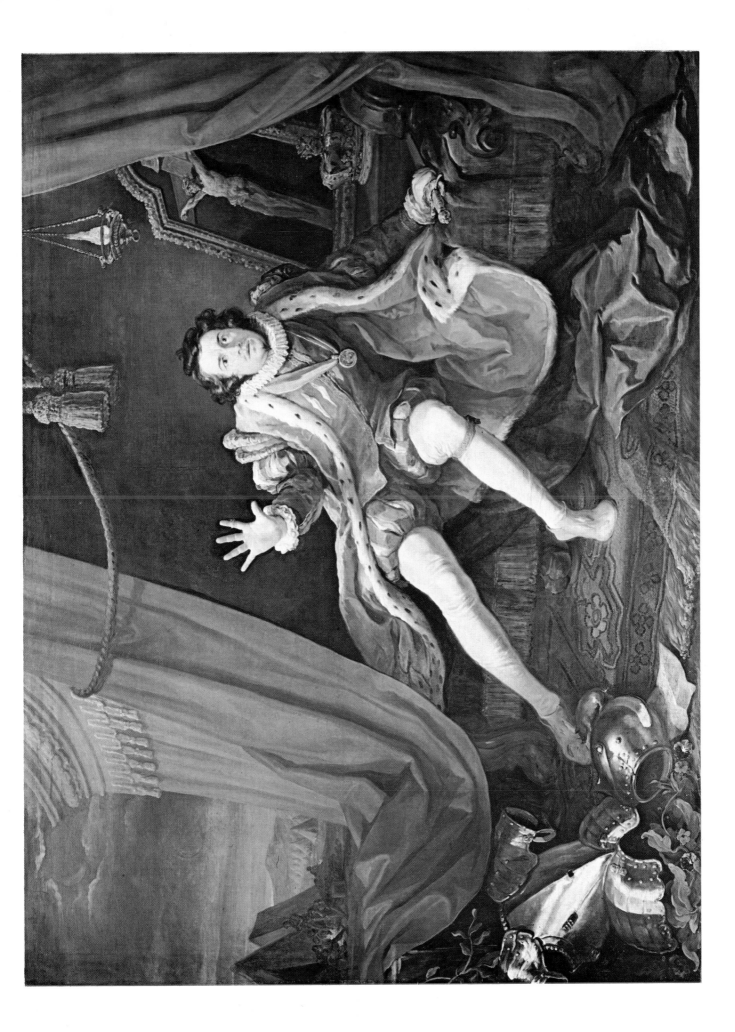

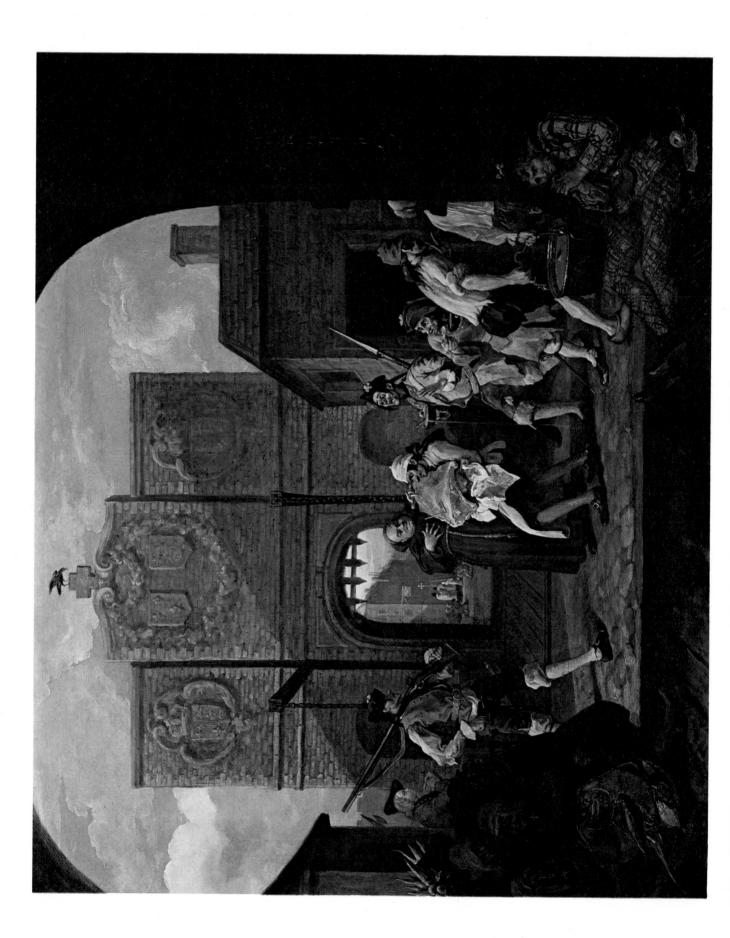

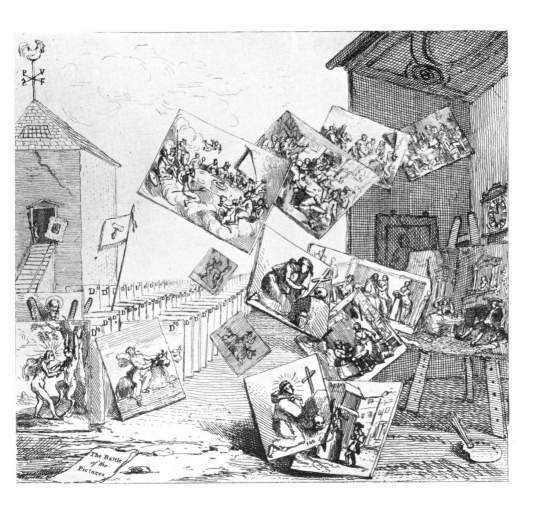

56  *The Battle of the Pictures*
LONDON, British Museum, Department of Prints and Drawings. February 1745. Etching
17·8 × 20 cm.

This was the ticket to the relatively unsuccessful 1745 sale of nineteen of Hogarth's paintings, with the individual canvases of *A Harlot's Progress* selling for nineteen guineas apiece, and with *A Rake's Progress*, *The Four Times of Day* and *Strolling Actresses* a total of just £427 and seven shillings being made. In front of Cock's Auction House are ranged ranks of duplicated Old Master paintings, some of which have broken to do battle with Hogarth's own works. A *St. Francis* beats *Morning* (Plate 34), and a *Penitent Magdelene* attacks the third picture from *A Harlot's Progress* (Plate 14), with behind it *Shortly after the Marriage* (Plate 51) damaged before it is off the easel. In a thrust at those who refused to see him as anything other than a painter of burlesques, Hogarth allowed only the tavern scene from *A Rake's Progress* (Plate 22) and *A Midnight Modern Conversation* (Plate 28), not itself in the sale, any success.

(*opposite*)
**VI**  *O the Roast Beef of Old England (Calais Gate)*
LONDON, Tate Gallery. 1748. Oil on canvas 78·5 × 94·5 cm.

Hogarth was angered enough by the incident he commemorated in the left background, his arrest for 'spying', to paint this picture and produce a print from it in a short space of time, the print appearing in March 1749. Through Calais Gate one can see the inhabitants kneeling before a religious procession. The main incident takes place in front of it. Hogarth's purpose in visiting France had been to look at recent painting. It is possible that the still-life group of fish which amuses the old women so much is an attack on French art as represented by Chardin's works (fig. 13). Again the subject fits neatly with contemporary mythology. The author of *A Trip through London* (1728) describes a City Alderman

> . . . . particularly fond of Beef, which he calls Protestant Victuals . . . and says, there is Religion and Liberty in an *English* Sirloin: but Foreign Cookery is like the *Latin* Mass, and wishes that Soups and Ragouts were out of Fashion, for that they savour too much of Popery and wooden Shoes.

*Industry and Idleness* (Plates 57–59).

This series consists of twelve plates, based on preparatory drawings, intended to contrast the behaviour and fates of two apprentices. They were intended as five pairs, with the first and tenth scenes involving both protagonists. The industrious 'prentice leads a moral life, the idle 'prentice does not, so that while the former attends church, the latter gambles in the graveyard. Hogarth wrote that he intended the series 'for the use & Instruction of youth wherein everything necessary to be known was to be made as intelligible as possible', and certainly his message seems unambiguous. Yet, as with *Paul before Felix Burlesqued* (Plate 47), one cannot help entertaining doubts about Hogarth's personal philosophy. The immoral actions are always more visually interesting than the moral ones, and the cumulative impression of the industrious 'prentice's chief personality trait is that of smugness.

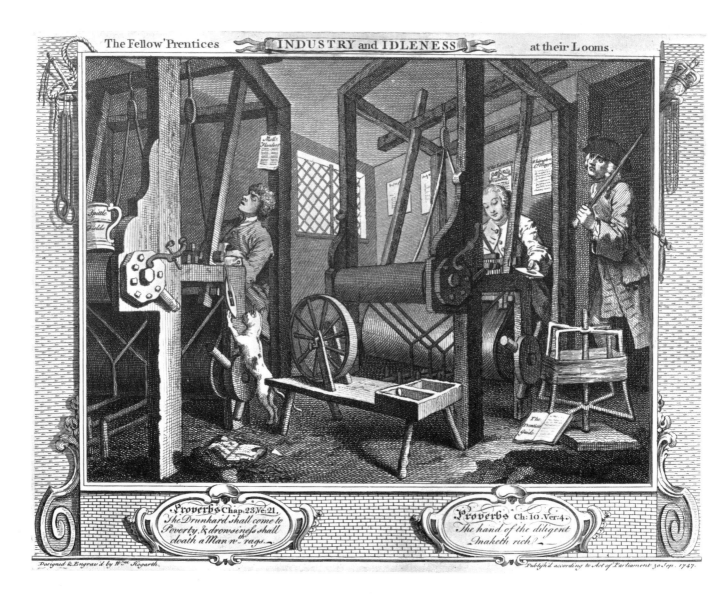

57   *Industry and Idleness*, plate one: *the Fellow-'Prentices at their Looms*
LONDON, British Museum, Department of Prints and Drawings. October 1747. Etching with some engraving and engraved frame (second state) 25·9 × 34 cm.

As in all the prints the frame contains, besides the title, biblical mottoes appropriate to the scenes shown. The idle 'prentice, who had been drinking, dozes gently at his unproductive loom, while his industrious companion works diligently. His moral worth is attested to by *The Prentice's Guide* lying open and in good repair, rather than shut, wrecked and thrown to the floor as is Idle's copy, by his combed hair and by a ballad about Dick Whittington pinned to the wall to spur his ambition. That weaving might not be the pleasantest occupation is suggested by the strong desire of each 'prentice to do something else.

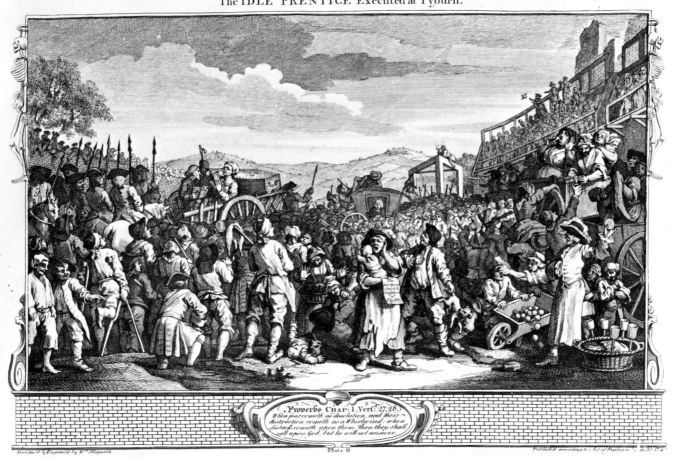

Proverbs CHAP: I. Verf: 27,28.
When fear cometh as desolation, and their
destruction cometh as a Whirlwind; when
distress cometh upon them, then they shall
call upon God, but he will not answer.

Design'd & Engrav'd by W<sup>m</sup> Hogarth.    Plate 11    Publish'd according to Act of Parliam<sup>t</sup>. 4. 30. 17 4

58  *Industry and Idleness,* plate eleven: *the Idle 'Prentice Executed at Tyburn*
LONDON, British Museum, Department of Prints and Drawings. October 1747. Etching with some
engraving and engraved frame (second state) 25·7 × approx. 40 cm.

Visiting executions was among the more popular eighteenth-century recreations. Idle, in a cart with
his coffin, is praying as he moves towards the gallows; the shadowed figure in the cart to the far
right, the only one actually grieving, is his mother. The populus eats, drinks and fights. In the
foreground a woman sells *The last dying speech & confession of Tho. Idle* .

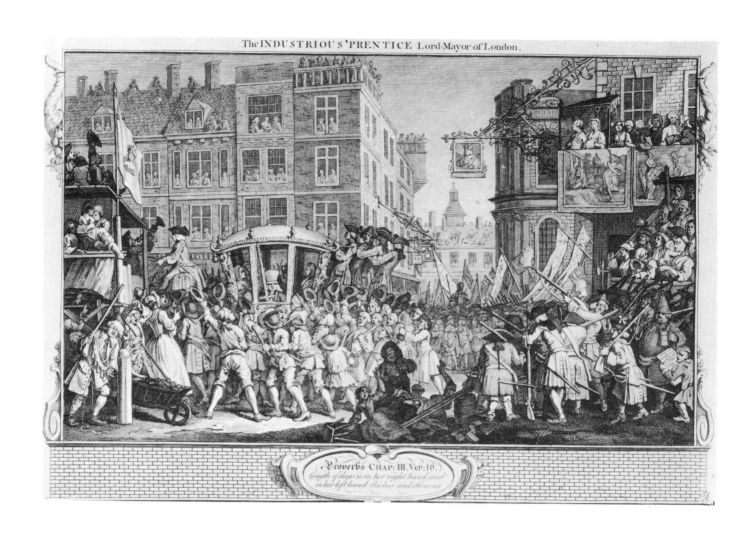

Proverbs CHAP: III. Ver: 16.
*length of days is in her right hand and in her left hand Riches and Honour.*

59   *Industry and Idleness*, plate twelve: *the Industrious 'Prentice Lord Mayor of London*
LONDON, British Museum, Department of Prints and Drawings. October 1747. Etching with some engraving and engraved frame (second state) 27·8 × approx. 40 cm.

The Lord Mayor's Procession has just emerged from St. Paul's Churchyard. A vast throng has assembled to watch it, including the Prince of Wales with his consort on the balcony to the right, gazing into the middle distance. In detail the scene provides much interest. In the booth to the left a couple are kissing with a small boy looking up the woman's skirt. A child to the right is reading *A full and true Account of ye Ghost of Tho: Idle. Which* . . . One wonders whom exactly the ghost intends to haunt.

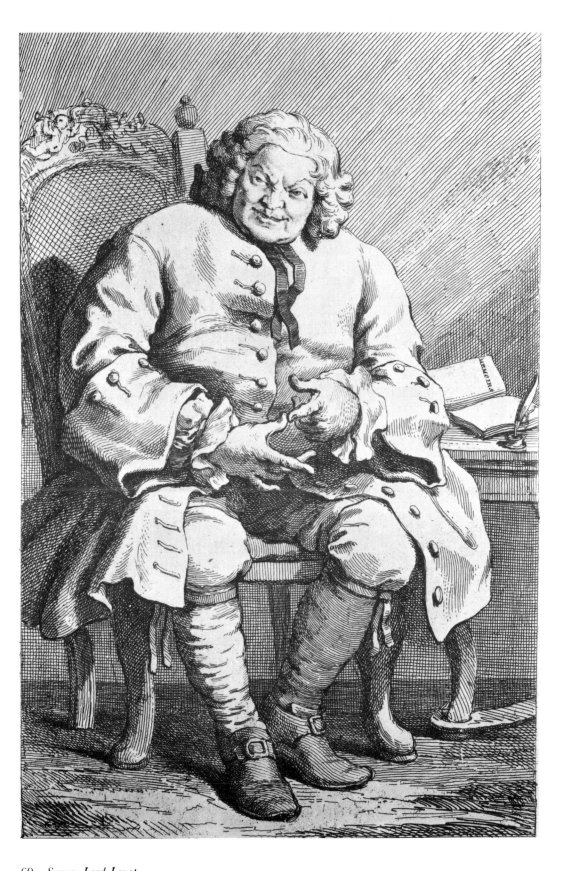

60   *Simon, Lord Lovat*
LONDON, British Museum, Department of Prints and Drawings. August 1746. Etching in aquafortis (first state) 33·5 × 22·5 cm.

Hogarth made a quick drawing of Lord Lovat as he stopped at St. Albans on his way to his trial in London. Lovat had fled after the battle of Culloden but had been retaken. The print sold for a shilling, and Vertue said that it went well, apparently 10,000 impressions earning Hogarth more than £300. Lovat is shown counting on his fingers the number of clans involved in the Jacobite rebellion of 1745, with his *Memoirs* lying on the table behind him. Hogarth took as much care with Lovat's features as with those in any of his 'grander' portraits and was fascinated by an individual whose history was spectacular, although to an Englishman, traitorous.

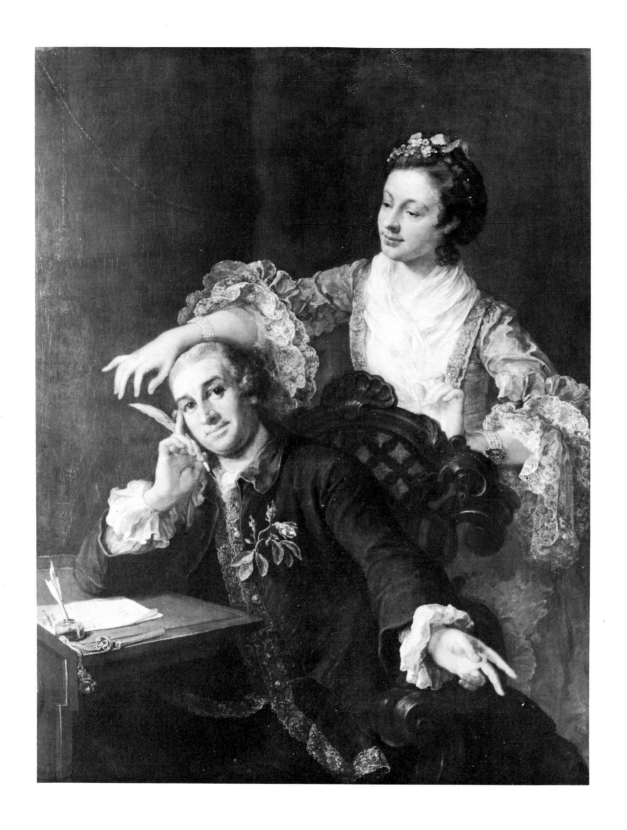

61  *David Garrick and his Wife*
Royal Collection (Reproduced by Gracious Permission of Her Majesty the Queen). 1757. Oil on canvas 127·5 × 99·5 cm.

Garrick enjoyed being painted, and this portrait was the fruit of a visit he paid to Hogarth. The artist introduced the traditionally Dutch, but more recently French, conceit of presenting the picture in the form of a domestic incident. Garrick has been writing and, unknown to him, his wife has crept up and is about to take the pen from his fingers. Like many of Hogarth's efforts of this period the painting remained unfinished. There is a story that Garrick made some remark facetious enough to annoy the artist who then slashed his brush across the eyes. Certainly there is some repainting in that part of the picture, and it did remain in Hogarth's possession rather than passing into Garrick's collection.

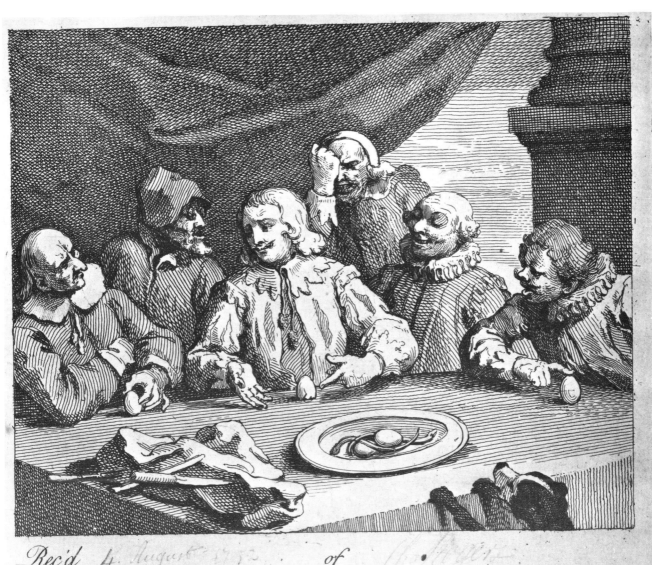

*Rec'd 4. August 1752 of Chr. Killigrew*

*five Shillings being the first Payment for a Short Tract in Quarto call'd the Analysis of Beauty; wherein Forms are consider'd in a new light, to which will be added two explanatory Prints Serious and Comical, Engrav'd on large Copper Plates fit to frame for Furniture.*

*N.B. The Price will be rais'd after the Subscription is over.*

*W.ᵐ Hogarth*

62  *Columbus Breaking the Egg*

LONDON, British Museum, Department of Prints and Drawings. April 1752. Etching (first state)
14·3 × 18·1 cm.

This print was the subscription ticket to *The Analysis of Beauty* (Plates 63 and 64). Its composition derived from Leonardo's *Last Supper* (fig. 5) and shows Columbus successfully making an egg stand upright. The two elvers in the plate each assume the 'line of beauty', possibly to show that although it is everywhere it is given to very few actually to see it.

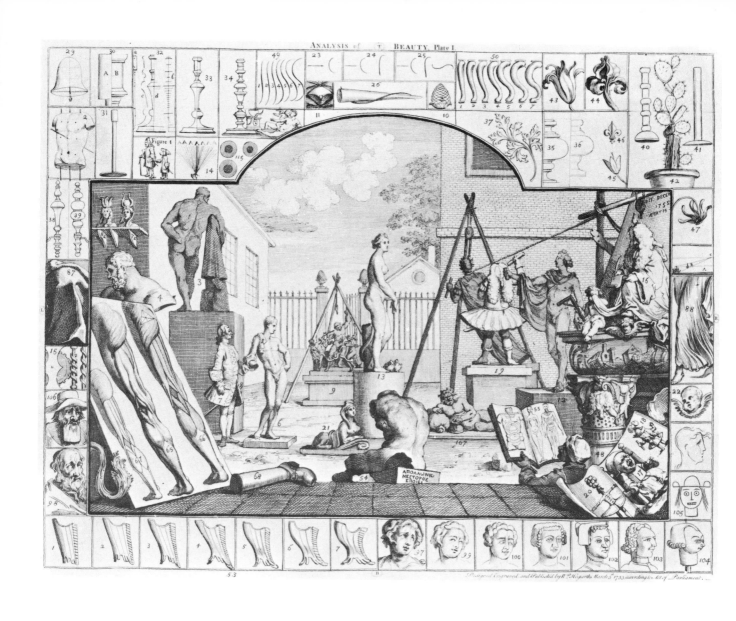

63  *The Analysis of Beauty*, plate one
LONDON, British Museum, Department of Prints and Drawings. March 1753. Etching and engraving (third state) 37·2 × 49 cm.

The main scene of this plate is Henry Cheere's statuary's yard at Hyde Park Corner, an allusion to Socrates, as documented in Xenophon's *Memorabilia*, discussing beauty in Clito's yard. Cheere was noted for the production of leaden copies after famous classical statues. Here the ancient and the modern are ludicrously juxtaposed. *The Apollo Belvedere* stands behind the pompous memorial to a judge, facing *The Medici Venus*. A stiff dancing master corrects the pose of *The Vatican Antinous*. All the classical figures display various 'lines of beauty', the modern ones lack them. The insets around the side of the print are intended to demonstrate the occurrence of the 'line of beauty' with direct reference to arguments advanced in *The Analysis of Beauty*.

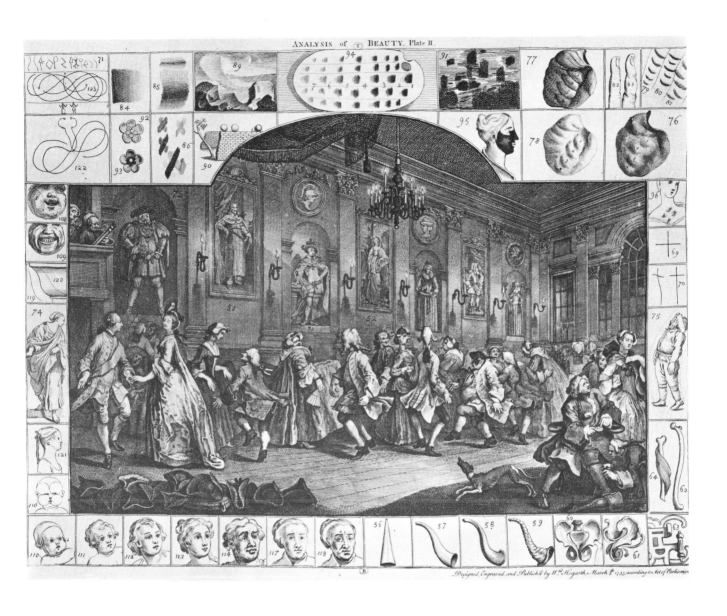

64  *The Analysis of Beauty*, plate two
LONDON, British Museum, Department of Prints and Drawings. March 1753. Etching and
engraving (first state) 37 × 49·9 cm.

This composition derived from *A Country Dance* from Hogarth's abandoned *Happy Marriage* series of
c. 1745 (London, Camberwell, South London Museum). The print shows how one forms an
aesthetic judgement through noticing relative grace and how this factor is dependent on the
dominance of the 'line of beauty'. In fact it is apparent everywhere, in the pile of hats or the curve
of the greyhound's back. It appears again in the incident to the right, in which a graceless and
stout farmer is angrily showing his young wife the time, and she conducts a liaison virtually before
his eyes. She is pretty and graceful and her face is composed of a large number of 'lines of beauty'
The insets around the side of the print serve the same function as they do in the first plate of the
series (Plate 63).

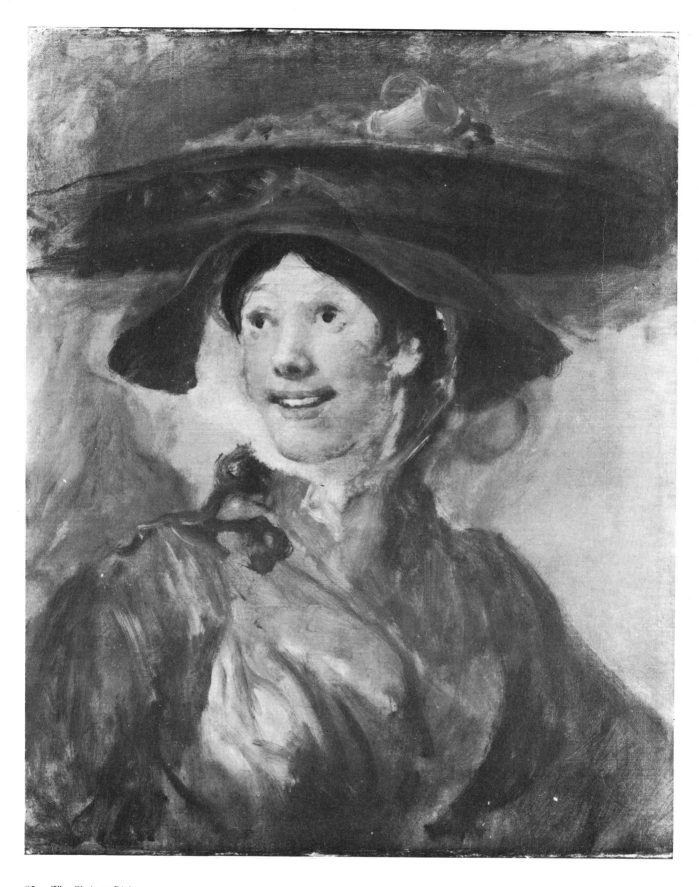

65  *The Shrimp Girl*
LONDON, National Gallery. mid-1750s? Oil on canvas 63·5 × 52·5 cm.

It is a measure of our lack of a true knowledge of Hogarth's methods of working that this sketch cannot be dated with any certainty. Hogarth did not work very frequently from the model, and it is possible that *The Shrimp Girl* was the fruit of his memory and the consequence of a relaxed hour or so in the studio. Although comparisons can be made with the brushwork of Hals or Fragonard, this painting impresses most by that enigmatic quality which is, thankfully, characteristic of all great art.

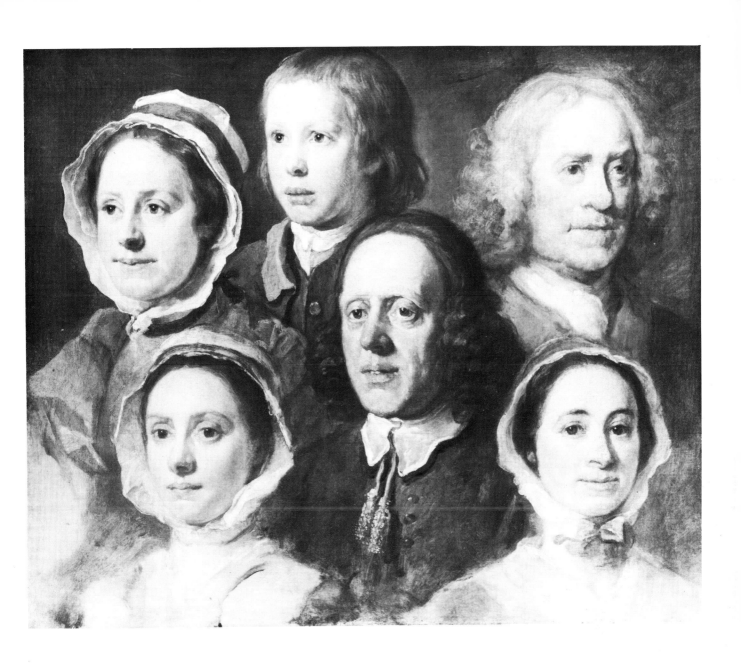

66  *Hogarth's Servants*
LONDON, Tate Gallery. mid-1750s? Oil on canvas 62 × 75 cm.

One imagines that, as its subjects were readily available to Hogarth, this group portrait, reflecting a relatively modest household, was painted from life. Hogarth worked directly onto the canvas, and the range of facial types shows he was still interested in what he saw about him. It is not certain why he painted this canvas. The most obvious explanation would be that he did it for his own pleasure.

This series describes in four paintings, also engraved over a period of years, scenes from an election. Hogarth made his point largely through understated exaggeration.

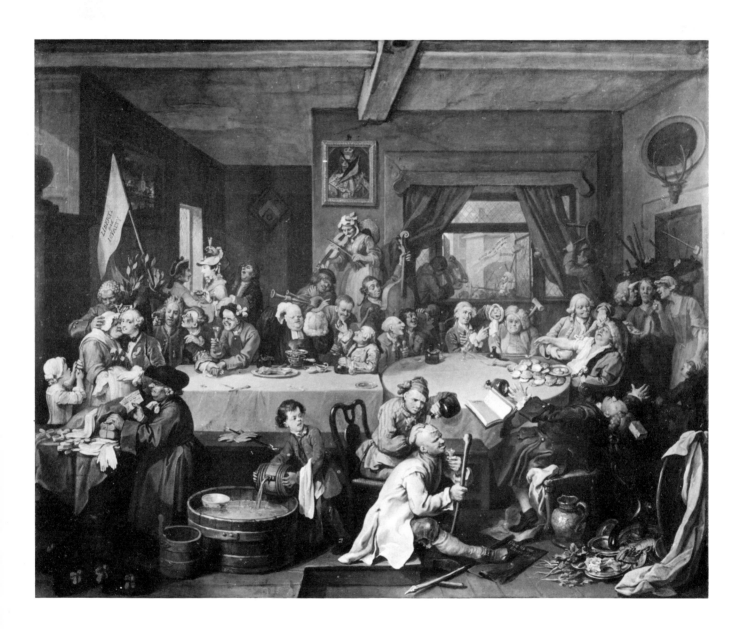

67   *An Election: an Election Entertainment*
LONDON, Sir John Soane's Museum. c. 1753–54. Oil on canvas 101·5 × 127 cm.

This painting shows a feast given by the Whigs in an attempt to influence voters; the candidates are hemmed in at the corner of the room. The Tories are parading outside with an effigy of a Jew. It is their supporters who are throwing bricks through the open window. In this composition we find the recurrence of the motif of a conversation round a table, used as a pictorial paradigm for an inverted moral and social order. The figure with his wig askew bears a close relation to his original in *A Midnight Modern Conversation* (Plate 28).

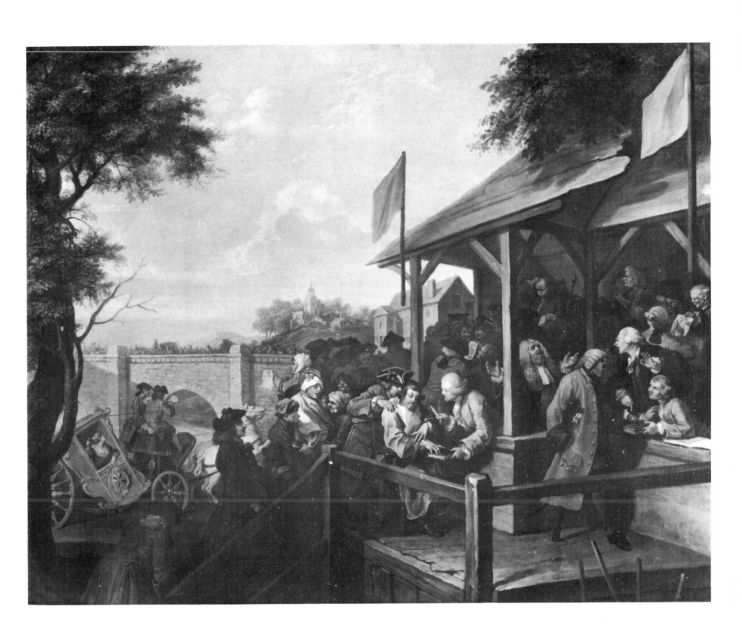

68   *An Election: the Polling*
LONDON, Sir John Soane's Museum. c. 1753–54. Oil on canvas 101·5 × 127 cm.

For the casting of the votes the two candidates stand at the back of the polling-booth. The sunlit landscape is again stylistically similar to those of Gainsborough. Individuals of various kinds are voting. In the right foreground there is a dispute over whether a virtually limbless ex-soldier, obviously a patriot and the salt of the earth, can use the hook on his left hand to make his mark. In the middle distance Britannia's coach has struck disaster because the coachmen are playing cards. Once again the mob is on the rampage, this time over the bridge.

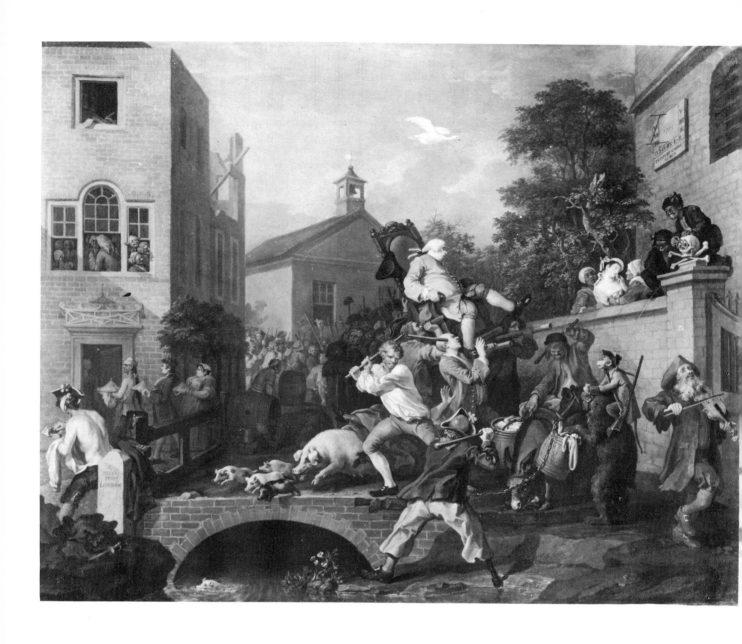

69 *An Election: Chairing the Member*
LONDON, Sir John Soane's Museum. c. 1753–54. Oil on canvas 101·5 × 127 cm.

The Tory candidate has been successful. Hogarth chose to paint a scene in which the split-second quality is more evident than usual. The way that the candidate is on the point of tumbling may refer specifically to the Oxford contest, because there the initial winner was eventually deposed. The mob with the losing Whig, visible as a shadow on the church wall, is just emerging into view, while a dinner is being had in the inn to the left. Hogarth delighted in exploring the visual chains of cause and effect. Two sweeps are sitting on a wall, one of whom urinates on the bear who is being beaten off by the man on the donkey riding across the path of the chaired member. There is a second chain. The bear itself belongs to the sailor who is fighting the labourer with the flail which, on its backswing, hits one of the chair's carriers thereby ensuring the precipitation of the new Member. The 'frozen moment' is evidenced too in the way that the Member's hat hangs in mid air. The only individual to be untouched by all this chaos is the blind Jewish fiddler, perhaps showing that politics need not be taken seriously by the sane and that even intended victims can often emerge unharmed.

70  *Self-portrait Painting the Comic Muse*
LONDON, National Portrait Gallery. c. 1758. Oil on canvas 39·5 × 37·5 cm.

The engraving after this small painting has *The Analysis of Beauty* propped against an easel leg, a paint pot and a recess behind the easel, possibly recording some early stage in the painting. It is known that at one point Hogarth included a model and a pug urinating against some paintings by Old Masters. While the expression on his face is determined, it is hardly happy, and the lack of progress of the work in hand might reflect the same feeling that we find in his writings of this period: it was all becoming a little too much for him.

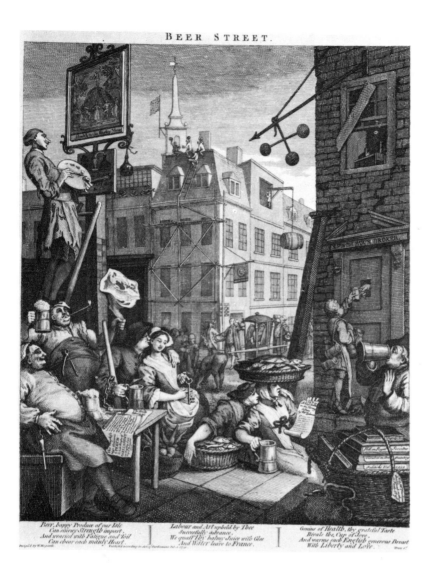

BEER STREET.

Beer, happy Produce of our Isle
Can sinewy Strength impart.
And wearied with Fatigue and Toil
Can cheer each manly Heart.

Labour and Art upheld by Thee
Successfully advance,
We quaff Thy balmy Juice with Glee
And Water leave to France.

Genius of Health, thy grateful Taste
Rivals the Cup of Jove,
And warms each English generous Breast
With Liberty and Love.

71   *Beer Street and Gin Lane: Beer Street*
LONDON, British Museum, Department of Prints and Drawings. February 1751. Etching and engraving (third state) 35·9 × 30·3 cm.

*Beer Street* exalts bluff English heartiness as being one consequence of beer-drinking. Others are thriving trade, shown by the multitude of different occupations, and social stability, the only building in ill-repair being the pawnbroker's shop. The individuals in the print indulge what may appear an excessive consumption of beer. Hogarth seems to have had doubts as to how he could best illustrate his theme. In early states the cooper brandishing the leg of beef was manhandling a Frenchman instead. His removal allows the introduction of a workman making advances to a young girl. In the street another paviour has been added in the third state, paving the street being itself another sign of peace and prosperity. This contentment is also indicated through the pamphlets lying around, while the works of authors of whom Hogarth disapproved, lying in a basket to the right, are destined for waste paper.

(*opposite*)
VII   *An Election: Canvassing for Votes*
LONDON, Sir John Soane's Museum. c. 1753–54. Oil on canvas 101·5 × 127 cm.

The second scene is set in a village street, with two inns on one side and an alehouse facing the one in the foreground. The alehouse is named The Portobello after the British naval victory over the French, which a couple of old men re-enact with coins and a broken pipe stem, oblivious to the happenings elsewhere, as if Hogarth was saying that virtue lies with ordinary people, politics notwithstanding. The Tory candidate is attempting to influence two young ladies. By the door of the inn a British lion is attempting to engulf the fleur-de-lis in another reference to wars with France. In the middle a wily freeholder is accepting bribes from both sides, while in the background the mob besieges The Crown Inn. The background landscape makes one curious to know the extent of Hogarth's acquaintance with Gainsborough, whom he may have met through the St. Martin's Lane Academy.

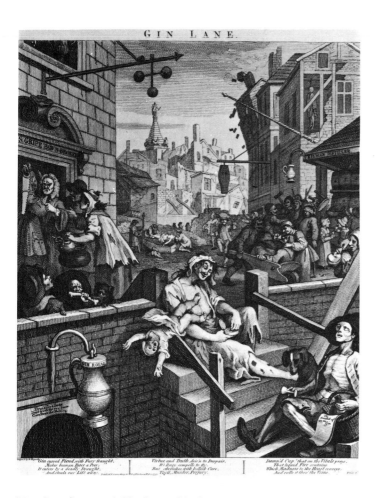

72 *Beer Street and Gin Lane: Gin Lane*
LONDON, British Museum, Department of Prints and Drawings. February 1751. Etching and engraving (second state) 36 × 30·5 cm.

The print, designed to have obvious formal and compositional links with *Beer Street* (Plate 71), illustrates the ravages of gin. The lady in a sedan chair in the central position of *Beer Street* is replaced by a young girl being laid in a coffin in *Gin Lane*, and where buildings were in repair, they are here on the point of collapse, with the background desolate. In *Gin Lane* the pawnbroker is doing well and taking as a pledge a carpenter's tools so that the latter can afford more gin. This shows that with gin there is a decline in trade and industry. The message on the door of the Gin Palace reads

> Drunk for a penny
> Dead drunk for two pence
> Clean straw for Nothing.

Above it a gin drinker disputes a bone with a dog. In the centre a mother is so oblivious that her child falls to his death, while the gin-and-ballad-seller is dead below her. In the right middle distance, at the booth of 'Kilman' the distiller, are scenes of conspicuous consumption and further in the background scenes of its effects. A barber has hanged himself, while a drunk has impaled a child and dances while beating time on his own head with a bellows. Hogarth's imagination could realize images of extraordinary horror.

**VIII** *The Lady's Last Stake*
BUFFALO, Albright-Knox Art Gallery (gift of Seymour H. Knox). 1758–59. Oil on canvas 91·5 × 105·5 cm.

Hogarth was at his best in this painting, employing a superb technique to exploit subtly the nuances of the scene. In comparison with the indoor versions of *Before* and *After* (Plates 30 and 31) the encounter is far less direct. The lady is older and more experienced, and the way she debates inwardly the officer's suggestion makes it impossible to consider the subject in terms of straightforward moral polarity. Symbolism is everywhere, for example in the fire which, because it has no visible means of replenishment, will, like the lady's 'fire of youth', go out, while the cards which have created her dilemma are about to be extinguished in the flames, thereby losing her the opportunity of enjoying the last flush of youth. The lap-dog has yet to be roused. Part of the painting's brilliance lies in the way that these clues are so unobtrusive.

*The Four Stages of Cruelty* (Plates 73–76)

As with *Beer Street and Gin Lane* (Plates 71 and 72) these prints were intended to purvey a relatively simple message to a wide audience. Indeed, Bell's woodcuts of the last two scenes are particularly stark. Hogarth made sure that the scenes were read correctly by including verse captions with each one. As he had done with *Beer Street and Gin Lane* he based the designs on preliminary drawings.

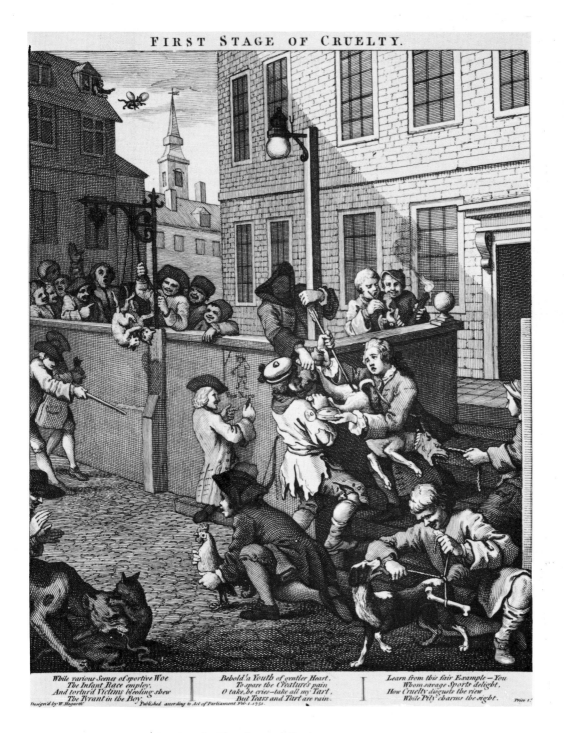

FIRST STAGE OF CRUELTY.

*While various Scenes of sportive Woe*
*The Infant Race employ,*
*And tortur'd Victims bleeding shew*
*The Tyrant in the Boy.*

*Behold a Youth of gentler Heart,*
*To spare the Creature's pain,*
*O take, he cries—take all my Tart,*
*But Tears and Tart are vain.*

*Learn from this fair Example—You*
*Whom savage Sports delight,*
*How Cruelty disgusts the view*
*While Pity charms the sight.*

*Design'd by W. Hogarth*      *Published according to Act of Parliament Feb. 1. 1751.*      *Price 1*

73   *The Four Stages of Cruelty: the First Stage of Cruelty*
LONDON, British Museum, Department of Prints and Drawings. February 1751. Etching with some engraving (first state) 35·6 × 28·1 cm.

The hero of the series is introduced perpetrating an atrocity on a dog, a youth offering him a tart to desist. The initials on his arm-badge stand for Saint Giles, which makes him a parish boy, dependent on local charity. We discover that he is called Tom Nero by way of the drawing on the wall, which prefigures his fate. All around are scenes of boyish barbarity. A cat in the background is being flung from an upper-storey window in an attempt to make it fly, while in the foreground a hound is being encouraged to maul another cat, and a cock is being held so sticks may be hurled at it. Cruelty in its first stage, then, comprises the childhood maltreatment of animals.

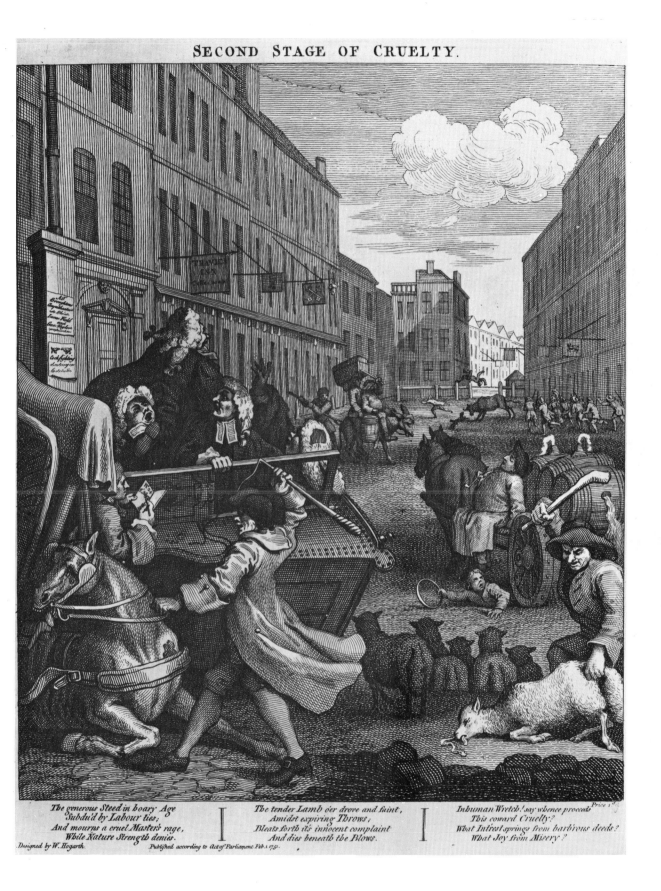

The generous Steed in hoary Age
Subdu'd by Labour lies;
And mourns a cruel Master's rage,
While Nature Strength denies.

The tender Lamb o'er drove and faint,
Amidst expiring Throws;
Bleats forth its innocent complaint
And dies beneath the Blows.

Inhuman Wretch! say whence proceeds
This coward Cruelty?
What Intrest springs from barbrous deeds?
What Joy from Misery?

Designed by W. Hogarth.          Publysbed according to Act of Parliament Feb.1.1751.

74   *The Four Stages of Cruelty: the Second Stage of Cruelty*
LONDON, British Museum, Department of Prints and Drawings. February 1751. Etching with some engraving (first state) 35·3 × 30·3 cm.

The second plate displays cruelty of various species. Nero is now a cab-driver, seen beating his half-starved horse. Beside him a drover has killed one of his sheep, while behind them a sleeping carter runs over a child. We see too an overladen ass being prodded with a pitchfork, and bull-baiting. Posters advertise other forms of cruelty, namely boxing and cock-fighting, so that the context has now expanded to both animals and man.

99

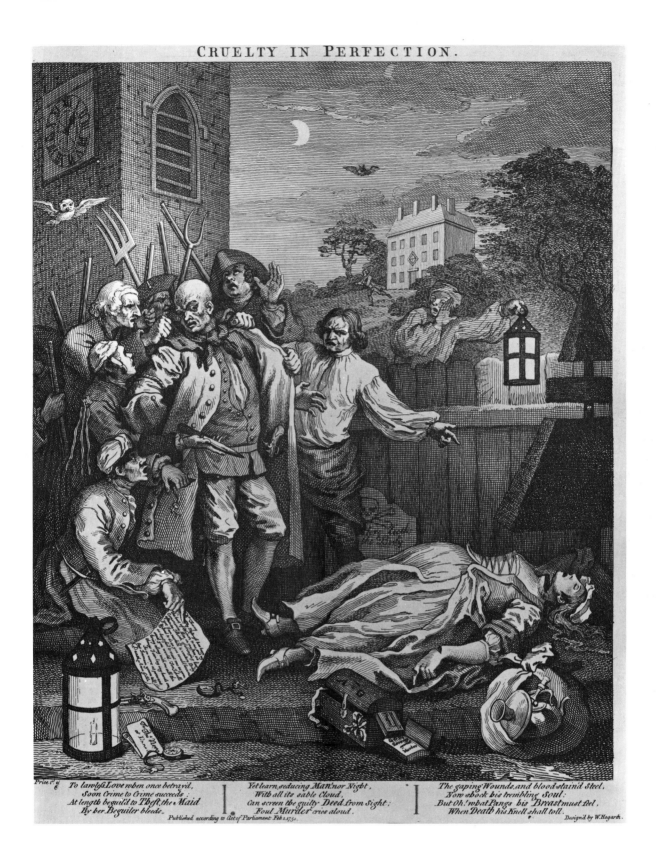

CRUELTY IN PERFECTION.

Price 1º 6ᵈ

To lawlefs Love when once betray'd,
Soon Crime to Crime succeeds;
At length beguil'd to Theft, the Maid
By her Beguiler bleeds.

Yet learn, seducing Man! nor Night,
With all its sable Cloud,
Can screen the guilty Deed from sight;
Foul Murder cries aloud.

The gaping Wounds, and blood-stain'd Steel,
Now shock his trembling Soul;
But Oh! what Pangs his Breast must feel,
When Death his Knell shall toll.

Published according to Act of Parliament Feb.1.1751.

Design'd by W.Hogarth.

75    *The Four Stages of Cruelty: Cruelty in Perfection*
LONDONN, British Museum, Department of Prints and Drawings. February 1751. Etching with some engraving 35·6 × 29·8 cm.

Hogarth showed a full familiarity with the props, such as the owl and the bat, of graveyard horror. Nero has induced the pregnant girl, in front of a gravestone with the legend 'Here lieth the Body', to rob her mistress and has then cut her throat. He has been apprehended by the locals, whose histrionic reactions give the scene virtually a melodramatic quality. We can learn the story by reading the letter in an onlooker's hand, and there are various other literary clues.

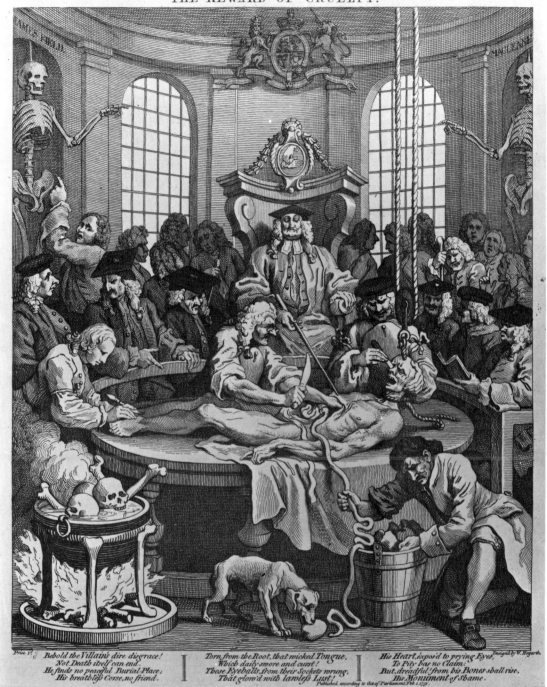

Bebold the Villain's dire disgrace!
Not Death itself can end.
He finds no peaceful Burial-Place;
His breathless Corse, no friend.

Torn from the Root, that wicked Tongue,
Which daily swore and curst!
Those Eyeballs from their Sockets wrung,
That glow'd with lawless Lust!

His Heart, expos'd to prying Eyes,
To Pity has no Claim:
But, dreadful! from his Bones shall rise,
His Monument of Shame.

Published according to dat of Parliament Feb 1.1751.

76   *The Four Stages of Cruelty: the Reward of Cruelty*
LONDON, British Museum, Department of Prints and Drawings. February 1751. Etching with some engraving (third state) 35·6 × 29·8 cm.

Nero's corpse, his initials burned on his arm, is being dissected for the edification of a group of doctors. The mechanical aspect of this performance and the gaping mouth are Hogarth's means of presenting Nero as sufficiently lifelike to appear to be barbarously treated himself and thereby gain our sympathy. That he is now receiving his 'reward' is shown in the way that a dog, like the one he tortured in *The First Stage* (Plate 73), is now feeding off his heart. The horror is increased by the disinterested inhumanity of the learned doctors. The skeletons pointing at one another are those of famous criminals and are included to show Nero's final state. The use of the "conversation round a table" composition, one which not only showed an inverted moral universe, but also originally implicated the spectator in a satire on drunkenness, might be a further way of forcing the message home. To participate with the doctors and remain unmoved demands a distressing lack of human sympathy.

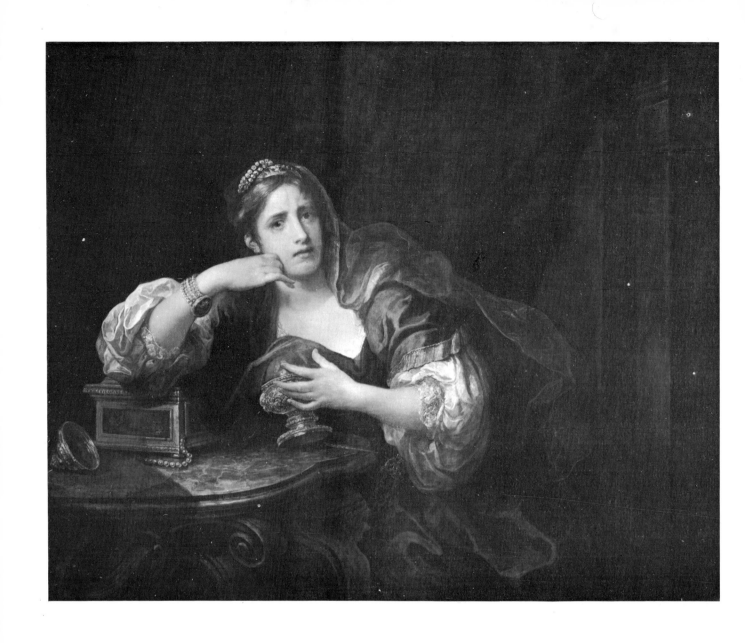

77 *Sigismunda*
LONDON, Tate Gallery. 1759. Oil on canvas 99 × 125·5 cm.

The story of this painting is complicated. It was made in competition with a painting supposed to be by Correggio, but actually by Furini, of the same subject and was the effort of much labour and anguish. The pose of the woman is developed from that of the lady in *The Lady's Last Stake* (Plate VIII), and Hogarth apparently had much emotional currency invested in this work. He is supposed to have modelled Sigismunda on his wife mourning her mother's death, and therefore she would, to the artist, have been a truthful representation of an extreme of emotion. Hogarth's realism went so far as to make him use, or so the story says, an actual human heart as a model for the one in the dish and to give Sigismunda blood-stained fingers. The latter feature he painted out. It was the truthful interpretation of the subject which most annoyed his contemporaries. Reynolds's 1759 parody, *Kitty Fisher as Cleopatra* (London, Kenwood House, Iveagh Bequest) showed one response in the expression of well-bred distaste on his heroine's face. The episode, probably derived from Dryden's *Fables*, depicts Sigismunda in anguish over the heart of her lover Guiscardo.

Χρονος γαρ ου τεκτων σοφος,  *See Spectator*
Απαντα δ'εργαζομενος αθενεςερα Vol: II Page 83.

VARNISH.

_____ As Statues moulder into Worth _P:W_

*To Nature and your Self appeal,*
*Nor learn of others, what to feel*     Anon:

78   *Time Smoking a Picture*
LONDON, British Museum, Department of Prints and Drawings. March 1761. Etching and mezzotint (first state) 20·3 × 17 cm.

This print was designed as the subscription ticket to a proposed plate of *Sigismunda* (Plate 77). Hogarth's intentions are clear both literally and visually. The Greek quotation from Crates is about the weakening effects of time, and the motto 'As Statues moulder into Worth' combines with the caption

> To Nature and your Self appeal,
> Nor learn of others, what to feel

to support the message that one should go to nature and see with one's own eyes. Time himself is darkening the canvas into unintelligibility and has poked a hole through it with his scythe. This composition attacked a false taste for darkened, 'brown' Old Master paintings and emphasized that when such canvases were newly painted they were as brightly coloured as the contemporary ones that connoisseurs decried. This issue was to remain an obsession with English artists, Constable being a particular case in point.

**79** *Credulity, Superstition and Fanaticism*
LONDON, British Museum, Department of Prints and Drawings. April 1762. Etching and engraving
(second state) 36·8 × 30·1 cm.

*Credulity, Superstition and Fanaticism* revises the unpublished *Enthusiasm Delineated* which Hogarth
withdrew from issuing on the grounds that it might have been seen as constituting an attack
against religion in general. There is here an unambiguous linking of Methodism with popular
deception, so that on the floor we see Mary Tofts giving birth to rabbits (see Plate 5), while the
shrouded figures with candles introduced everywhere are references to the contemporary imposture
in Smithfield of the Cock Lane Ghost. Methodism is personified in the ranting preacher. To the
right, resting on a volume of Wesley's sermons, is a heart, from which springs a thermometer
designed to register the reactions of the congregation. This composition practically marks a return
to the emblematic character of the first prints (Plate 2). We need a wide knowledge of
contemporary scandal to understand the design fully, and the imagery is full of explanatory
legends which we have to read.

80 *The Cockpit*
LONDON, British Museum, Department of Prints and Drawings. November 1759. Etching and engraving 29·7 × 37·3 cm.

Although this theme may originate in one of *The Four Stages of Cruelty* (Plates 73–76), no reason is known for Hogarth to have suddenly produced a print which masquerades as an admission ticket to a cockfight. If we understand the motif of a conversation round a table as always being ironic in Hogarth's work and showing the converse of desirable or civilized behaviour, the composition serves the same end here. It is packed with bodies, and it takes a good deal of effort to discover what they are all doing. In the centre, and the object of attention, is the blind nobleman, Lord Albermarle Bertie, who attracts a crowd willing to advise him or more directly to steal his money. He lacks one vital sense yet is totally involved in events. Hogarth's view of human behaviour has become despairing.

81  *The Times*, plate one
LONDON, British Museum, Department of Prints and Drawings. September 1762. Etching and engraving (third state) 21·8 × 29·5 cm.

Hogarth intended this print as a satire on the futility of both war and political faction. The fire refers to the Seven Years War, as we can see by the eagle and the fleur-de-lis, representing the Empire and France respectively. The flames are spreading to a globe and being fanned by a stilted figure of Pitt. The Union Office, attempting to extinguish the fire, with the help of Scotsmen, refers to George III and the Bute ministry. They are being attacked with well-directed jets from clysters by Wilkes and Churchill at an upstairs window of the Temple Coffee House. The building to the left presumably symbolizes the ill repair into which England has fallen through faction, while homeless citizens sit in despairing heaps to the right.

82　*The Times*, plate two
LONDON, British Museum, Department of Prints and Drawings. 1762 or 1763. Etching and
engraving (first state) 23·2 × 30·2 cm.

The second plate of *The Times* is a further attack on the detrimental effects of faction. To the left
the Lords are asleep while the Commons fire volleys at the dove of peace. Fruit trees in the royal
garden are being watered, which carries a self-evident symbolism, while to the right the figures
both of conspiracy, in the form of the Cock Lane Ghost, and of defamation, Wilkes, stand in the
pillory. The rebuilding and neat aspect of the houses in the background refer to the urban
improvement which was being carried out by the Bute ministry.

83 *John Wilkes*
LONDON, British Museum, Department of Prints and Drawings. May 1763. Etching (first state)
31·8 × 22·2 cm.

This caricature was etched from an outline in crayon and designed to form a pair with *Simon, Lord Lovat* (Plate 60). Hogarth, thus, not only implied that Wilkes was a traitor, but also, by contrast with the relatively distinguished figure of Lovat, Wilkes was made to appear even more ridiculous. The print, incidentally, sold very well indeed. The copies of *The North Briton* are the ones in which Wilkes slandered Hogarth (number 17) and the king (number 45).

THE BRUISER, C. CHURCHILL (once the Rev:ᵈ) in the Character of a Russian Hercules, Regaling himself after having Kill'd the Monster Caricatura that so forely Gall'd his Virtuous friend the Heaven born WILKES.
— But he had a Club this Dragon to Drub,      Or he had ne'er don't I warrant ye. —— Dragon of Wantley.
Deſign'd and Engraved by Wᵐ Hogarth Price 1ˢ.6ᵈ      Publish'd according to Act of Parliament August 1. 1763.

84   *The Bruiser*
LONDON, British Museum, Department of Prints and Drawings. August 1763. Etching and engraving (second state) 34·3 × 26·2 cm.

Hogarth here used the plate for *Gulielmus Hogarth* (Plate 85), replacing his own portrait with that of a bear in a clergyman's collar, presented as a drunken liar. The bear, representing Wilkes's cohort, Charles Churchill, gazes at the pug as if he cannot understand its scornful opinion of him, while the palette and graver remain as if to emphasize that the artist was unhurt by Wilkes's and Churchill's attacks and keen to return to battle.

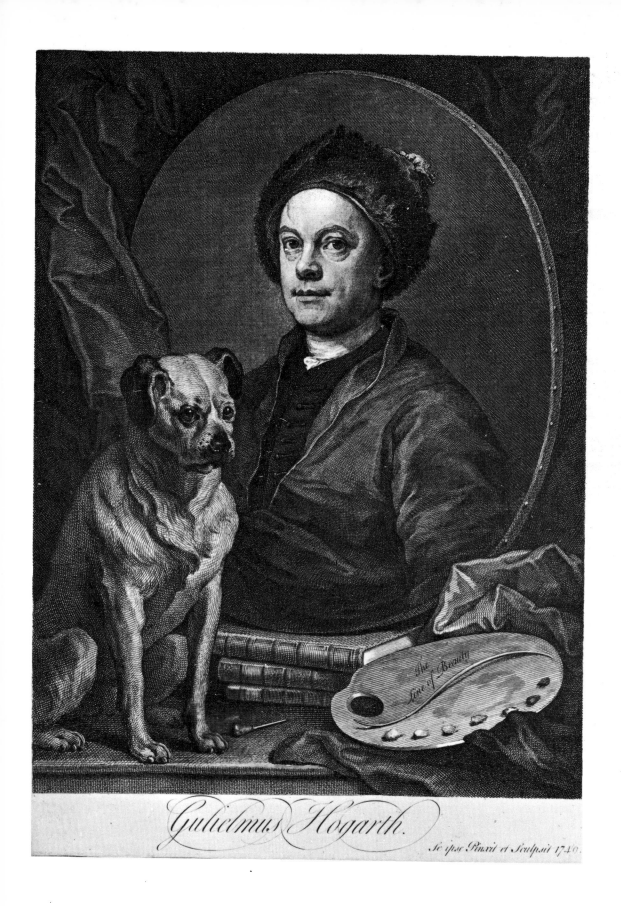

*Gulielmus Hogarth.*

*Se ipse Pinxit et Sculpsit 1749.*

85  *Gulielmus Hogarth*
LONDON, British Museum, Department of Prints and Drawings. 1749. Etching and engraving (fourth state) 34·3 × 26·2 cm.

This reversal of the painting is accurate as a self-portrait. Hogarth used this plate as the frontispiece to his collected prints, and there are differences between it and the painting. The books' titles are erased, perhaps to suggest a more general idea of 'English literature', and 'the line of beauty' more clearly labelled. The palette is now loaded with pigment, and his graver lies by its side, to remind us of his skills in both paintings and prints.

Designd and Engravd by Wᵐ Hogarth.　　THE BATHOS,　　Publishd according to Act of Parliamᵗ March 3ᵈ 1764.

or Manner of Sinking, in Sublime Paintings,

inscribed to the Dealers in Dark Pictures. ✝

86　*Tailpiece* or *The Bathos*
LONDON, British Museum, Department of Prints and Drawings. April 1764. Etching and engraving
27·3 × 32·4 cm.

Hogarth intended that this plate should form an endpiece to collected volumes of his prints.
Although he closed pessimistically he tells us too that he considered his output to represent the
history of one man's way of looking at the world and that his work ought to be considered as such.